Jeanne —

Thank you for your Support!

Never Forget!

Christine
Conrad

Journey of a Beam:

A 9-11 Pictorial Remembrance

Library of Congress Control Number: 2012948077

 tm Rosstrum Publishing
The Rosses
8 Strawberry Bank Rd.
Suite 20
Nashua, New Hampshire 03062-2763

Manufactured in the United States of America

First Printing, September, 2012

1 3 5 7 9 10 8 6 4 2

Dedication

This book is dedicated to the Kovalcin family, with the hope that this memorial may bring some comfort and help with healing. Also to all who have served and continue to serve in our armed forces, as well as their families. We can never repay the sacrifice of those who gave their lives. Nor can we fail to recognize the selfless heroism and assistance, without regard for their own safety, of those who were at the World Trade Center. Also to the Town of Hudson and its officials.

This book is a reminder of the necessity of this memorial and will let it be known that we will NEVER FORGET.

Acknowledgements

I would like to thank my mother, who I love and miss every day, and who taught me to be creative and to be myself. Without her love, I would not have had the confidence to complete this project. My son, Chris, and my brother, Sean, taught me to believe in my own ability. Dawn Philbrook spent hours poring over photos and helping me make choices, even when I didn't want to. The Philbrook/Howe family offered the love, support, and encouragement for which I will always be thankful.

Aunt Niecey joined my mother in raising me with understanding and teaching me that it is okay to take chances. Uncle Dave and Aunt Lou, along with the rest of the Reed family, offered great support over the past years. Kerri Cook and Britter Bug: thank you so much for all your support. You and Dawn helped me through some of my hardest choices.

Peter Antoinette offered the encouraging words and support which taught me to have faith in myself and not to cut myself short. Esther Ross offered valuable help and support.

The Herd at Nanocomp were both understanding and an inspiration. I appreciate the forgiveness and understanding of my friends who still sent invitations and remained kind and supportive, despite the times I declined their invitations in favor of a long night of editing photos. My friend, Tracy, deserves praise and thanks for providing needed support and the getaways I needed.

This book could not have been completed without the encouragement and assistance of the 9/11 Committee: David Morin, Carole Whiting, Torrey Demanche, Dennis Haerinck, John Rudolph, Brian Alley, Robert Buxton, Martin Conlon, Roger Coutu, Lafe Covill, Gilles Dube, Todd Hansen, Elizabeth Kovalcin, Bill Leblanc, Adam Lischinsky, Rick McCartney, Corey Morin, Michelle Rudolph, and Jason Sliver. I am gratified that this committee invited me to join and gave me the opportunity to tell the story as the Memorial came to be.

In addition to the committee, I would be remiss if I did not offer thanks to the spouses, family members, volunteers and friends who often joined behind

the scenes in order to make this effort successful.

A special thank you to Dave Morin, who spent endless hours at all hours of the day and night, whether by text, e-mail or phone, to help with information, contacts, and whatever releases were required.

Torrey Demanche and Carole Whiting spent hours after work to review 1,000s of photos, help make the hard choices, and assist with photo releases.

Selectman Roger Coutu was instrumental in arranging for some book signings.

Thanks also to the many unknown volunteers who stopped at the Memorial during its construction. Your help was noticed and appreciated.

The many companies who provided media and other coverage, helped in fundraising, and assisted in the construction of the Memorial, offering many hours of volunteer service and material helped make both the Memorial and this book possible. They include: Aggregate Industries; Area News Group; Barlow Signs; Bay State Welding; Brox Industries; Buxton Concrete; Country Brook Farms; Continental Paving Company; Enterprise Bank; Fillmore Industries, Inc.; Hudson Firefighters Relief Association; Hammer & Sons, of Pelham; Hudson Highway Dept.; Hudson Monuments; Hudson Nottingham West Lions Club; H.C.T.V.; Hudson Quarry; Hudson Police Relief Association; Kelly Crane, Inc.; Kinney Towing; Lowell Sun; T.J. Malley Electric, Inc.; New England Signs, Inc.; Modern Protective Coating, Inc.; Professional Firefighters of Hudson; The Telegraph newspaper; Tamarack Landscaping; Sousa Realty & Development Co.; Winding Brook Turf; Tim's Turf & Landscaping Material LLC; V.F.W. Post 5791; WMUR Television; Foley Buhl Roberts & Associates, Inc., Structural Engineers; Harvey Construction; Maynard & Paquette Engineering Association, LLC - Civil Engineering & Surveying; Morin's Landscaping; and PMR Architects, PC.

Every company and individual was instrumental, and should take justifiable pride in knowing what we have all accomplished together.

Julie Hansen, Louis Brown, and Samuel Zerillo were kind enough to donate some photos which appear in this book.

I would also like to thank Joseph Ross, my editor and publisher at Rosstrum Publishing, for his guidance and assistance.

Finally, a thank you to the Hudson, New Hampshire community for the support, contributions, faith, and belief in both the 9/11 Committee and this project.

A huge thank you goes to those who have served and continue to serve in our armed services, including the men and women, as well as their families, who have given so much. We can never repay the sacrifice of those who gave their lives as well as those at the World Trade Center whose selfless heroism and assistance, without regard for their own safety, made this memorial necessary.

A final thank you to all of those, including my grandson, Jacan Estes, who will visit the Memorial, learn about the events of that day, respect our country, and NEVER FORGET.

Journey of A Beam:

A 9-11 Pictorial Remembrance

By

Christina Green

Introduction

On September 11, 2001, the world watched in horror as an airplane plowed into Tower 1 of the World Trade Center in New York City. Moments later, another plane hit the second Tower, followed by a third plane which hit the Pentagon and another which was diverted by brave passengers and crashed in Pennsylvania. On radio and television, the events were seen live. Our citizens realized quickly that the United States was under attack.

The terrorists who perpetrated that attack felt these acts would divide our country. The opposite happened. These events served to unite our citizens, who mourned together, decried the senseless acts together and helped each other to cope.

Almost immediately, in Hudson, New Hampshire firefighters and volunteers, under then Lieutenant Dave Morin, recognized an urgency to help. They were not sure about what was needed or how to help. Lieutenant Morin said that "all we could do is wait for word on what we could do."

Then Lieutenant Todd Hansen suggested sending a truck full of supplies for the rescue workers at Ground Zero. Lieutenant Morin, Lieutenant Hansen, and Firefighter Steve Benton discussed sending equipment, supplies and food relief. Fire Chief Frank Carpentino approved their plan. Within four days, a 53' trailer was filled by residents of Hudson and surrounding towns. It contained food, water, clothing, tools, first aid equipment, and even dog food for the rescue animals.

Since that time, the Town of Hudson and the Hudson firefighters have continued to help wherever possible. They also organized a yearly Memorial.

Under Deputy Chief Robert Buxton and Dave Morin (by then Captain), Hudson applied to the NY/NJ Port Authority for two pieces of the wreckage. Morin was named President of the Hudson 9/11 Committee. Captain Hansen drew the plans on a napkin (right).

One of the beams used to construct the Trade Center was approved for Hudson on May 1, 2011, and plans were under way.

With the assistance of many volunteers, by both individuals and companies, the beam made its way to Hudson, New Hampshire, where volunteers constructed the memorial to those who lost their lives in this terrorist attack. Those include the many civilians as well as police, firefighters, emergency services personnel, and other volunteers, all of whom ran toward the towers to help without regard for their own safety.

This book follows that beam in its journey.

JOURNEY OF A BEAM

At 2:00 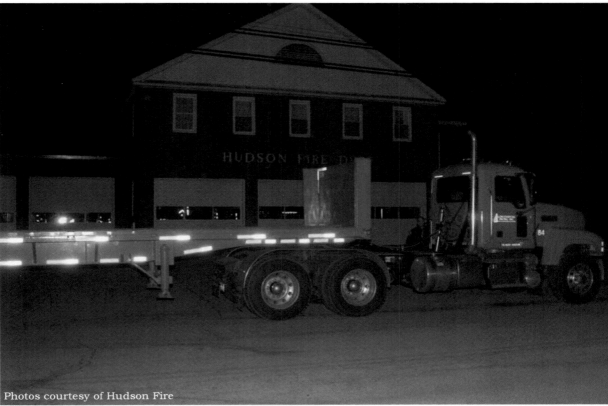 a.m. on May 12, 2011, a flatbed truck and driving team, gathered in Hudson, New Hampshire. Hudson's Continental Paving volunteered the truck and crew to make its way to New York.

Ⓑ

Photos courtesy of Hudson Fire

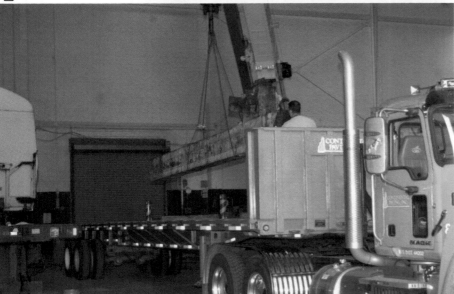

In New York, Hudson fire captain Dave Morin and several others arrived at Hanger 17 at JFK Airport. During the visit, they viewed many other artifacts from the attack.

Morin said that seeing the cars, trucks, and other vehicles crushed "... really put in perspective the project [we] were undertaking."

Hudson Selectman Roger Coutu said, "It was heart wrenching to see all the destruction. We arrived excited and left respectfully somber."

Hudson Animal Control Officer Carole Whiting added, "It made you realize the mass destruction of that day. It gave us such a different feeling."

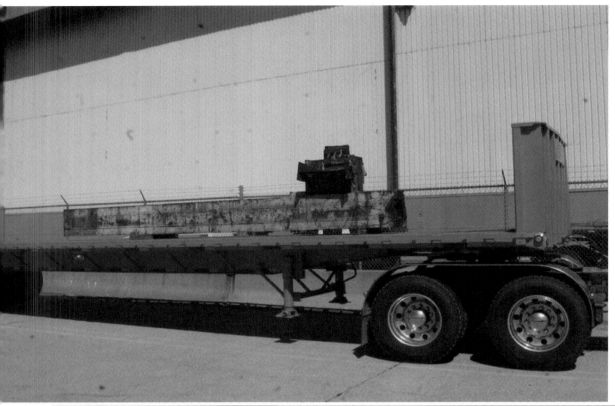

Once loaded, the beam was ready for its journey to Hudson. Firefighters Corey Morin (left) and Jay Sliver drape the beam for the trip.

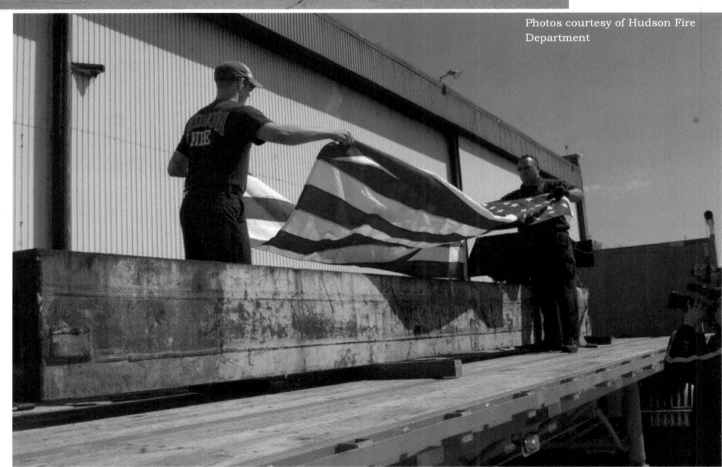

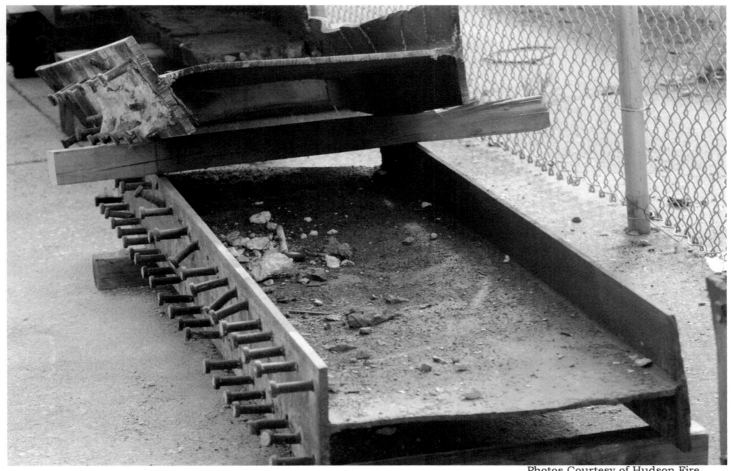

Photos Courtesy of Hudson Fire

Other pieces of the wreckage were picked up to be utilized in other memorials and to be placed in the hangar for use in the Museum. The sheer volume of steel was overwhelming. This scrap (below) was not in view of the general public.

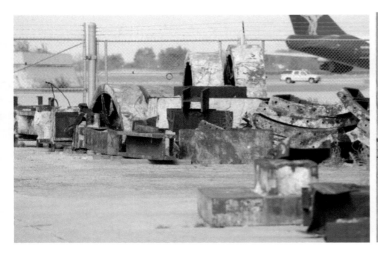
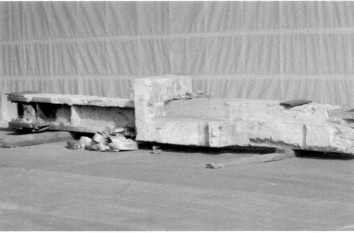

Photo courtesy of Hudson Fire

Workers at Ground Zero fashioned crosses and stars out of the steel.

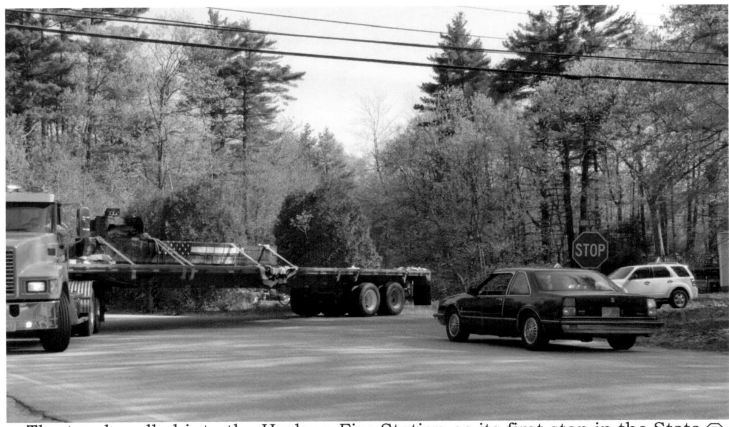

The truck pulled into the Hudson Fire Station as its first stop in the State Ⓑ of New Hampshire.

12

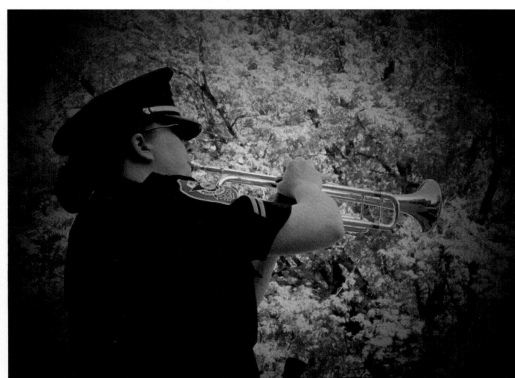

(A) Hudson police officer Allison Cummings plays Taps at the welcoming ceremony.

Animal Control Officer Carole Whiting stands at attention and salutes during the playing of Taps.

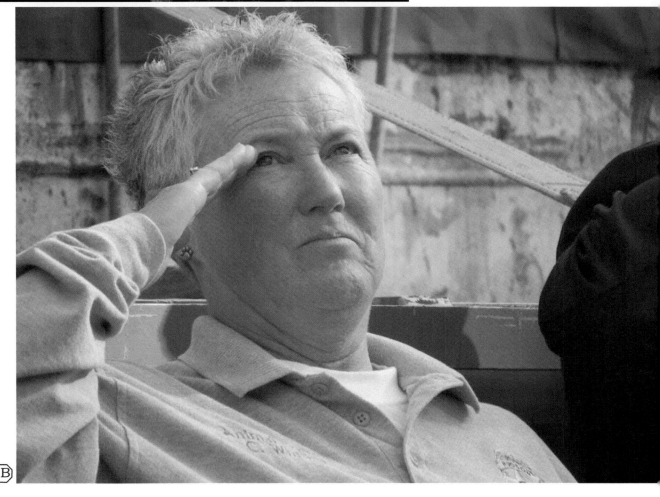

(B)

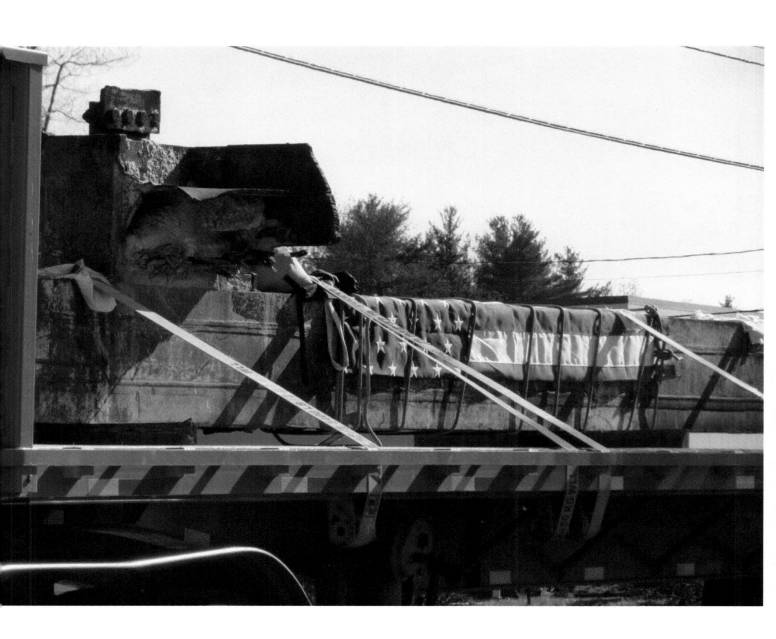

The flag-draped beam, firmly secured to the truck, awaits further action.

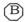

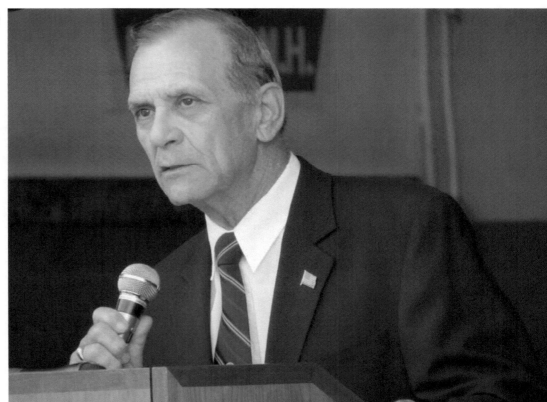

Selectman Roger Coutu, addresses the crowd at the welcoming ceremony. He was one of those who accompanied the beam from New York to Hudson.

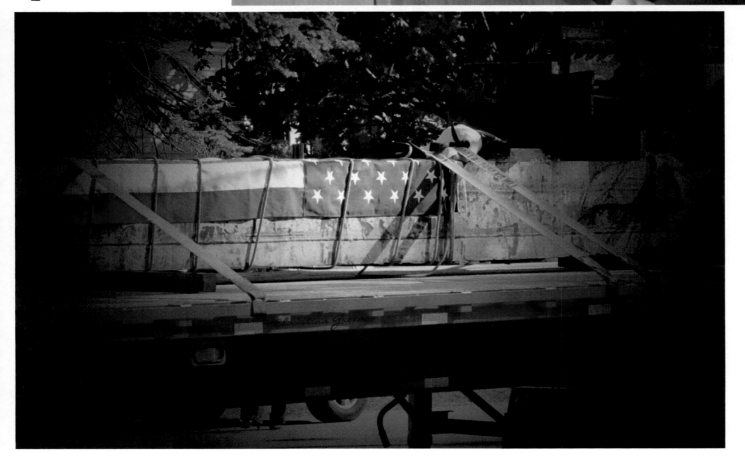

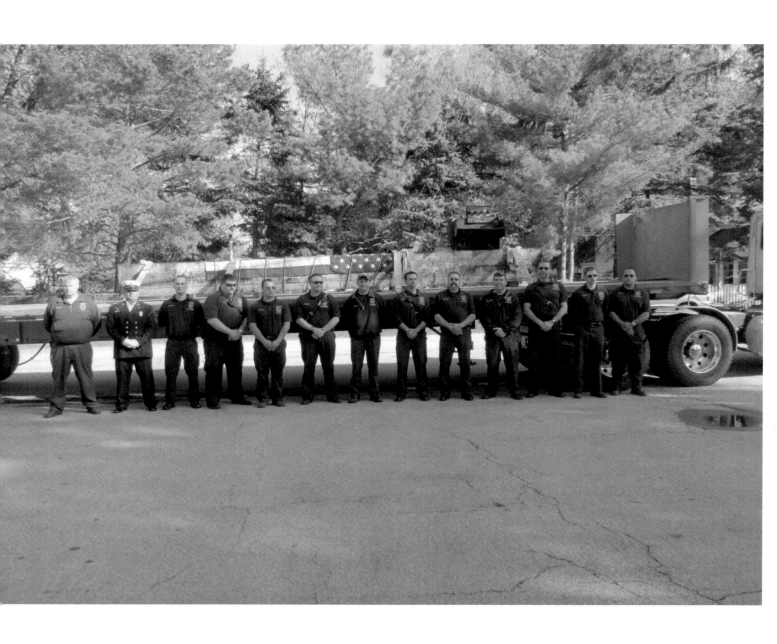

Shown in front of the beam are Captain Dave Morin, along with Firefighters Gerry Carrier, Todd Berube, Kevin Blinn, Brian Alley, Ben Crane, Dean Sulin, Glen Bradish, Dave Brideau, Sean Mamone, Allen Winsor, Corey Morin, and Jason Sliver.

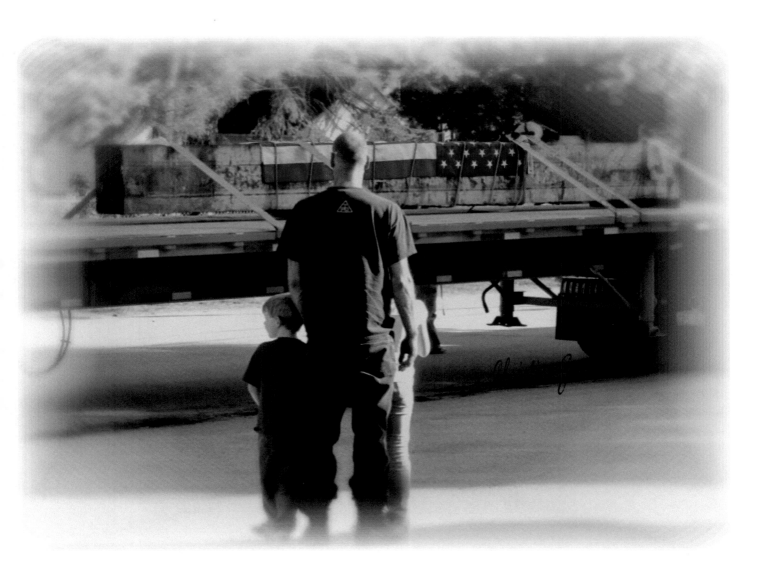

An unidentified man looks reverently at the beam with his two children.

The welcoming ceremony lasts until dark. The crowds of interested people continue to arrive for a glimpse at the steel.

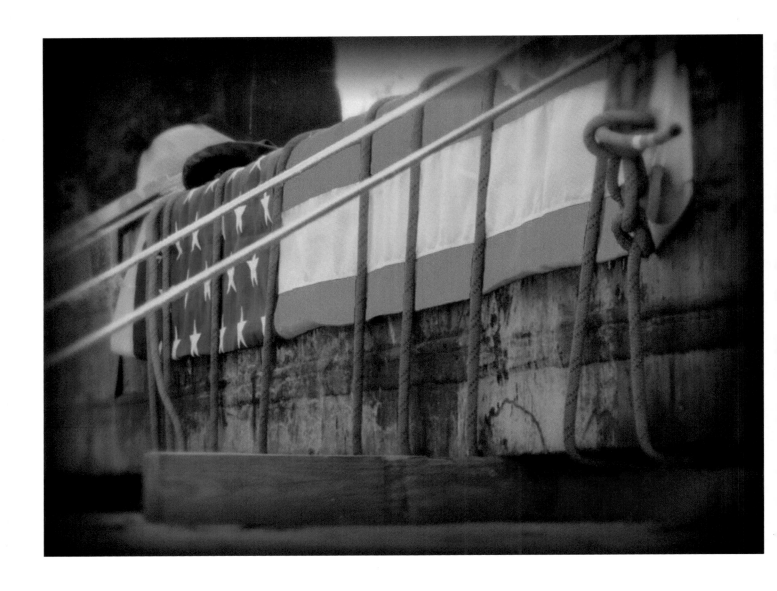

Continental Paving holds the beam at their facilities before it is transported to the Hudson Highway Department garage where it will be cleaned and draped once again with an American Flag.

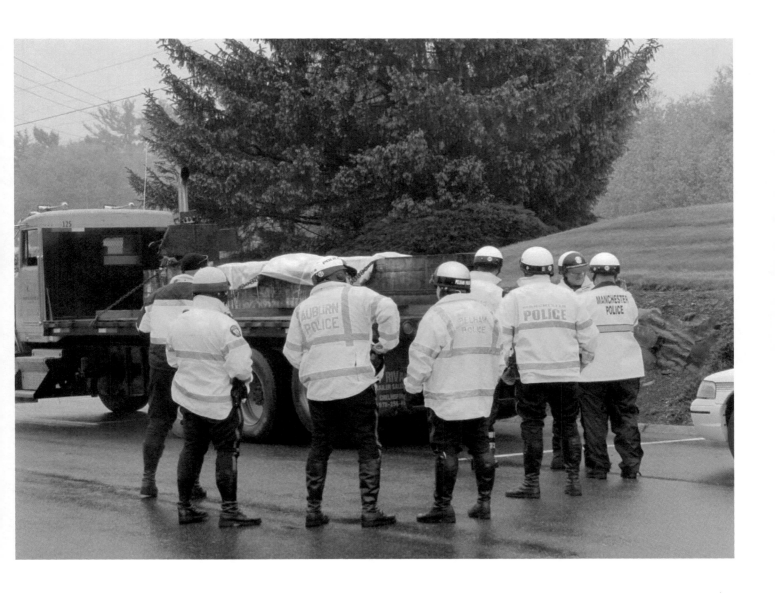

Police from a variety of New Hampshire communities gather for a first look at the beam before they provide an escort to Concord, the state capital.

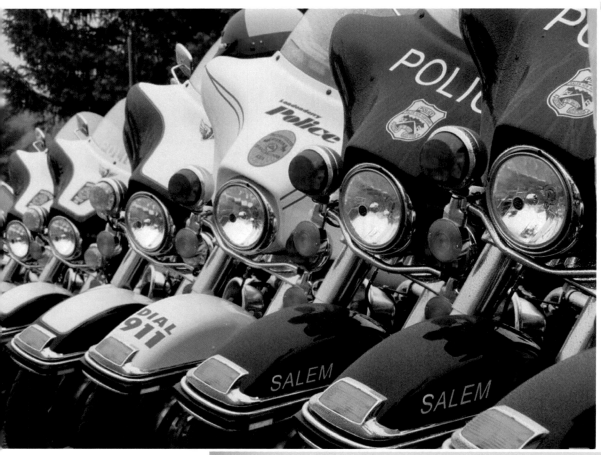

A At the request of the New Hampshire State Police, the beam is transported to the annual Memorial Service of the New Hampshire State Police Association, where it is put on view.

Motorcycle officers brave the elements to accompany the truck.

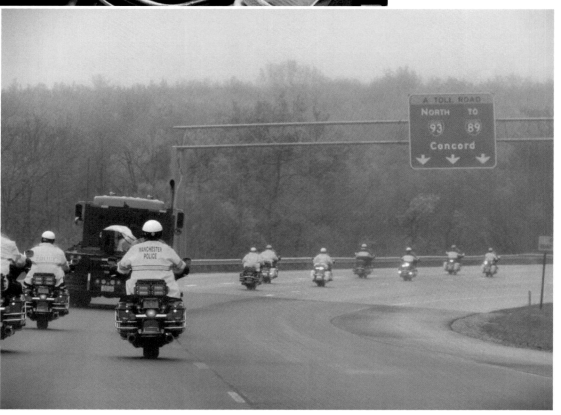

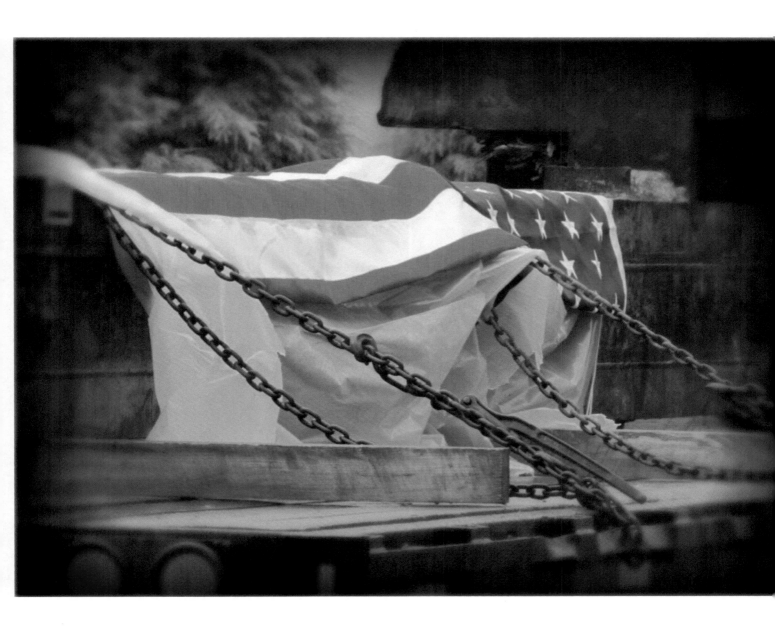

The beam waits patiently for the beginning of the service in Concord, NH.

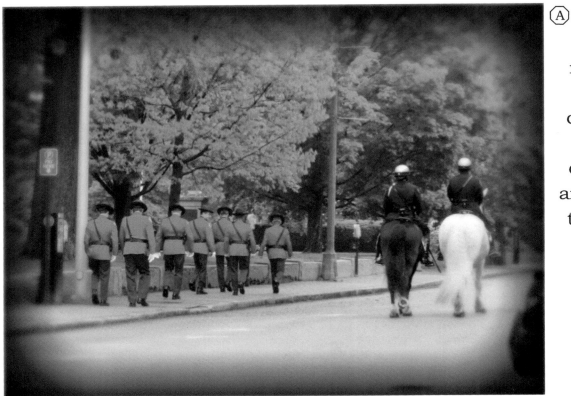

The beam receives all the pomp and circumstance it deserves. Full dress uniforms and formality are the order of the day.

The beam remains the center of attention. Prior to the start of the service, two unidentified women are engrossed in thought.

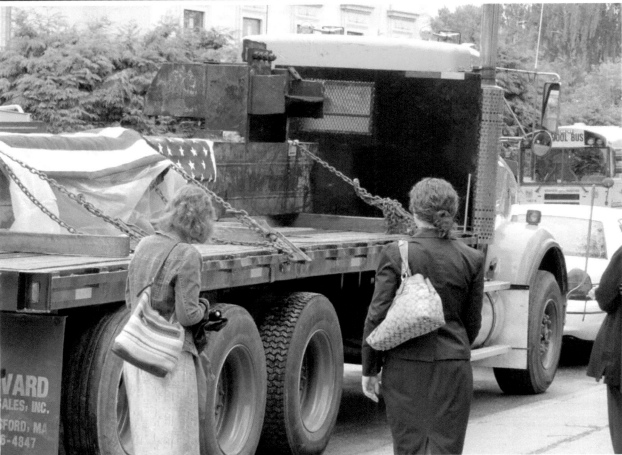

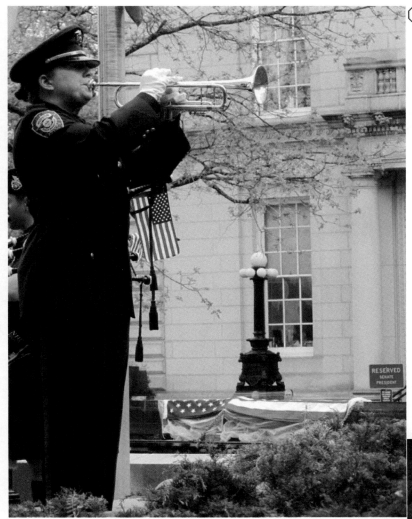

(A)

Allison Cummings, Hudson, NH, police officer is called upon once again to play Taps at the Memorial Service,

and then stands at attention.

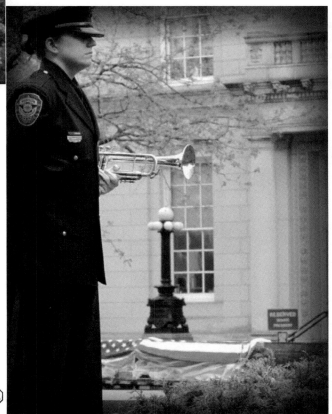

(B)

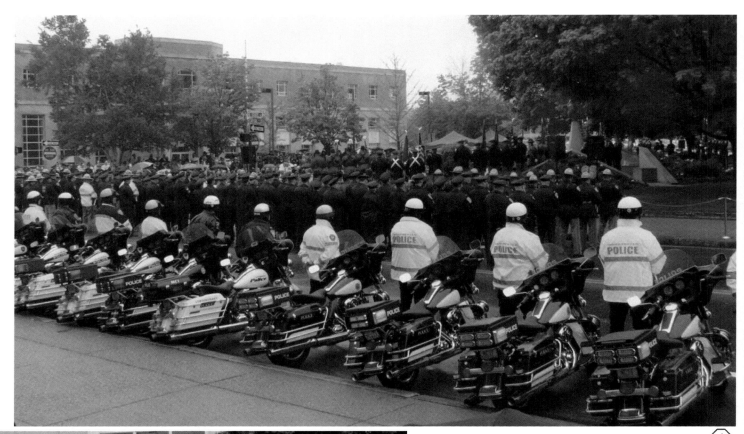

(A)

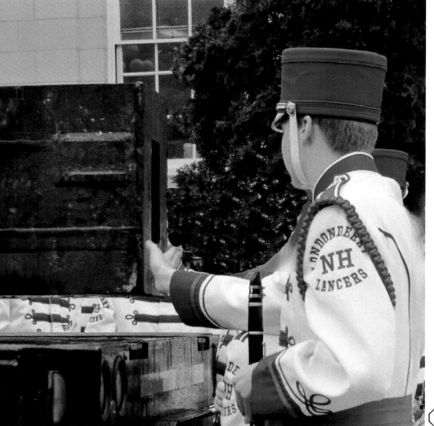

(B)

Those in attendance have to brave the elements. The weather does not lessen the crowd.

The importance of the event is not lost on this unidentified member of the band from Londonderry High School.

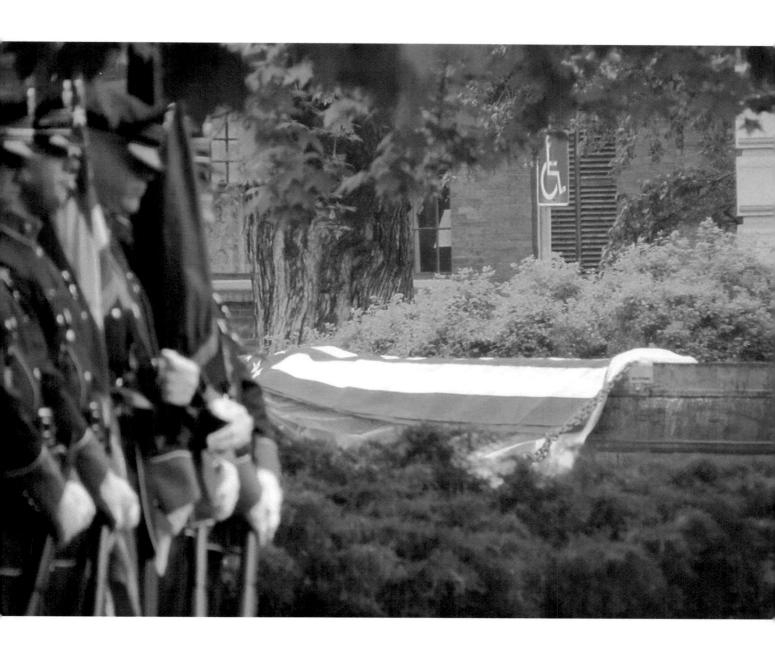

The honor guard stands by.

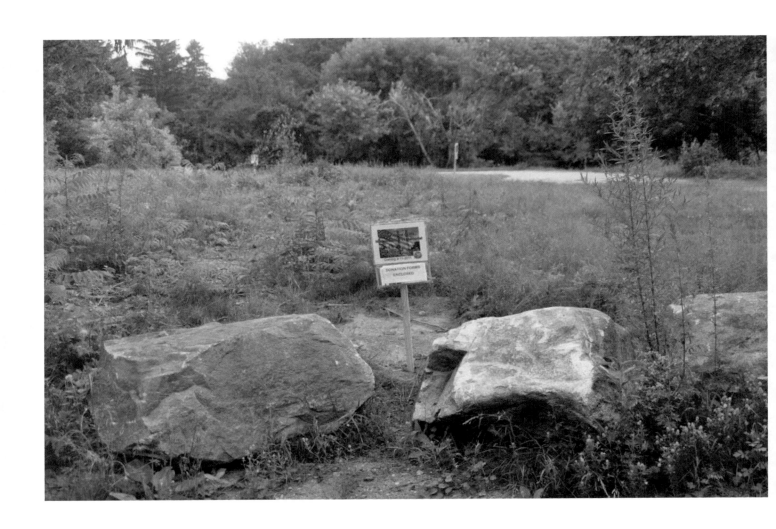

After the Memorial Service in Concord, the beam is returned to Hudson. For days thereafter, the fire station is flooded with visitors, all hoping to get a glimpse of the beam. In person and by phone, the entire community offers to help in any way possible. The Hudson Police Relief Association make a donation. The Nottingham West Lions Club donates a 30-foot flagpole and a flag. Several singing groups offer to perform at the dedication, scheduled for the 10th anniversary on 9-11. The first step is a sign, marking the site of the future Hudson 9-11 Memorial.

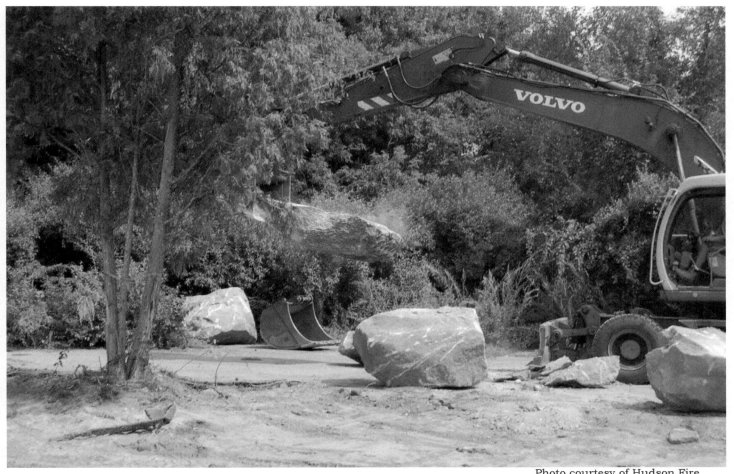

Photo courtesy of Hudson Fire

The Hudson Highway Department is assisted by the Hudson Fire Explorers in the clearing of brush and boulders.

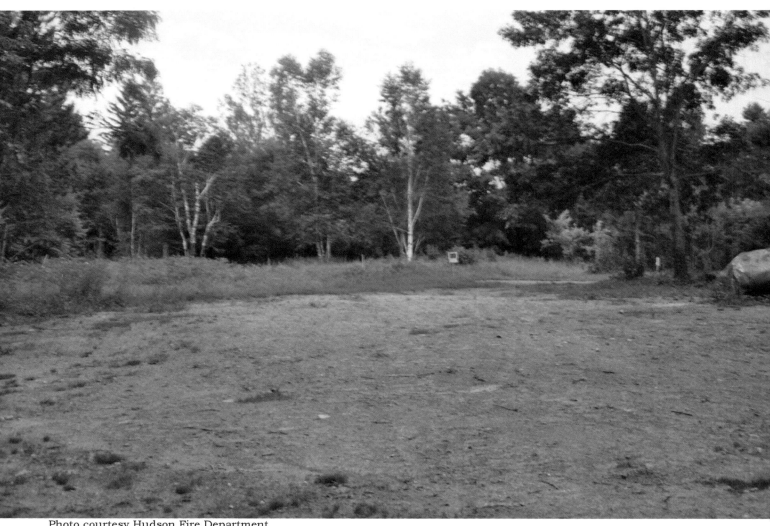

Photo courtesy Hudson Fire Department

After most of the rocks are removed, the site is ready for construction to begin.

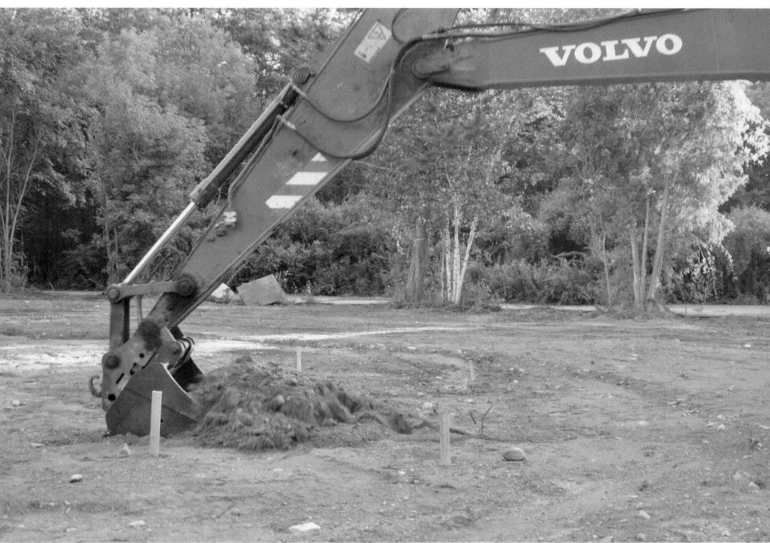

Photo courtesy of Hudson Fire

The first scoop by the Hudson Highway Department marks the beginning of preparation for the beam's platform.

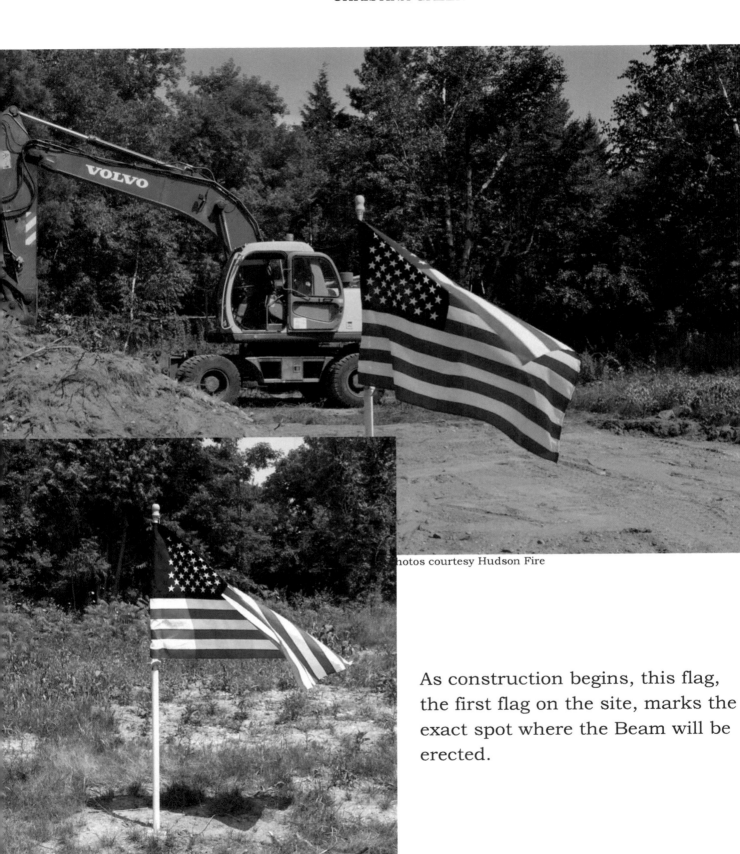

photos courtesy Hudson Fire

As construction begins, this flag, the first flag on the site, marks the exact spot where the Beam will be erected.

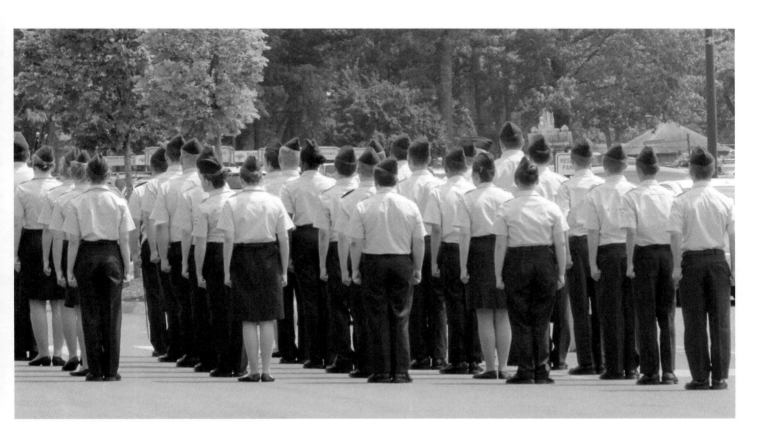

Because of the overwhelming community response, the steel beam enjoys a place of honor in the Hudson Memorial Day parade. Following the parade, the beam is displayed for several hours at the Town Hall. At the parade, an honor guard (shown here) is in attendance.

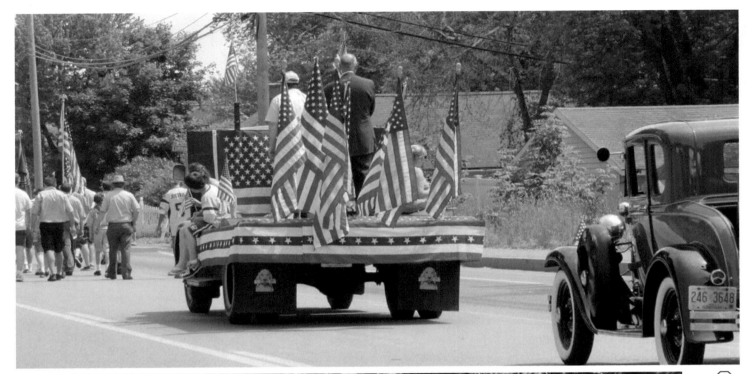

(A)

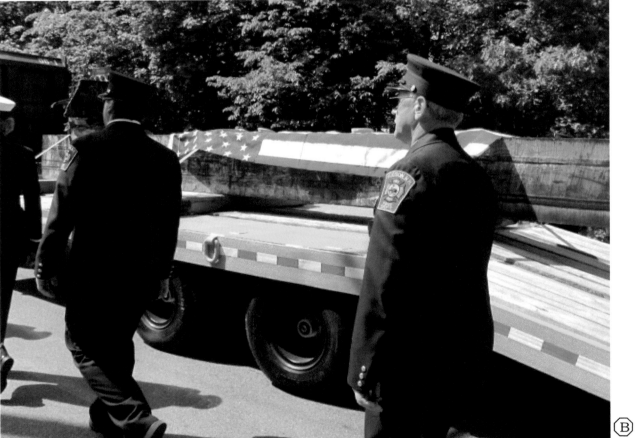

(B)

The parade is a great success. The beam is the centerpiece of the patriotic event. It is escorted by firefighters.

↑ (A)

(B) ↓

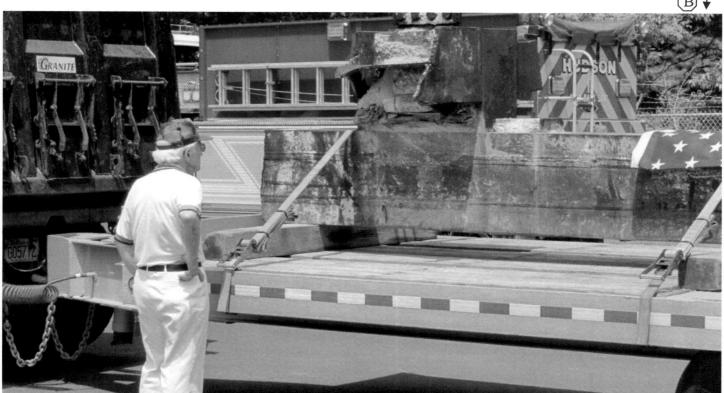

Members of the general public have the chance to look at the beam throughout the day. Patriotism is on display everywhere.

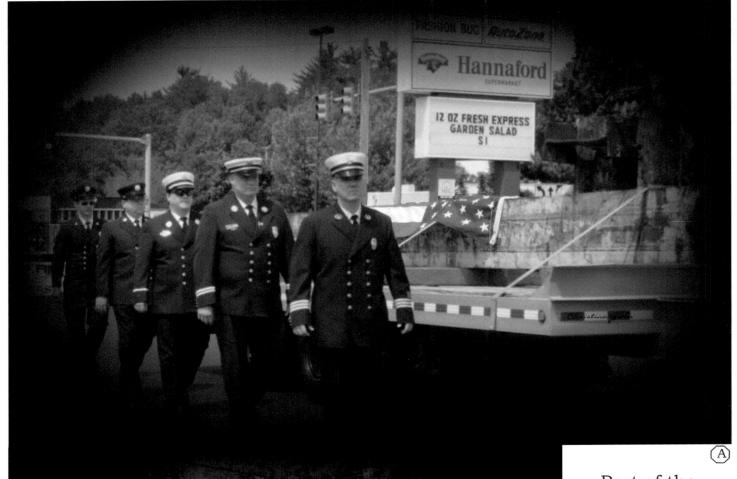

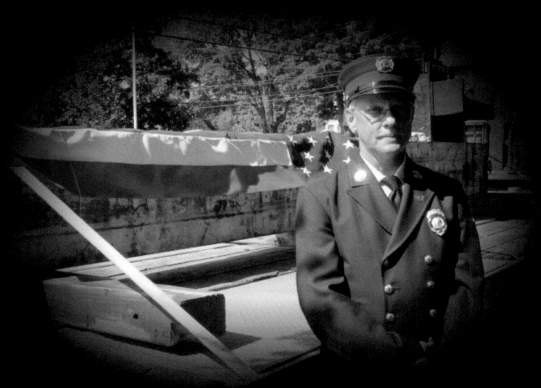

Ⓐ

Part of the honor guard for the Beam during the parade includes (front to back) Neal Carter, Dave Morin, Tim Kearns, Ted Tro donest, and Corey Morin. At left is Bob Haggerty.

Ⓑ

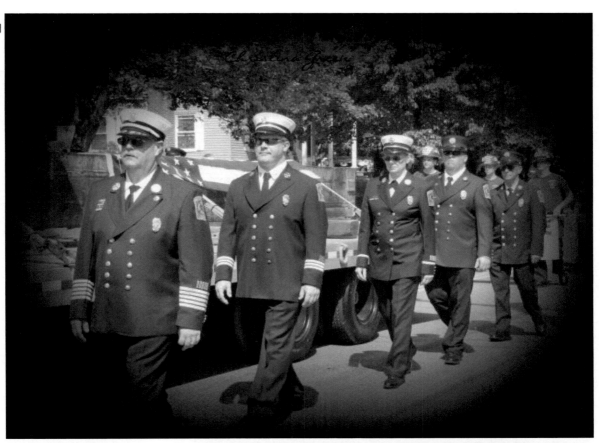

Other members of the Honor Guard include (front to back) Shawn Murray, Rob Buxton, Michelle Rudolph, Sean Mamone, and Bob Haggerty.

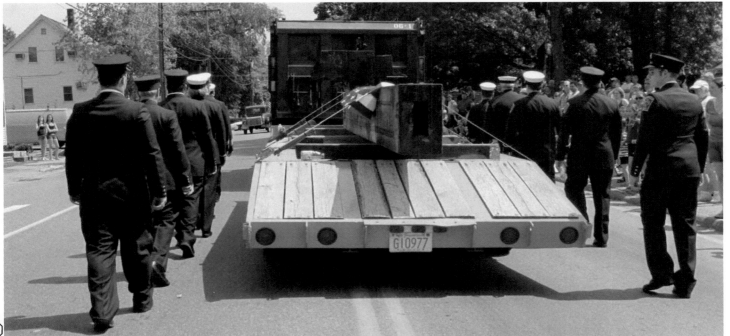

The firefighters accompany the beam to Town Hall.

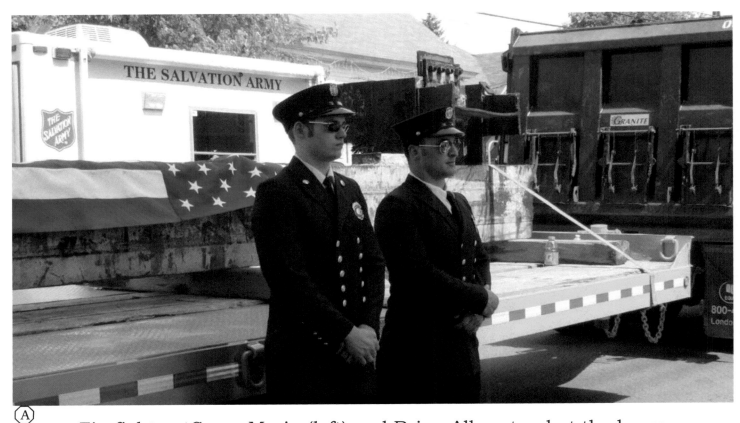

Firefighters Corey Morin (left) and Brian Alley stand at the beam throughout the Memorial Day exercises.

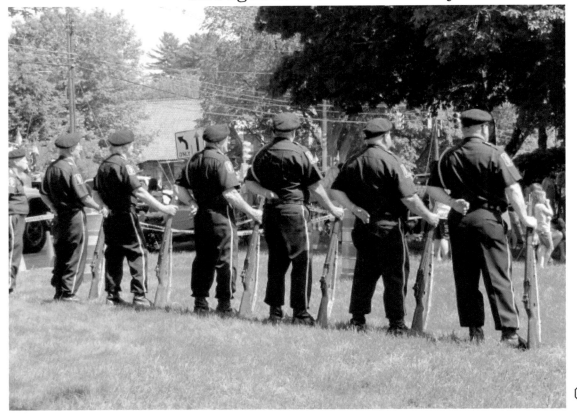

Members of the American Legion line up along the line at the ceremony.

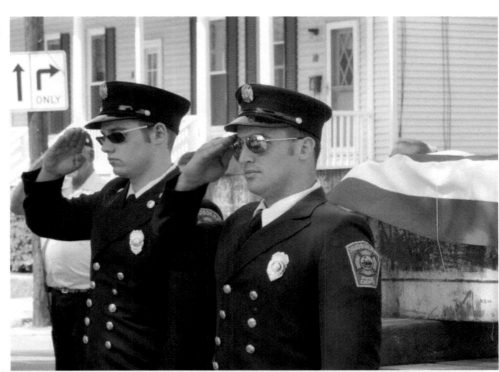

Brian Alley (left) and Corey Morin salute during the playing of Taps

while members of the Hudson Fire Explorers (below) stand in respectful silence.

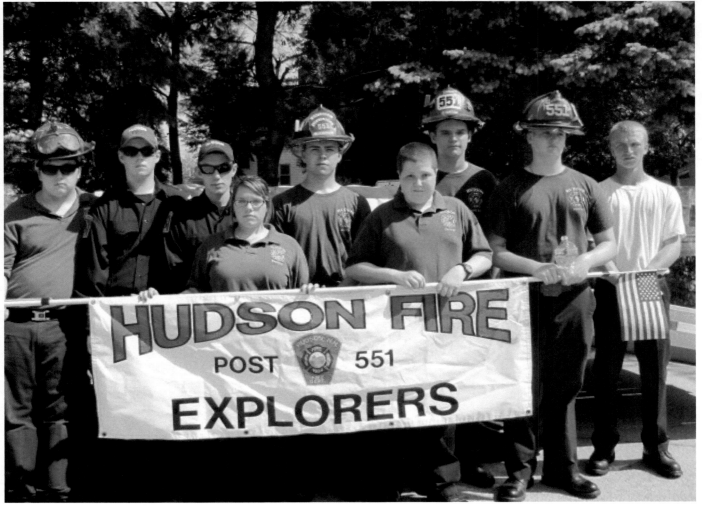

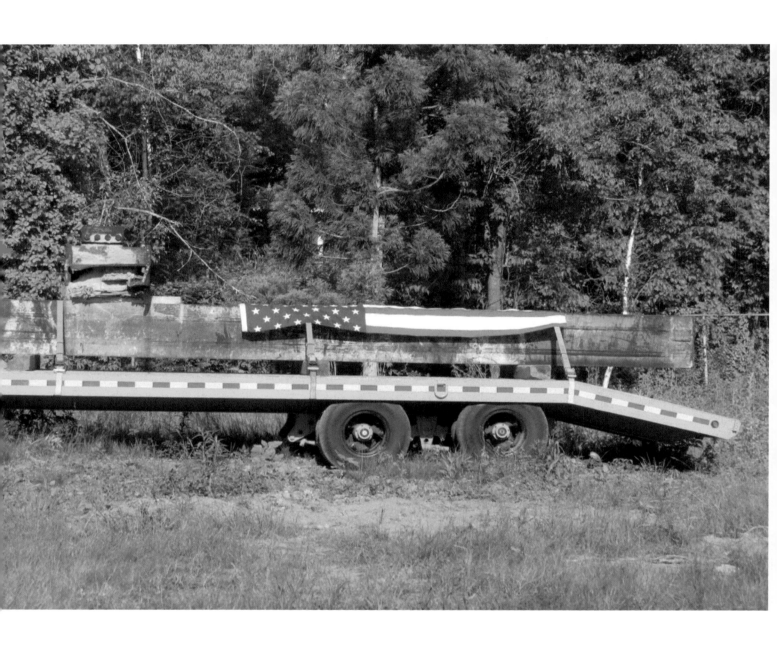

After all the ceremonies, the beam is transported to the Memorial site, where it waits for groundbreaking to begin. At the same time, fundraising efforts continue.

Hudson firefighter 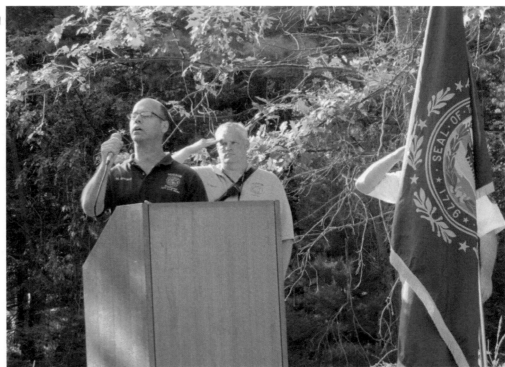 Mike Armand sings the National Anthem and America the Beautiful. (right) 9/11 Committee President Dave Morin and Deputy Fire Chief Robert Buxton are in the background.

Some of the 9-11 Committee are shown during the singing of the National Anthem. Shown (l-r) are Torrey Demache, Brian Alley, Jay Sliver, Carole Whiting, Mickey Rudolph, John Rudolph, and Bill Leblanc.

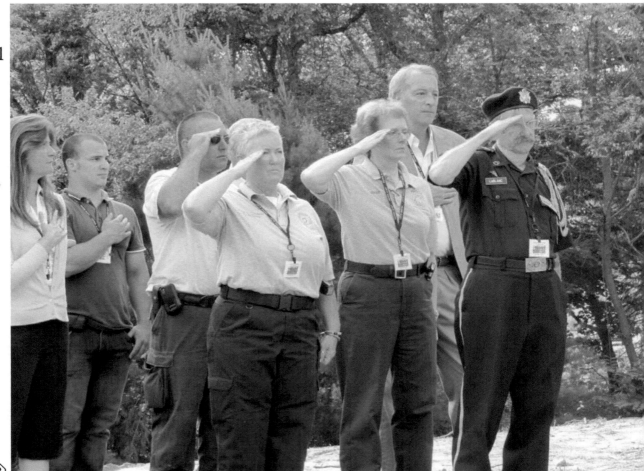

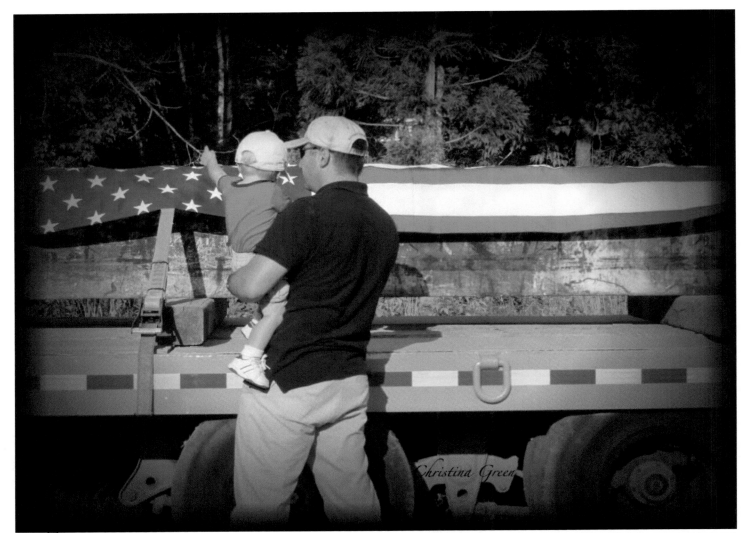

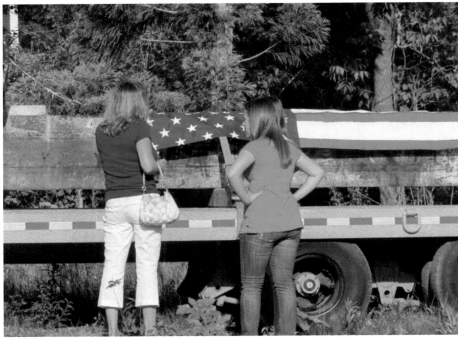

(A) The beam continues to attract visitors and the curious. In the top photo, Hudson resident Keith Langis gives his son an opportunity to see it up close, while (r) 9/11 Committee member and Hudson resident, Liz Kovalcin and her daughter get a closer look. Liz's husband was on Flight 11. (B)

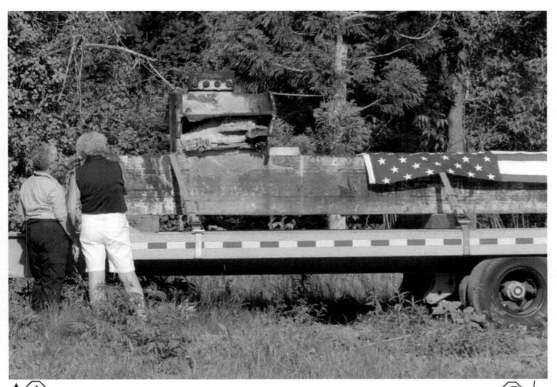

Shown (left) with the beam are Carole Whiting and Vicki Kostrzewa.

Below: Gill Dube and Dave Morin conduct the first fundraiser, outside the Hudson Wal-Mart. They and the committee manage to raise nearly $1,200 toward the memorial.

(A)↑ (B)↓

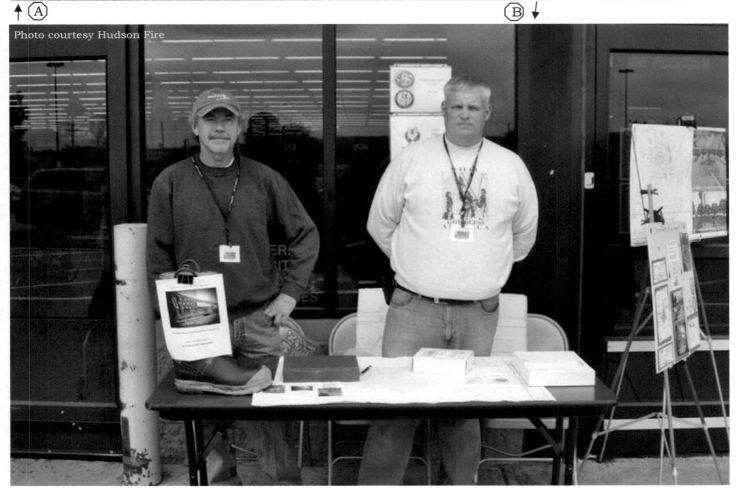

Photo courtesy Hudson Fire

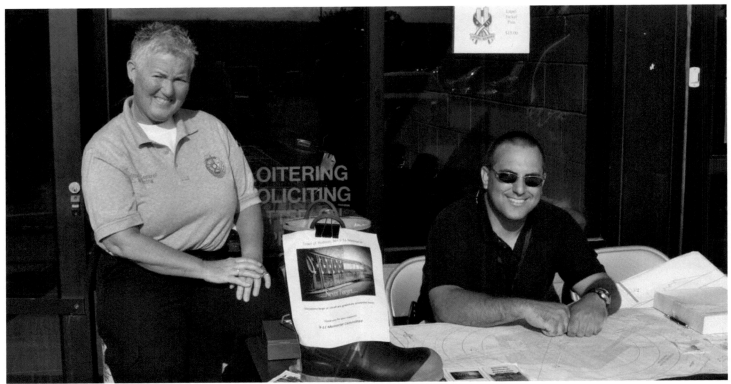

Photo courtesy Hudson Fire

Also at the fund raising table are (top photo): Carole Whiting, Animal Control Officer and committee vice president; and firefighter/paramedic Jason Sliver; along with (bottom photo); Call firefighter Brian Alley, Stephanie Simms, and Call Firefighter Corey Morin.

Photo courtesy Hudson Fire

Photo courtesy Hudson Fire Department

Photographer and author of this book, Christina Green (left) is flanked by
Torrey Demanche, Secretary of the 9/11 Memorial Committee.

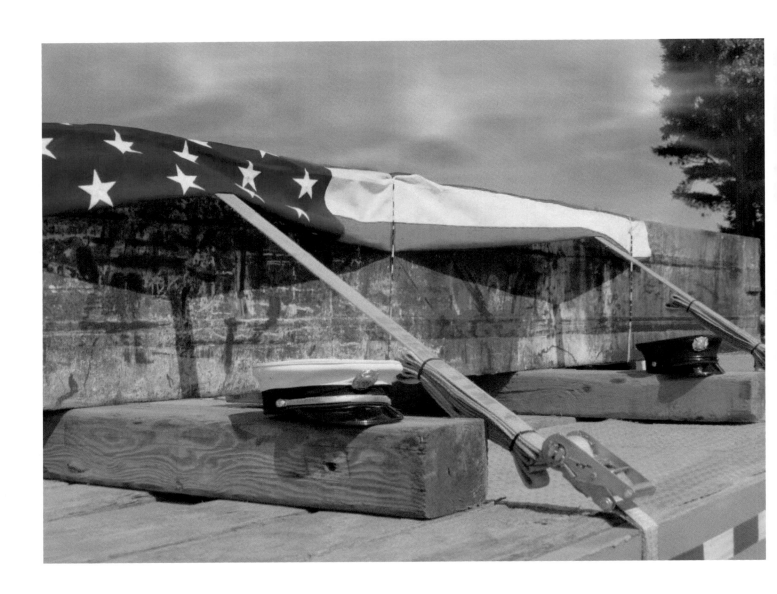

The popularity and excitement at the presence of the beam can not be underestimated. The Rotary Club of Chelmsford, Massachusetts, requests the beam for the town's Fourth of July parade, where thousands line the streets each year. This was one of very few events the committee could accommodate because of the fundraising and construction schedules.

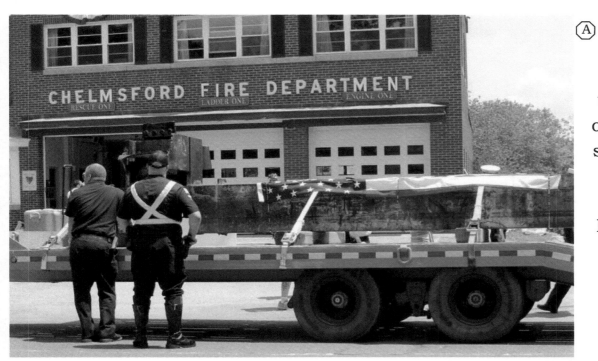

(A)

Two unidentified officers get to see the beam outside the Chelmsford Fire Station.

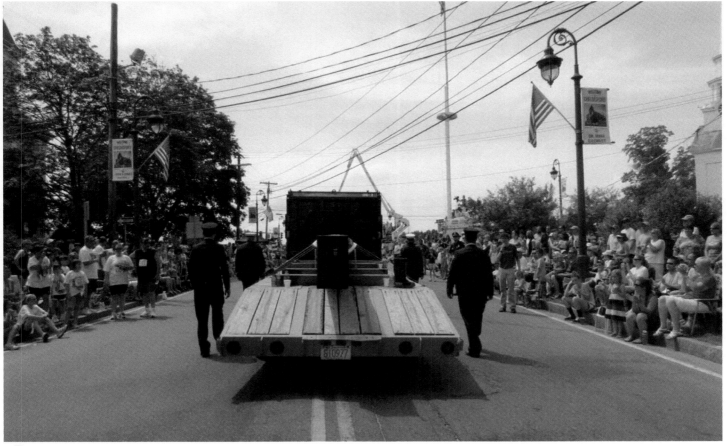

(B)

During the Chelmsford festivities, the beam is accompanied by members of the Hudson Fire Department.

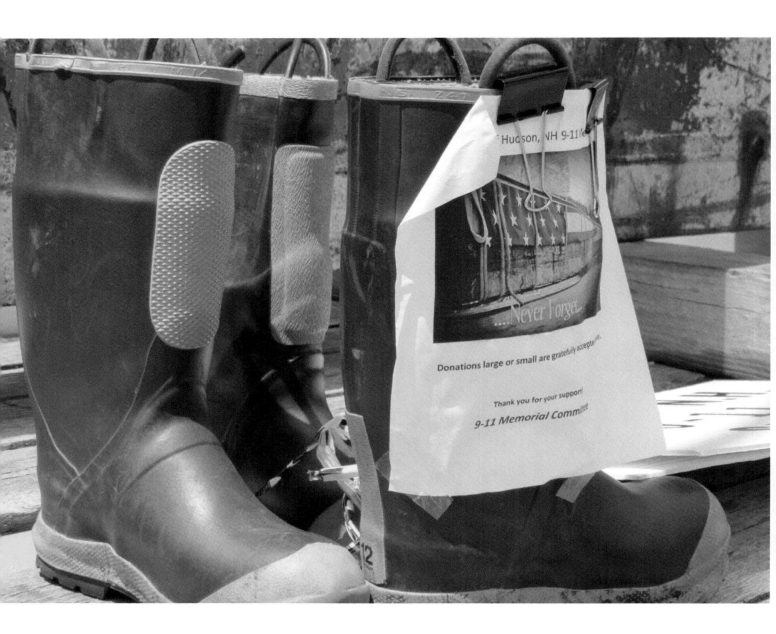

There is a long-standing custom for firefighters to use the boots to collect donations for worthwhile causes. This memorial is no exception.

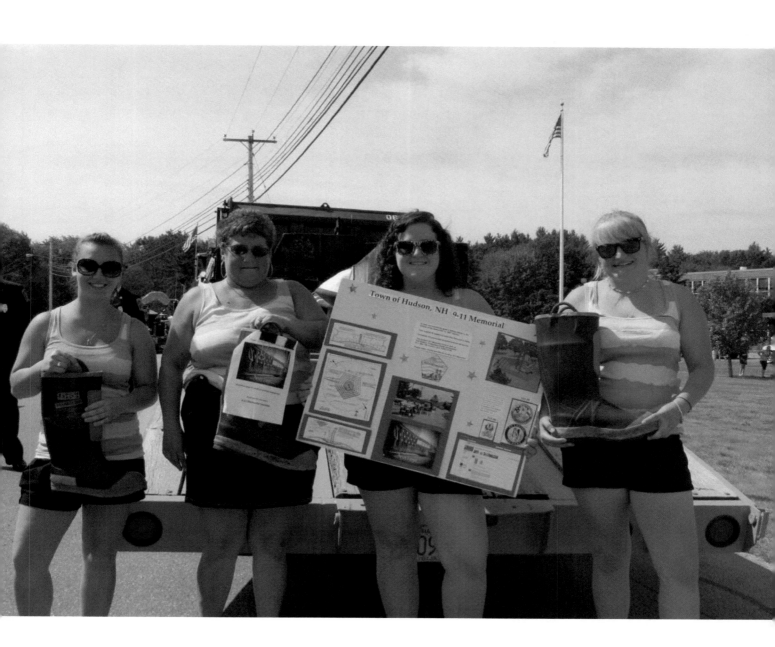

Assisting in the fundraising efforts are (from the left) Stephanie Simms, Sue Morin, Becca Dupont and Taylor Morin. They walk behind the beam during the parade collecting donations for the 9/11 Committee and the Memorial.

Ⓐ

Left: Brian Alley and Corey Morin.

Bottom: Even children are curious and interested. These unidentified youngsters get a look, up close and personal.

Ⓑ

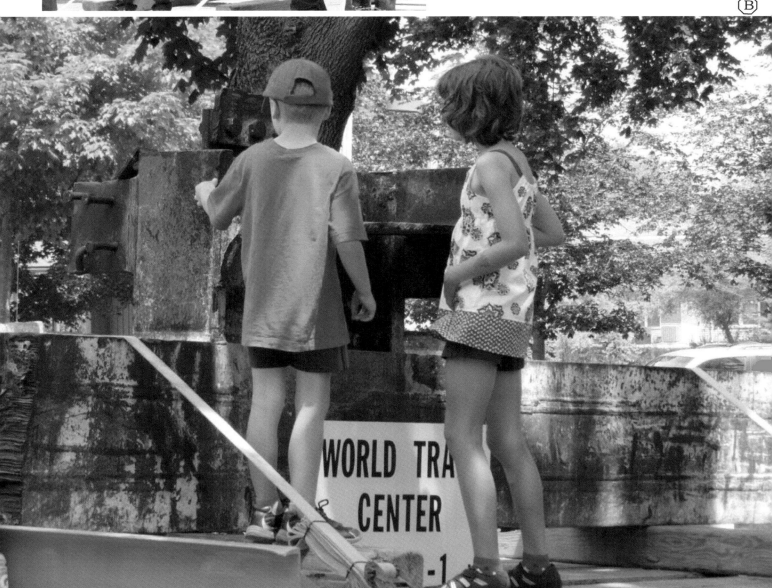

WORLD TRA
CENTER
-1

Following the parade, the beam is transported to Modern Protective Coatings in Hudson, where the crew, shown here and on the following page, volunteer to seal the beam with a protective coating designed to prevent vandalism and protect the beam from the weather.

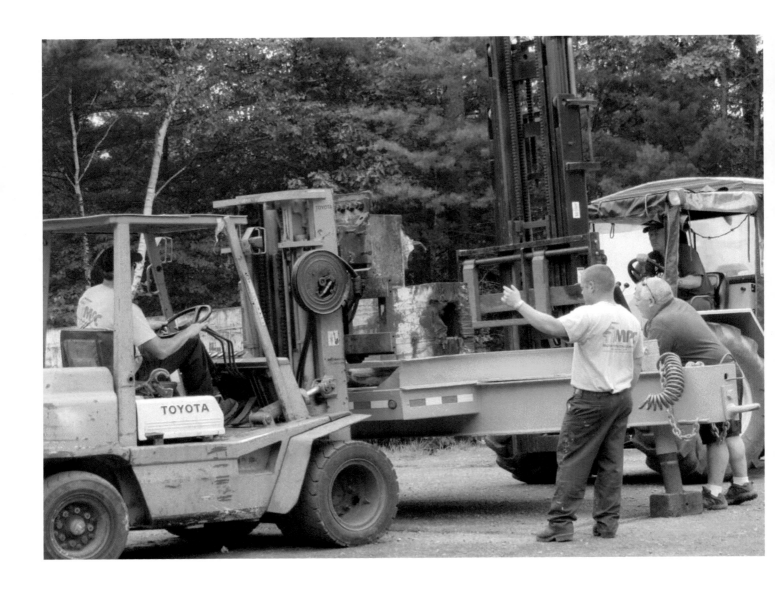

Lifting the beam is not an easy task. Members of the Modern Protective Coating staff prepare to hoist the beam off the trailer.

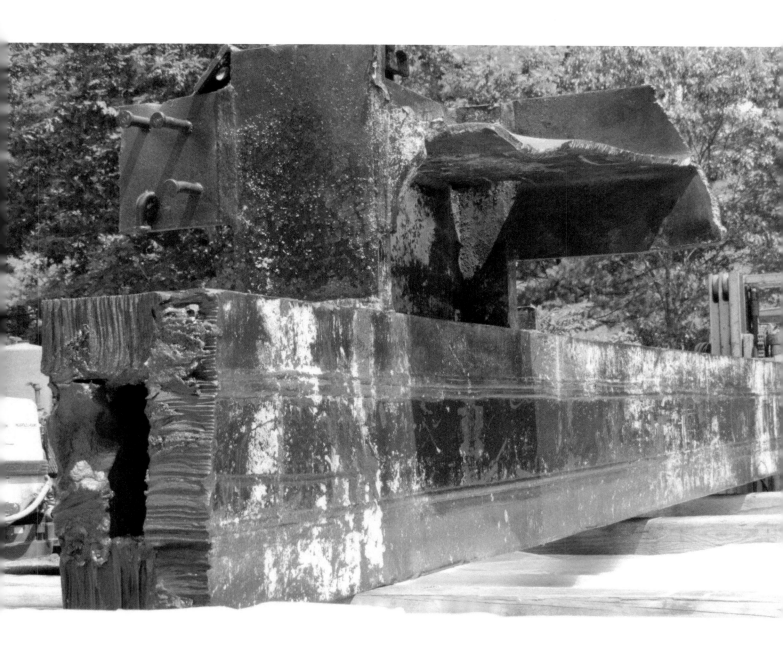

They will lift one end at a time to coat it. Otherwise it will be too heavy.

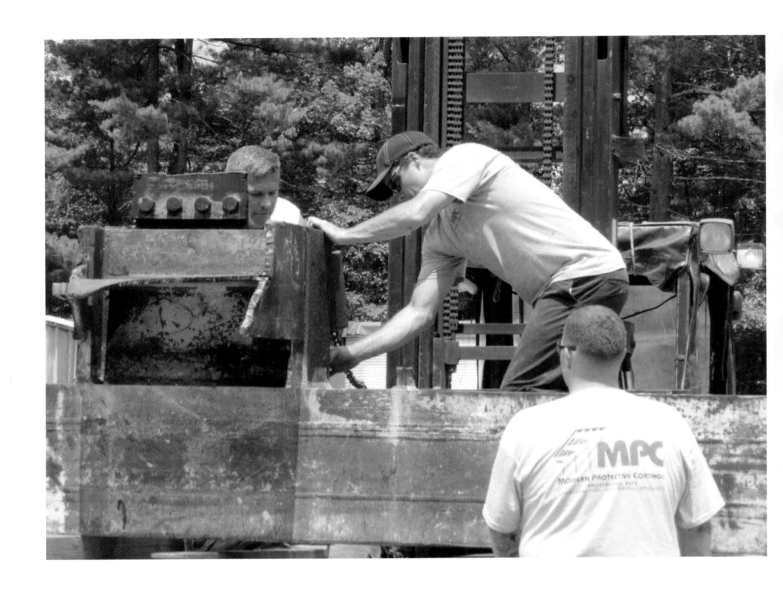

Preparations continue to apply the sealant.

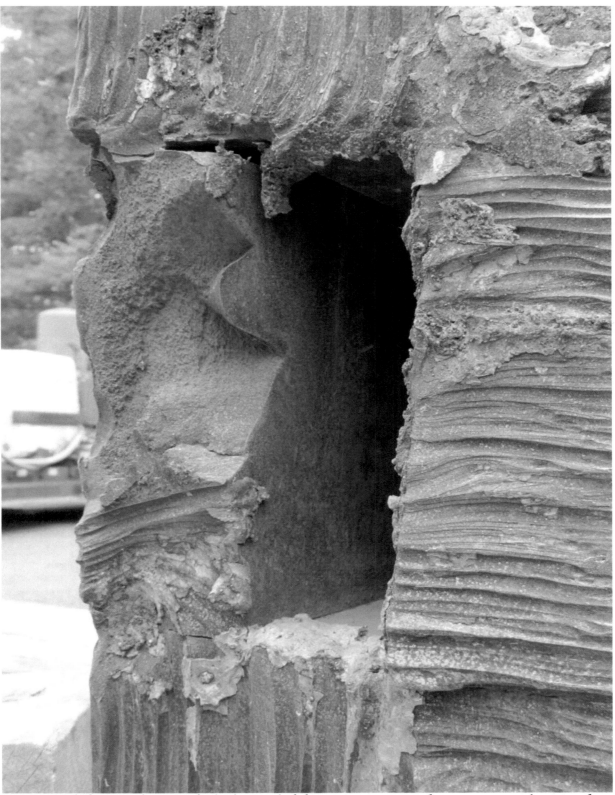

Viewed from the end, it is quickly apparent what a massive task this is. The beam is huge. This view also shows how the beam was sheared off as it toppled.

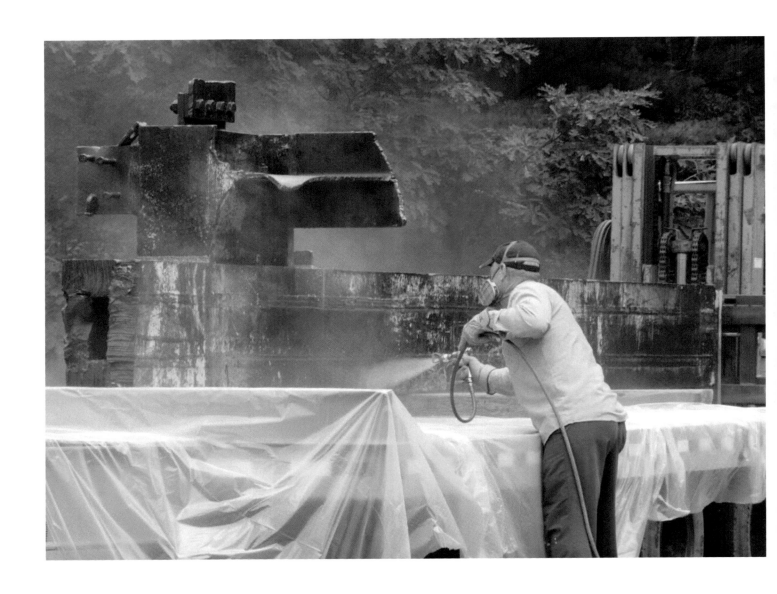

The protective sealant being applied by workers at Modern Protective Coating.

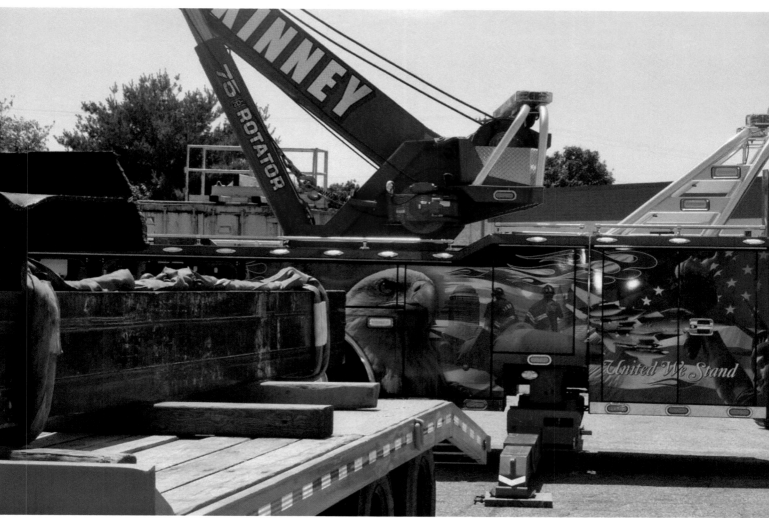

Photo courtesy of Hudson Fire

The beam is picked up from Modern Protective Coating by Kinney Towing of Amherst, NH, and brought to storage. The Kinney family is supportive of the project and volunteer in memory of Brian Kinney, a family nephew who perished on flight 175.

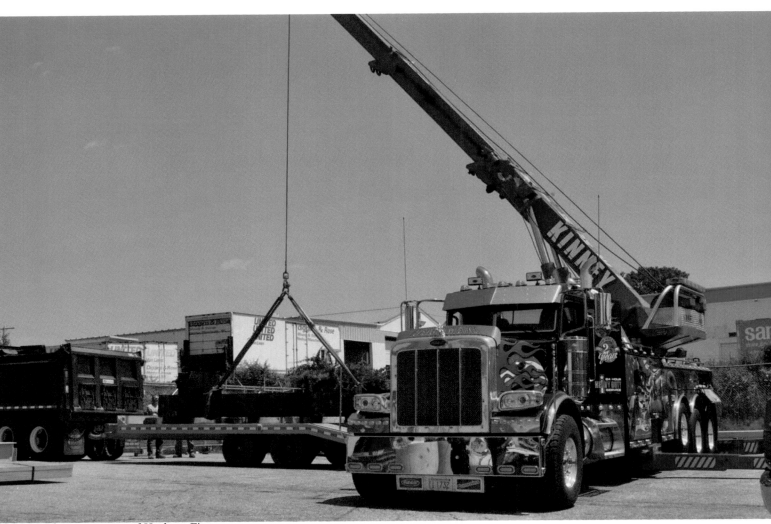

Photo courtesy of Hudson Fire
Department

Kinney Towing workers display a well-practiced ability to handle heavy, yet fragile items.

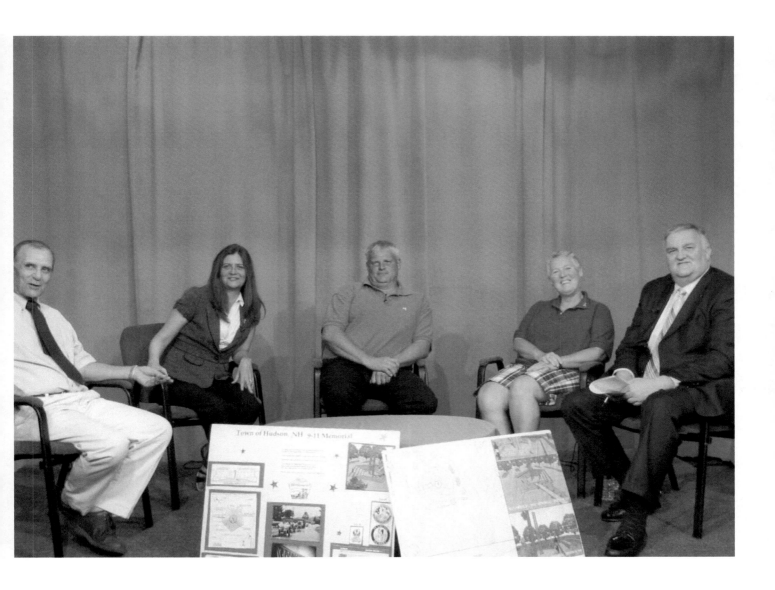

To promote the memorial, including the funds required and the goals of the project, the committee appear for an interview on HCTV, the Hudson local community television station. Shown (from left) are Roger Coutu, Torrey Demanche, Dave Morin, Carole Whiting, and host Leonard Lathrop.

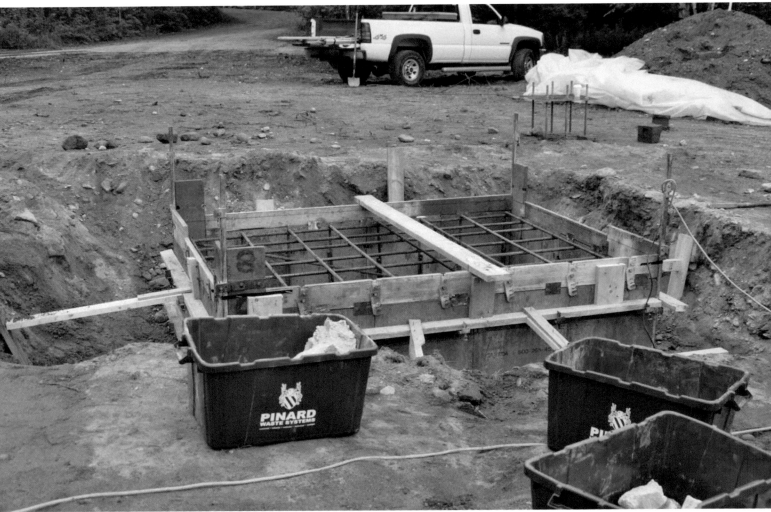

Photo courtesy of Hudson Fire

Volunteers from Buxton Concrete complete the base and pour the concrete with an assist from some Hudson Firefighters. The cement that was attached to the beam is mixed with the fresh concrete, making it part of the finished structure. Shown in this photo is the cage that will support the platform base.

Mike Buxton, Brian Alley, and Matt Perault mix the rubble which was attached to the beam into the cement mix as Buxton Concrete fills the base.

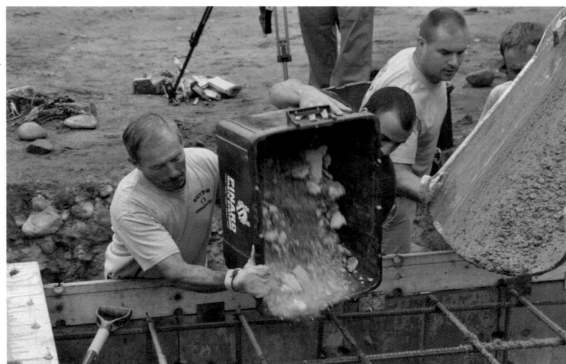

Photos courtesy of Hudson Fire

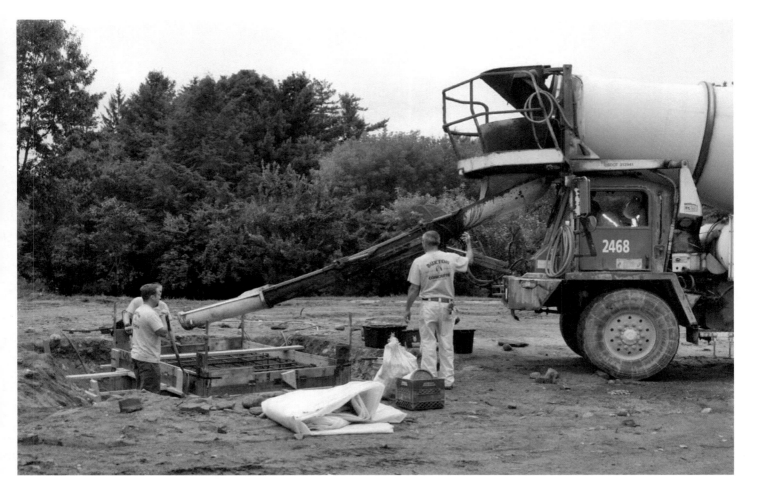

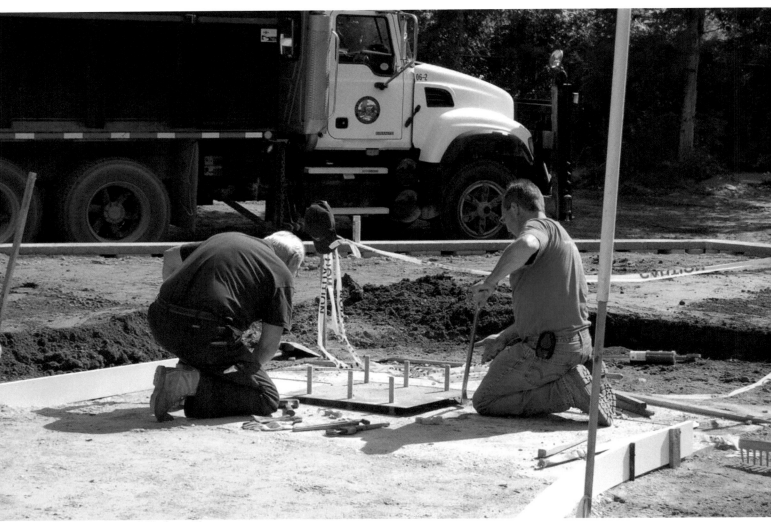

Photo courtesy of Hudson Fire

Workmen from Bay State Industrial Welding and Fabrication, Inc., of
Hudson put in the base which will hold the beam

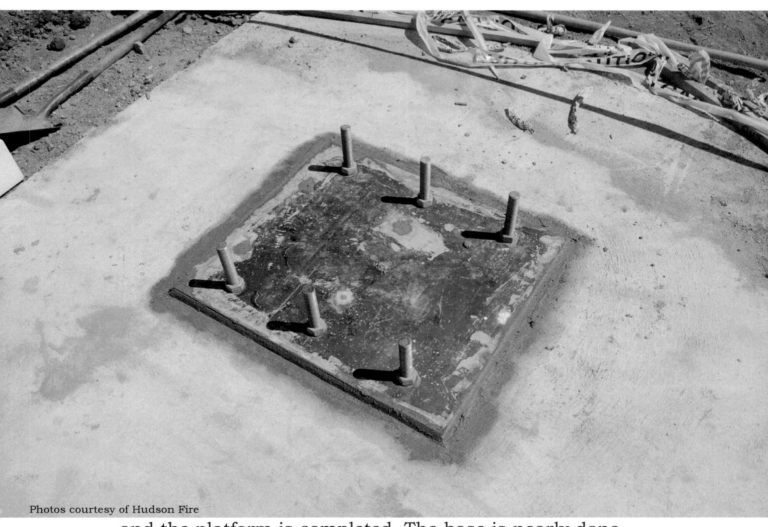

and the platform is completed. The base is nearly done.

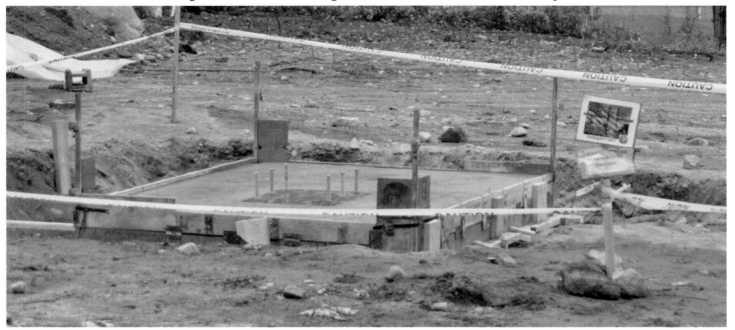

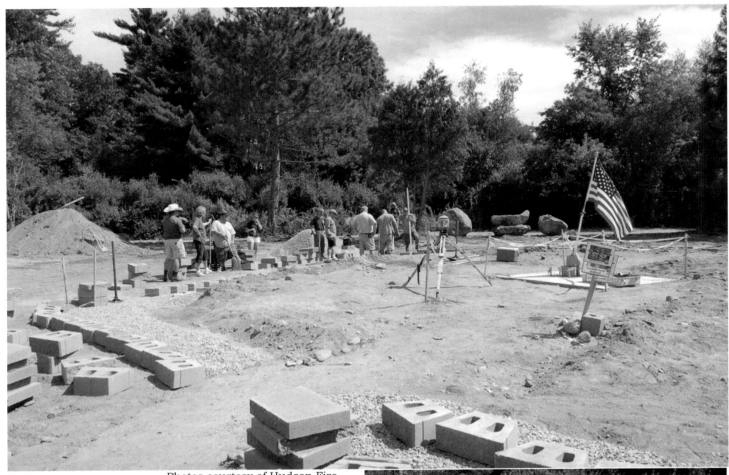

Photos courtesy of Hudson Fire

The wall around the beam is designed in the shape of the Pentagon. Here, firefighters, Committee members and volunteers, under the direction of Todd Hansen and several others, view the area and discuss the exact plans. Todd Hansen (front) and Roger Coutu walk the area.

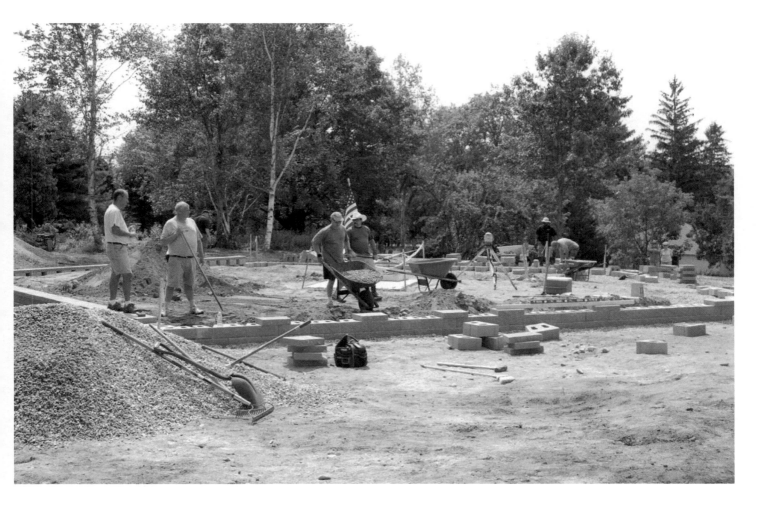

Despite the extreme heat of August, the site is filled with volunteers.

Photos courtesy of Hudson Fire

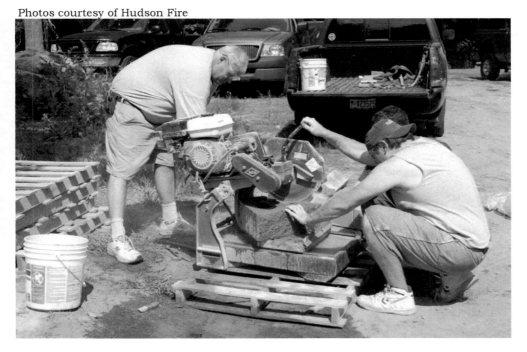

Cutting bricks to size is a painstaking task.

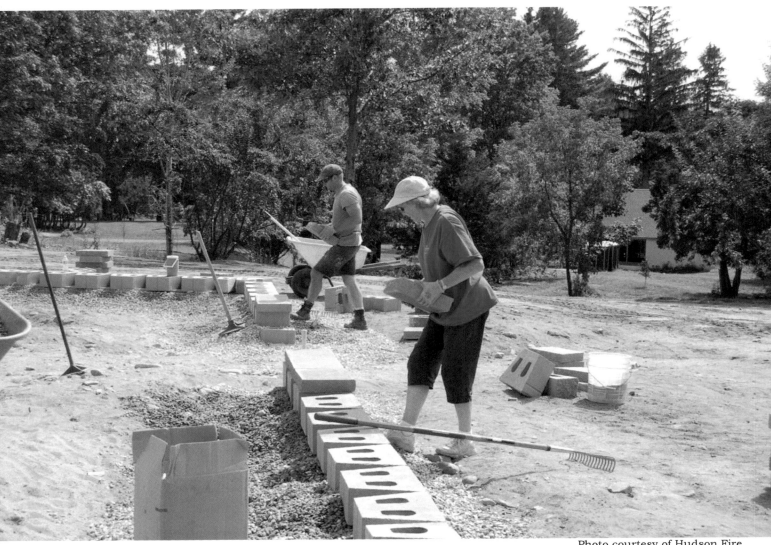

All work on the wall is done by volunteers.

Jim Bavaro (above) delivers a supply of stone while (below) Todd Hansen carefully measures each block to be sure it is level.

Photos courtesy of Hudson Fire

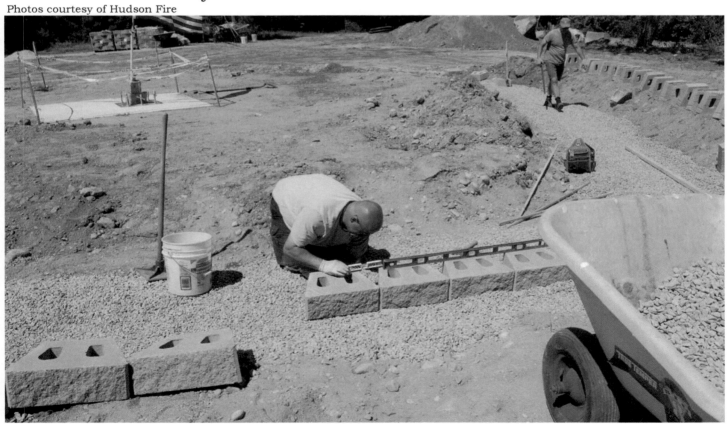

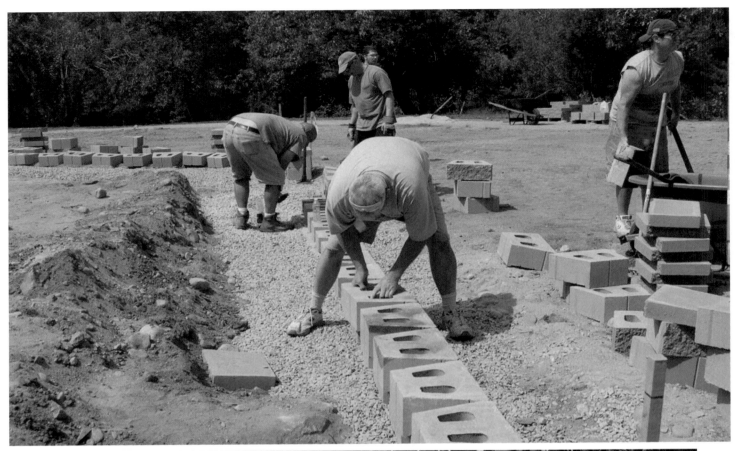

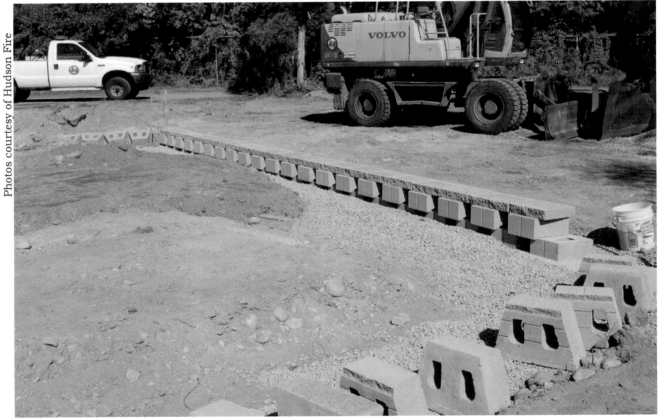

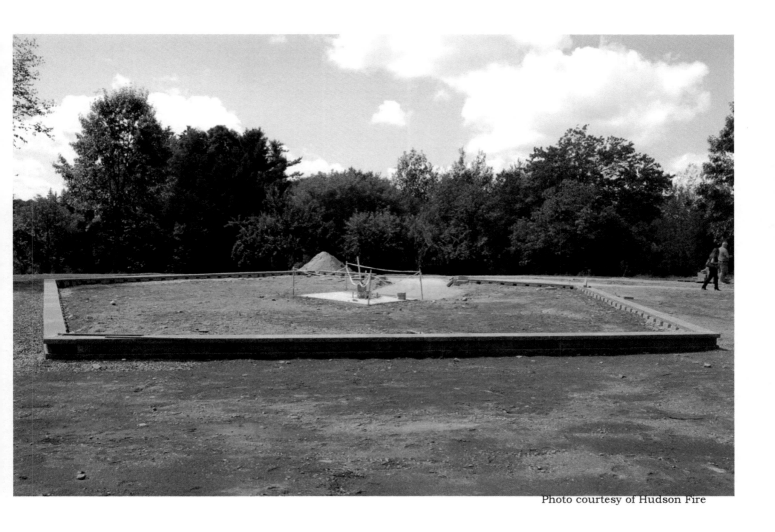

Photo courtesy of Hudson Fire

All the hard work shown on the facing page culminates in the completion of the Pentagon-shaped wall.

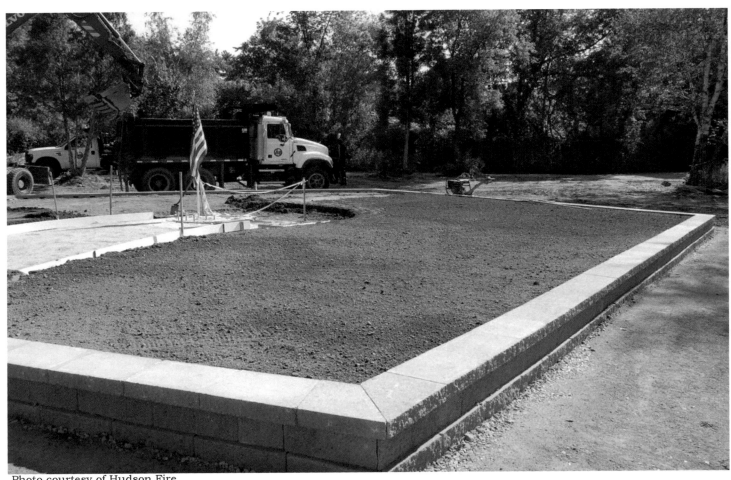

Photo courtesy of Hudson Fire

After the wall is completed, the Hudson Highway Department fills the space with fresh dirt.

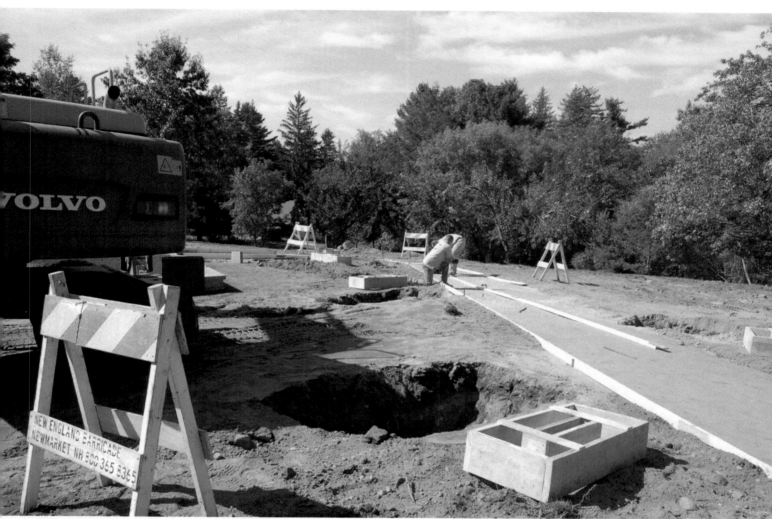

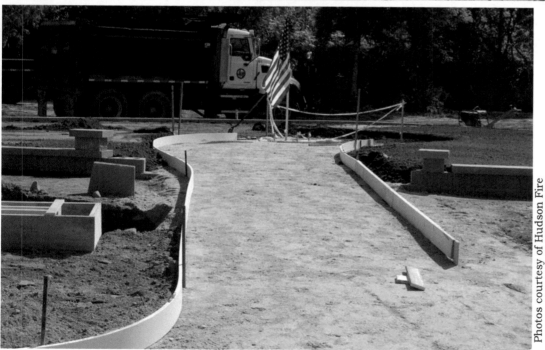

After completion of the wall, Buxton Concrete returns to install the sidewalk. The sidewalk is designed to represent and follow the flight path of American Airlines Flight 77.

Photos courtesy of Hudson Fire

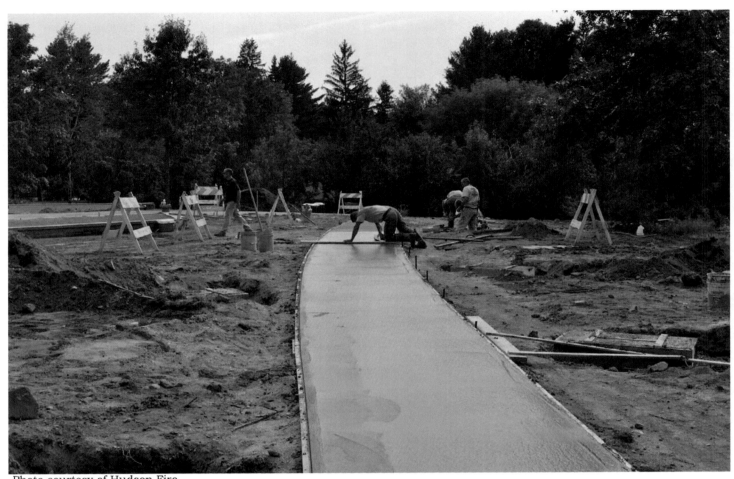

Photo courtesy of Hudson Fire

The Buxton Concrete crew assures that the flight path sidewalk is level.

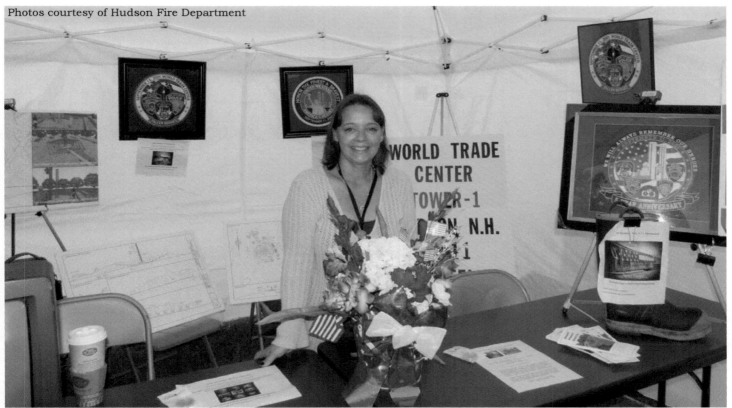

Fundraising continues at the Old Home Days where the 9/11 Committee sells gold coins and pins, while taking donations. Christina Green (top), Robert Buxton, and Torrey Demanche were among those manning the table.

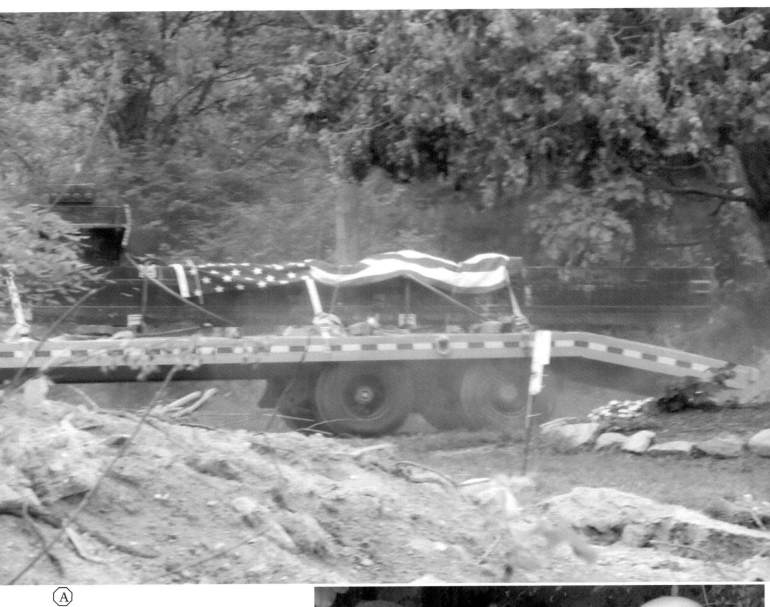

(A)
Robert Buxton (left) and Todd Hansen are among the Committee members who watch the beam on its final ride to its permanent resting place. Kelly Crane (facing page) employees prepare to hoist the beam.

(B)

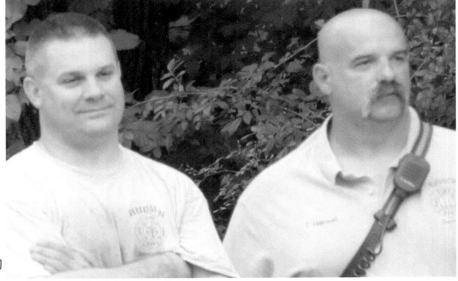

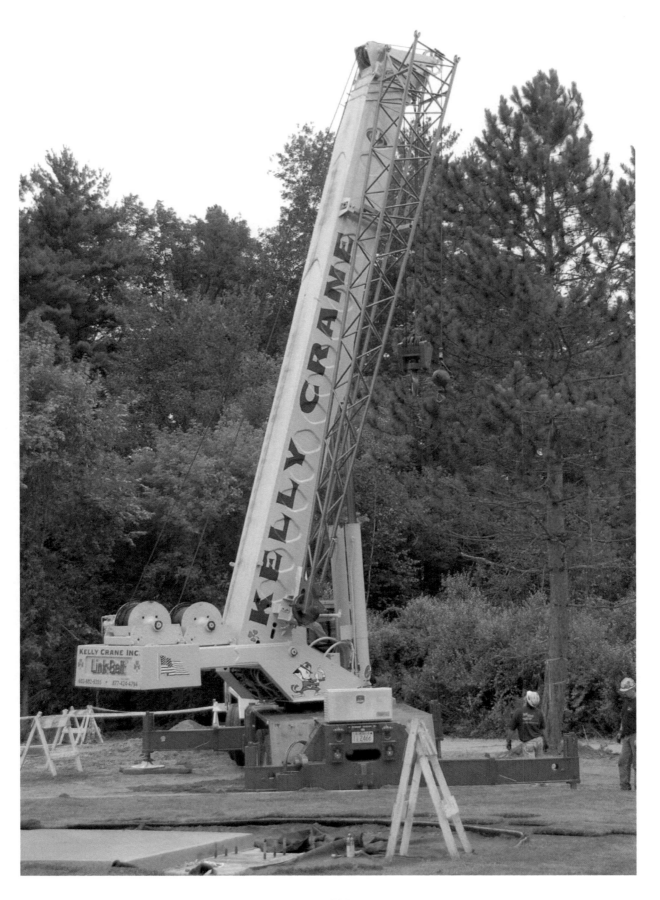

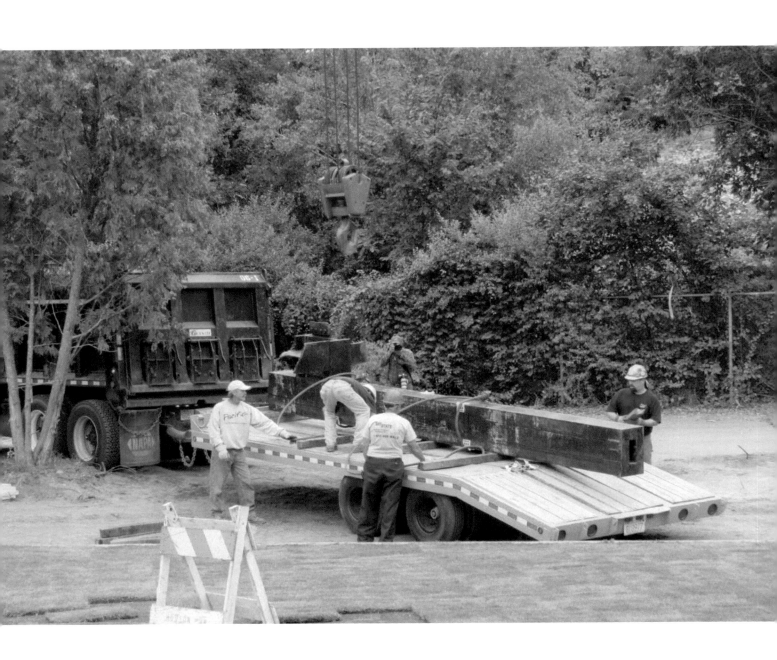

Kelly Crane employees prepare to guide the beam to its position.

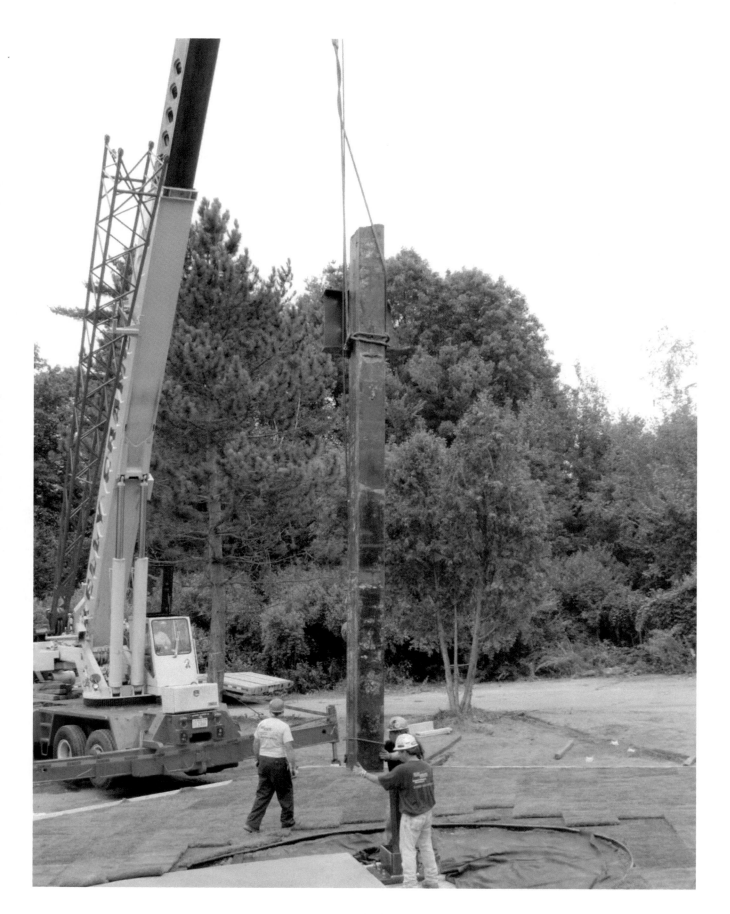

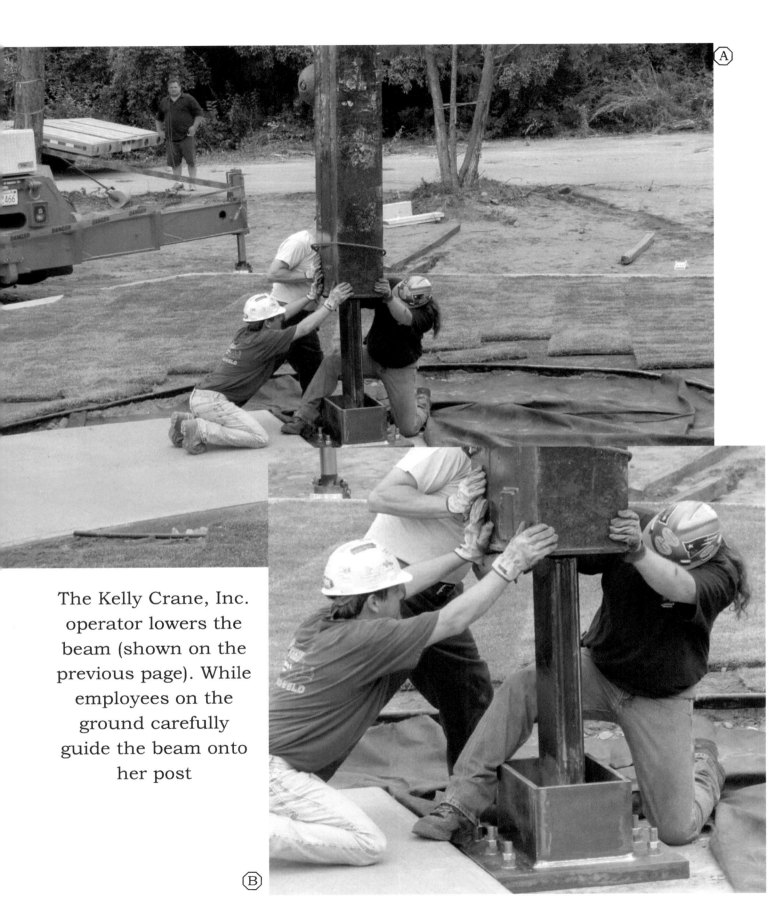

The Kelly Crane, Inc. operator lowers the beam (shown on the previous page). While employees on the ground carefully guide the beam onto her post

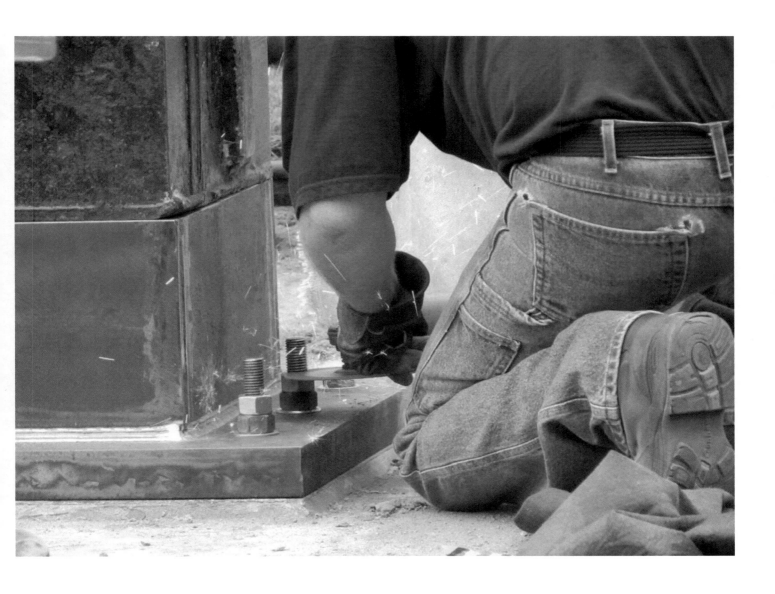

where it is firmly secured.

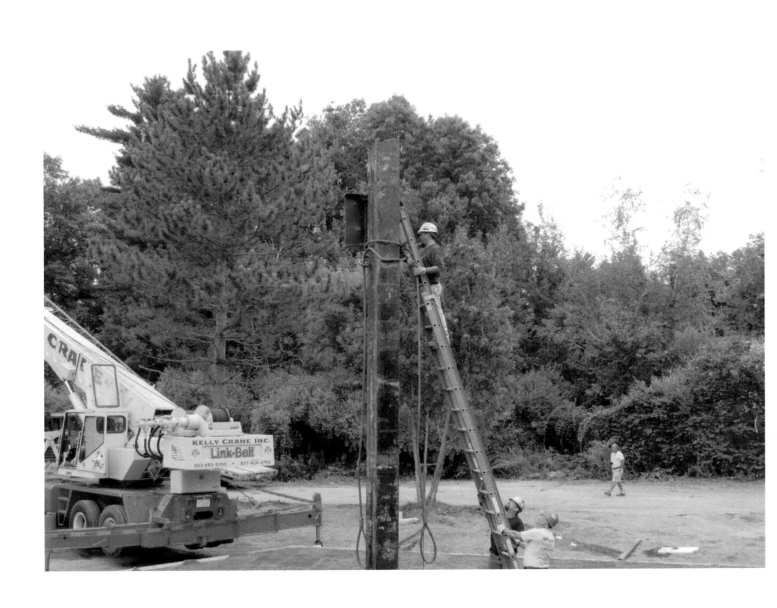

Employees remove the final support cables

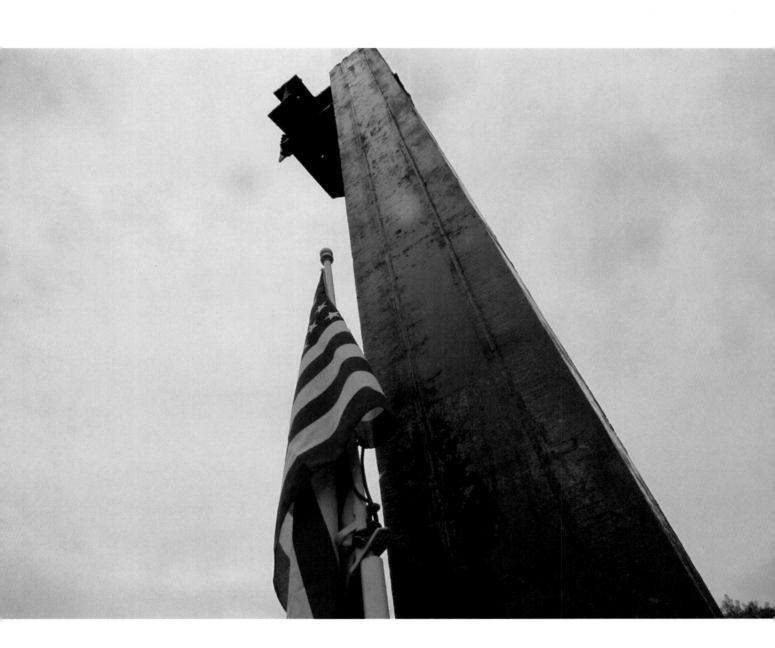

and the beam is on its own.

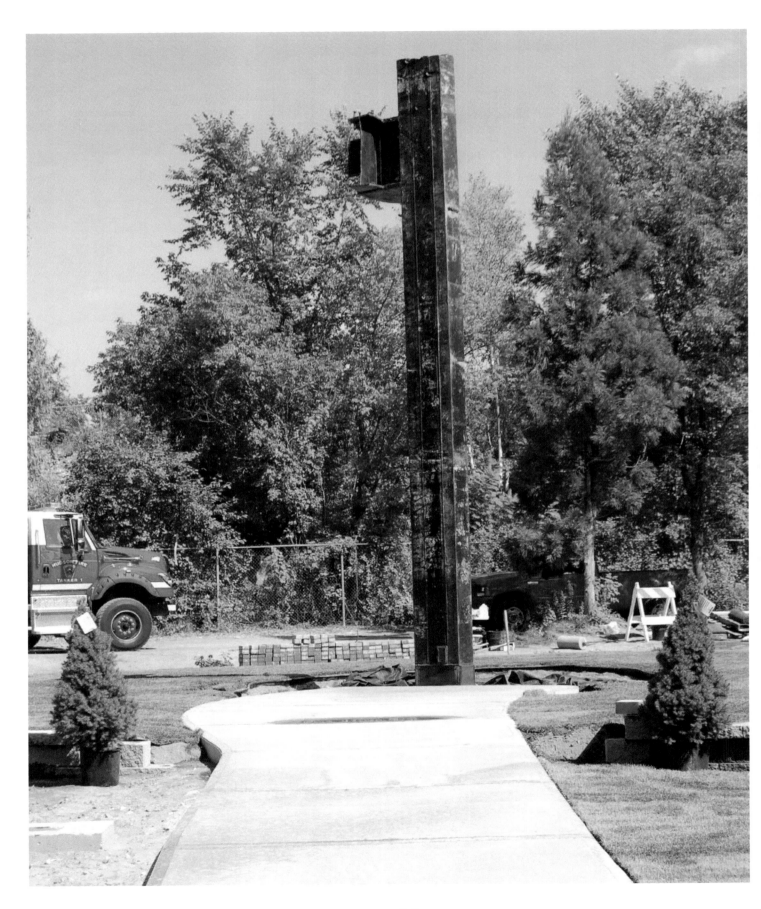

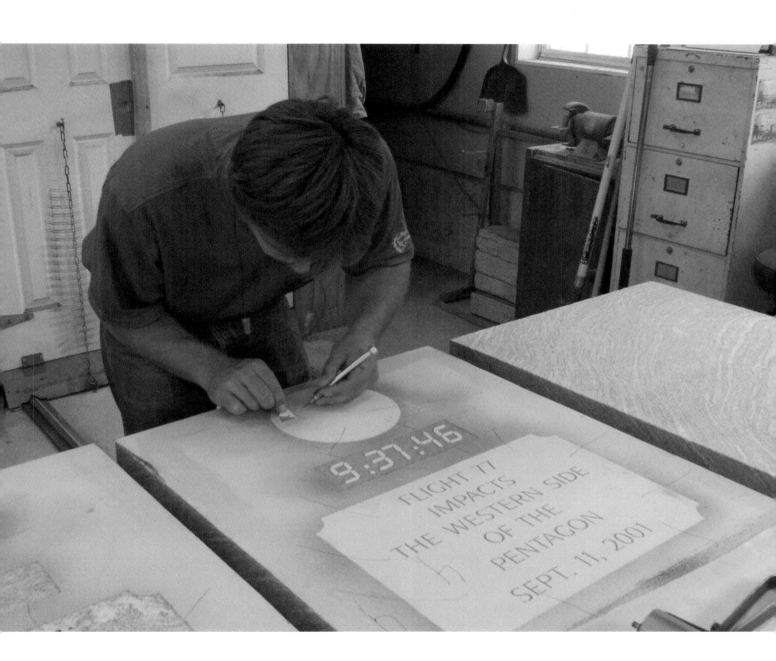

Even as the steel is being placed in its position, the staff of Hudson Monuments is busy preparing the stones which will become time-line markers.

The unveiling is two weeks away.

(A)

After the etching of the stones, they need to be cleaned.

(B)

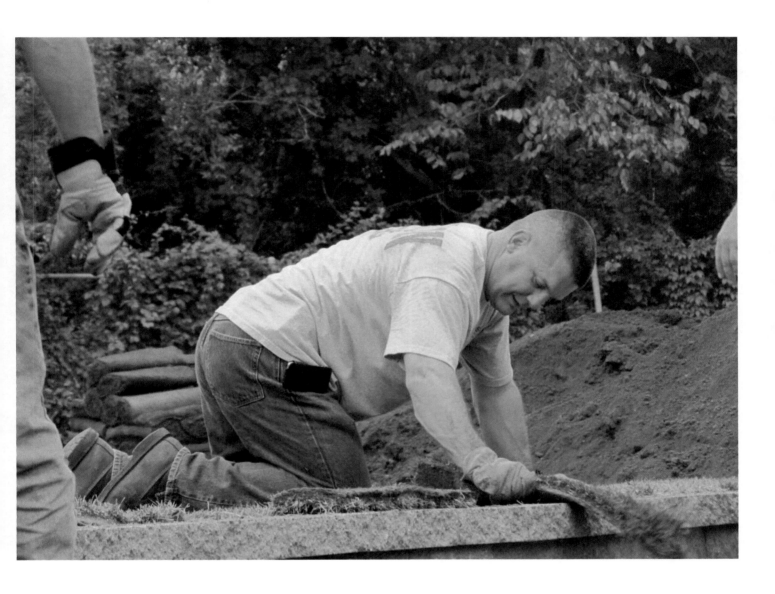

While the beam is in place and crews are working on the stones, the site still needs to be completed. Here, Robert Buxton is laying down sod. Many firefighters and volunteers remain busy to complete the landscaping.

Shawn Murray and Roger Coutu surveyed the progress in front of an unidentified Committee member, while (below) Torrey Demanche, Brendan Perault, and Josh Hansen pour river rocks around the rose bushes.

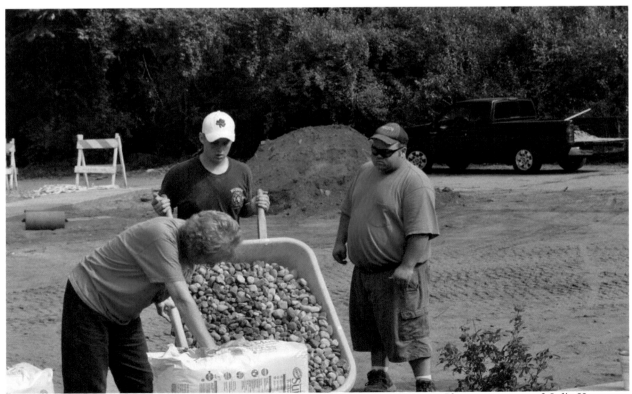

Photos courtesy of Julie Hansen

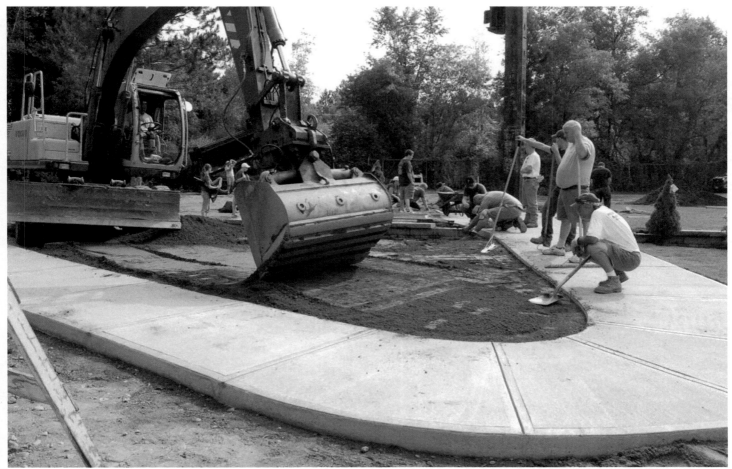

Photos courtesy Hudson Fire

Volunteers stand by as soil is being leveled in preparation for the sod.

On the right, Dave Morin and Robert Buxton work on the leveling.

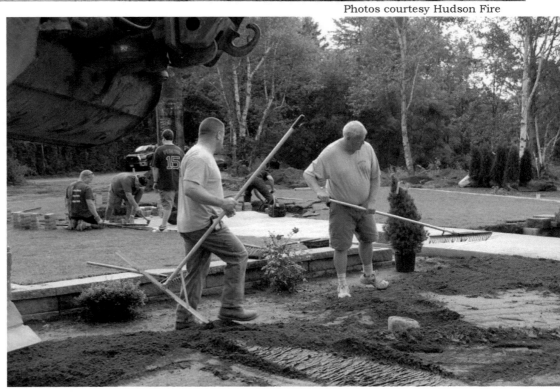

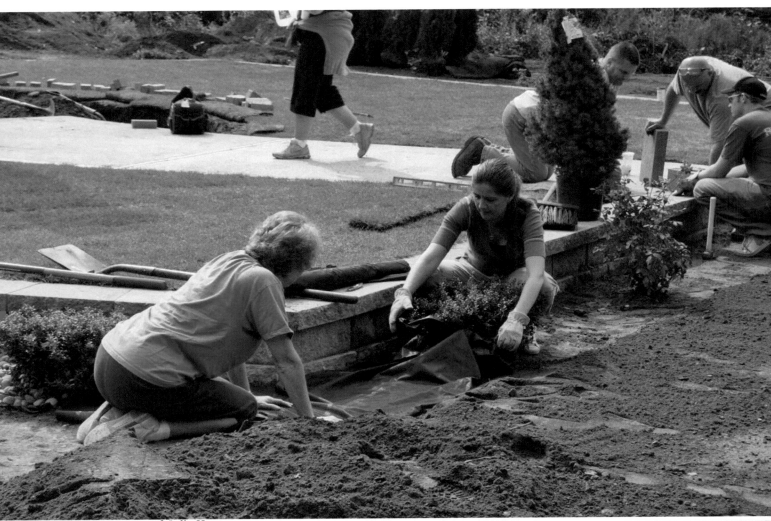

Photos courtesy of Julie Hansen

Mickey Rudolph (above left) and Torrey Demanche plant bushes along the Pentagon while, (right) Anna Buxton helps dad, Robert, lay some river rocks.

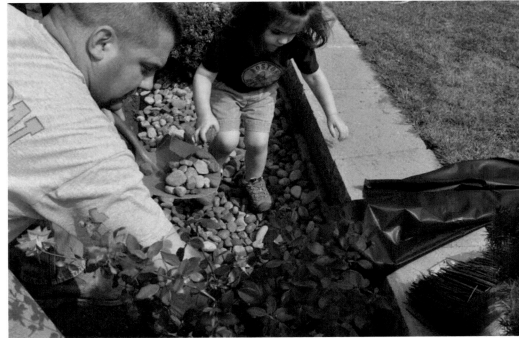

Photos courtesy of Julie Hansen

Ivy Rose Buxton (above, left) and Isabel Mae Buxton help with the landscaping and cleanup, while Torrey Demanche and Brendan Perault finish planting.

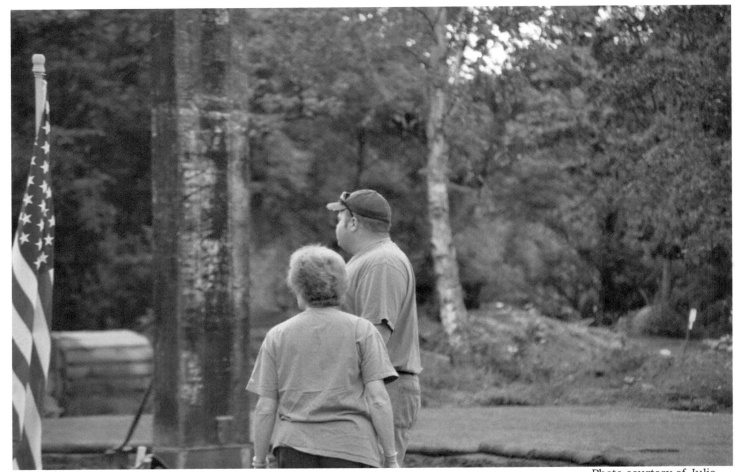

Photo courtesy of Julie

Mickey Rudolph and Josh Hansen take a moment to reflect on the events of the day.

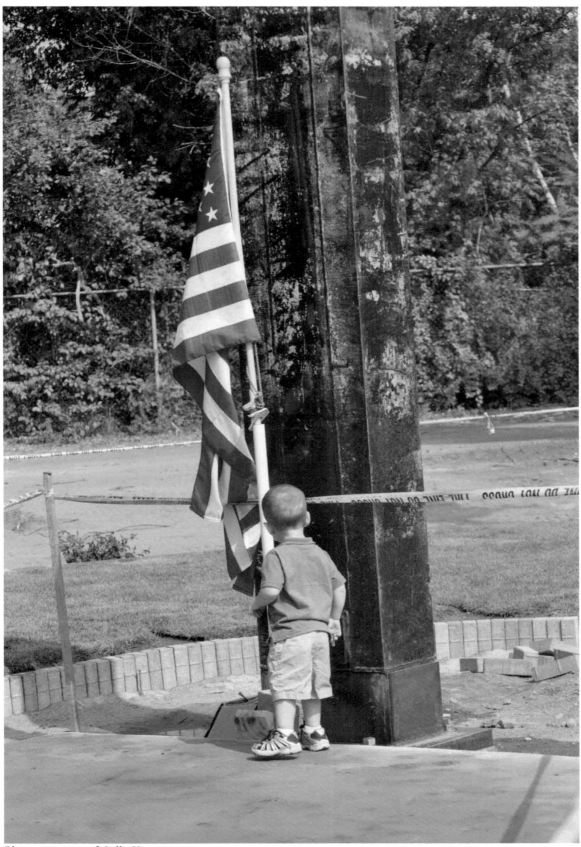

Photo courtesy of Julie Hansen
An unidentified little boy gets a closer look.

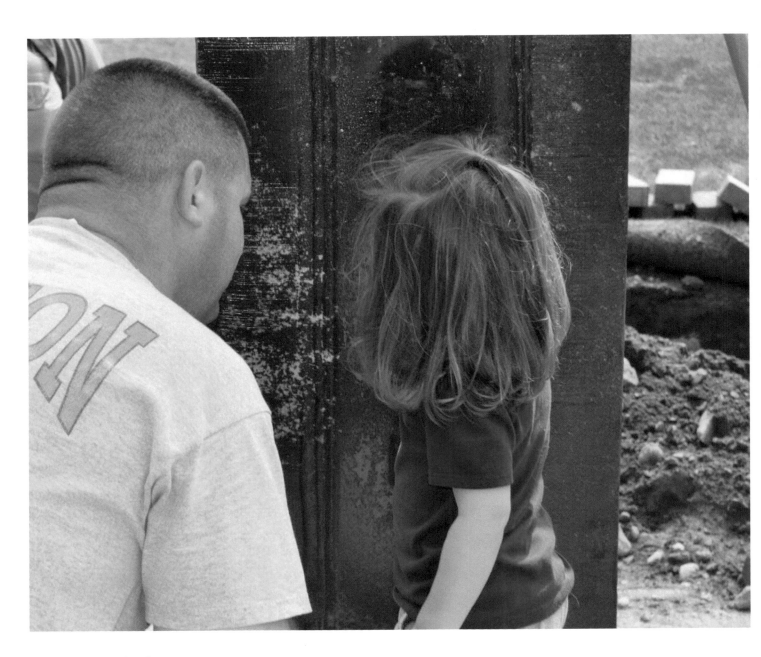

Photo courtesy of Julie Hansen

Robert Buxton tells his daughter, Anna, about the significance and importance of this beam. Anna gets the feel of the steel.

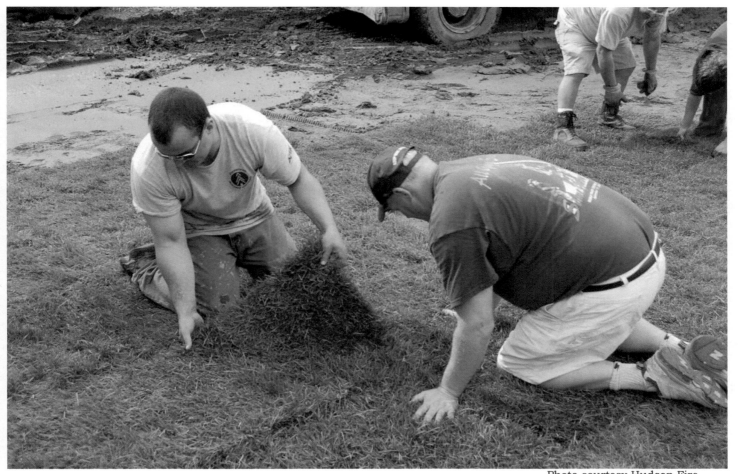

Photo courtesy Hudson Fire

Brian Alley (left) and Dave Morin lay the sod like a new carpet outside the Pentagon.

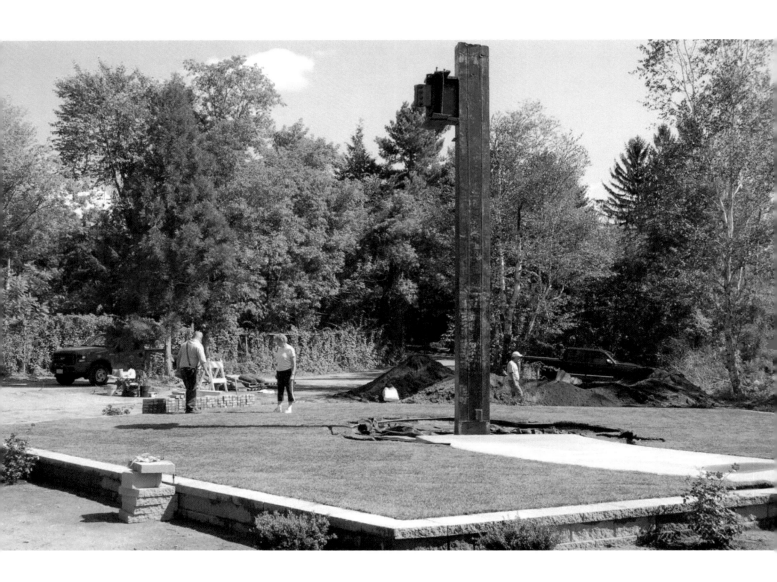

The memorial has the benefit of long days filled with committee members, firefighters, the firefighters' families, and volunteers. All come together to make the site look like the 9/11 Committee envisioned it.

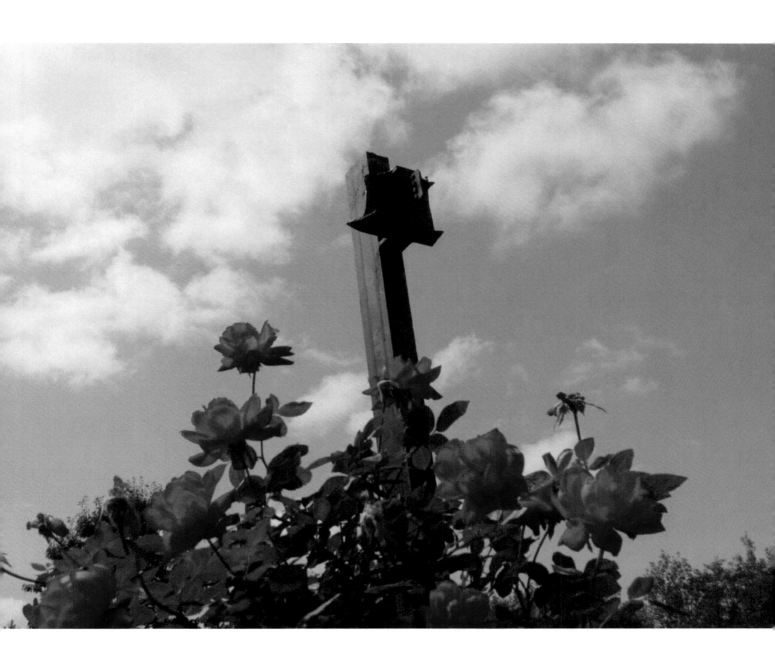

The steel beam stands as a beacon and a reminder.

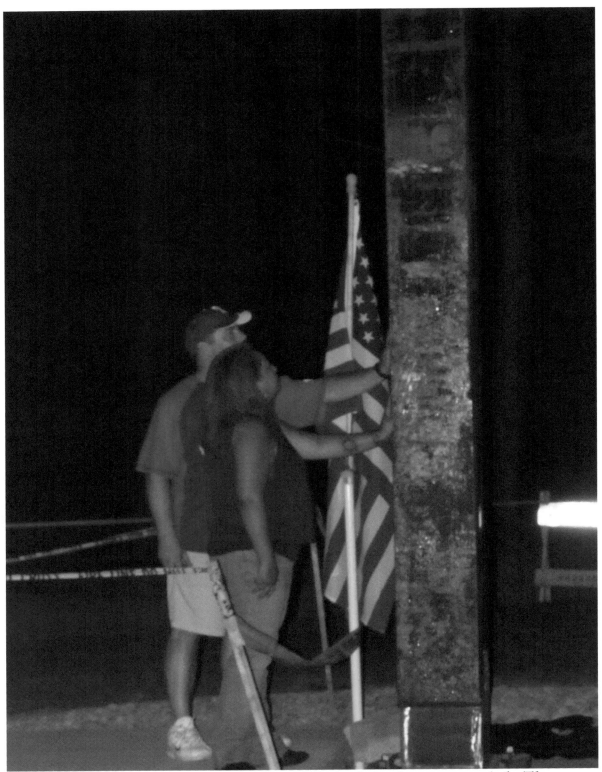

Texas residents Sean Estes and Kim Filini visit the memorial. They came to Boston for a Red Sox-Rangers game and drove to Hudson to visit family and to see the memorial construction. Estes had served in the army in the 1990s. Filini has children in the military, serving a tour.

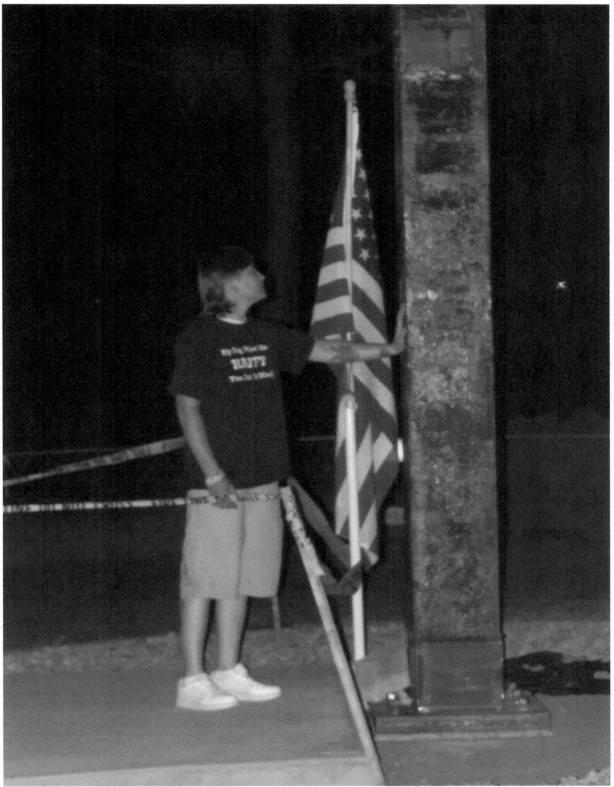

Hudson native Dawn Philbrook accompanied Estes and Filini to the memorial.

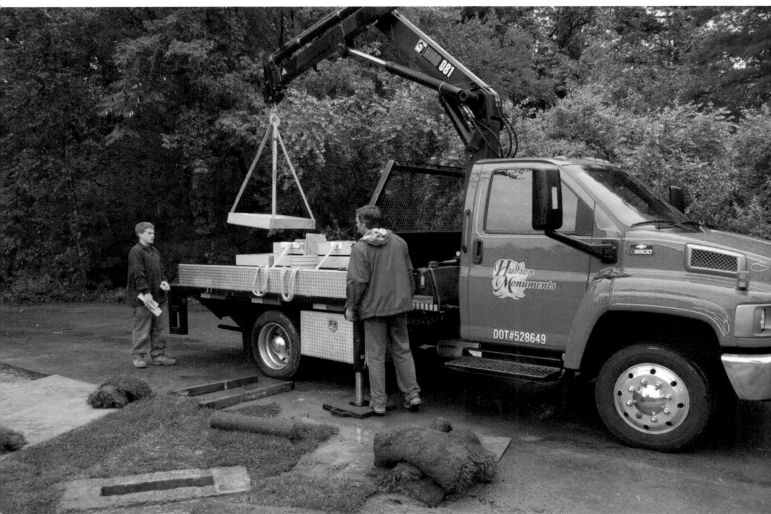

Photos courtesy Hudson Fire

Hudson Monuments works in the pouring rain to deliver the timeline markers. The staff of the monument company work with firefighters and volunteers to install all nine markers.

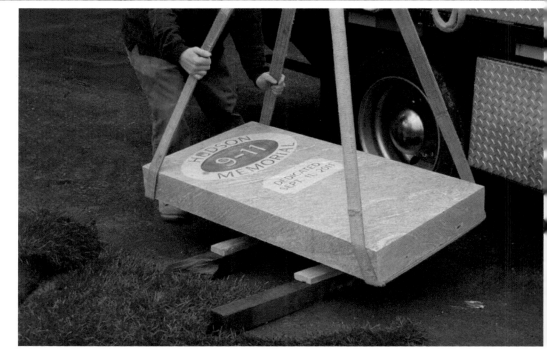

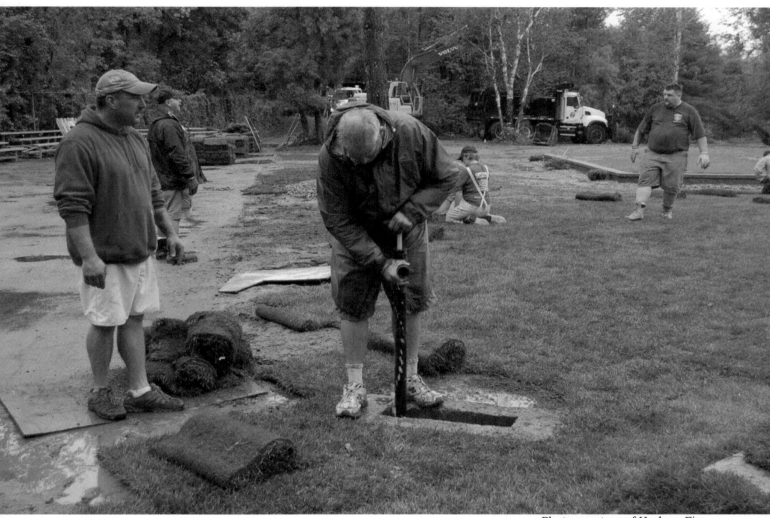

Photo courtesy of Hudson Fire

Captain Dave Morin and Erich Weeks pump water out from a tropical storm that hit one day earlier.

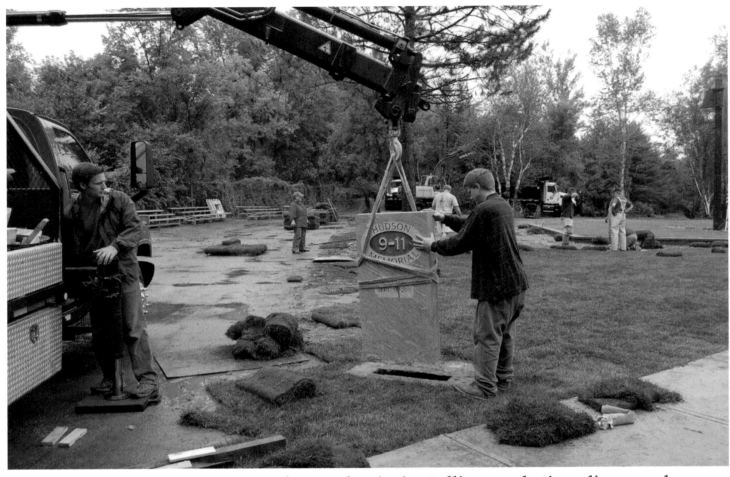

Hudson Monuments employees begin installing each time-line marker, beginning with the first until all the markers are in place.

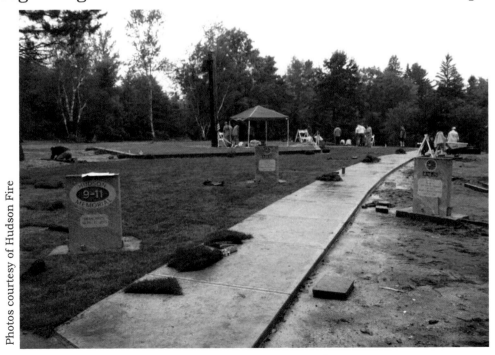

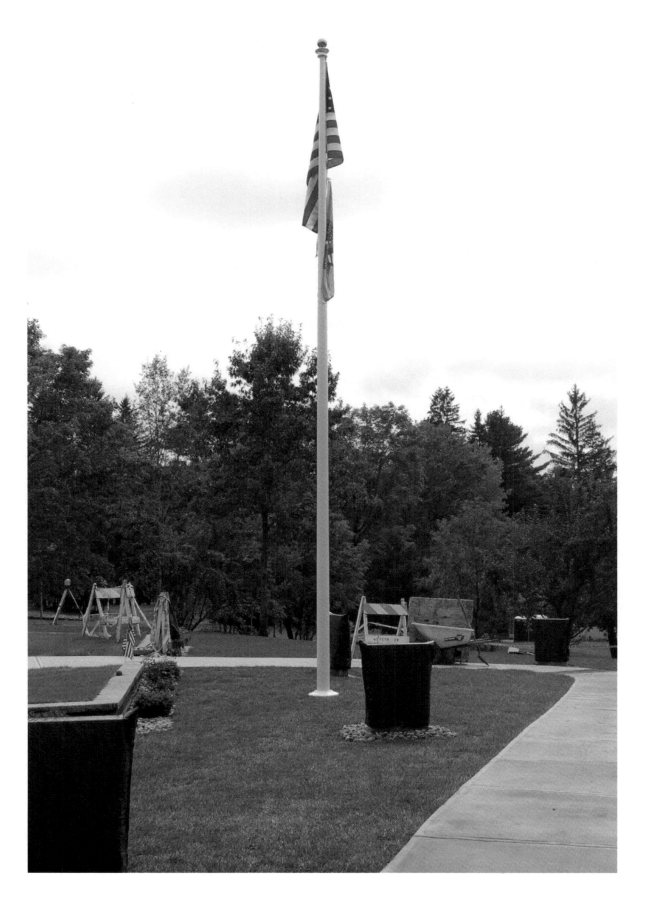

The flag pole, shown on the facing page and the previous page, was donated by the Hudson Nottingham West Lions Club. It was installed free of charge by Rich Enterprises.

The flag, which was flown in Kuwait, was donated by Paul Moore, founder of Moore Mart, an organization that sends care packages to soldiers serving overseas.

The United States Army
197th Fires Brigade

BE IT KNOWN THAT THIS AMERICAN FLAG WAS FLOWN OVER CAMP ARIFJAN, KUWAIT THE 16TH DAY OF JUNE 2011 IN HONOR OF

MOORE MART

On Behalf Of

197TH FIRES BRIGADE

IN GREAT APPRECIATION FOR YOUR SUPPORT TO THE UNITED STATES ARMED FORCES WHILE DEPLOYED IN SUPPORT OF OPERATION NEW DAWN

Stanton R. Noyes
Command Sergeant Major
Command Sergeant Major, Camp Arifjan Zone 6

Nicholas S. Adler
Lieutenant Colonel
Commander, Camp Arifjan Zone 6

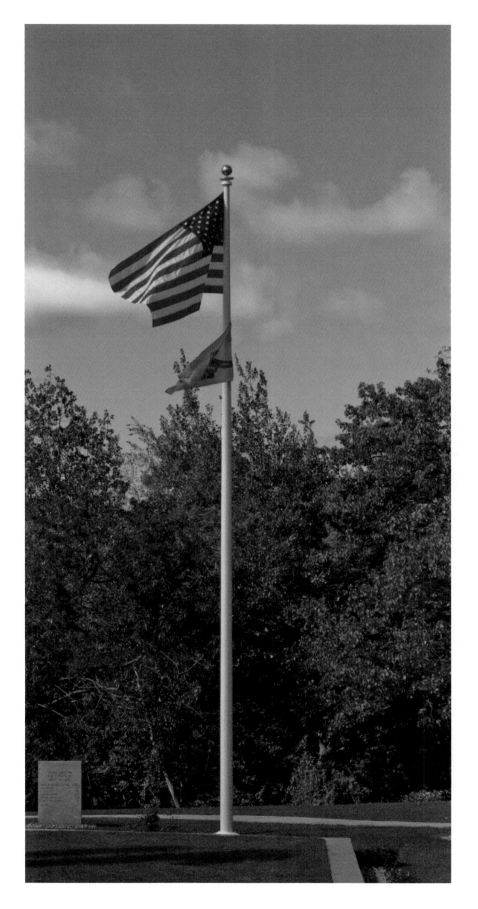

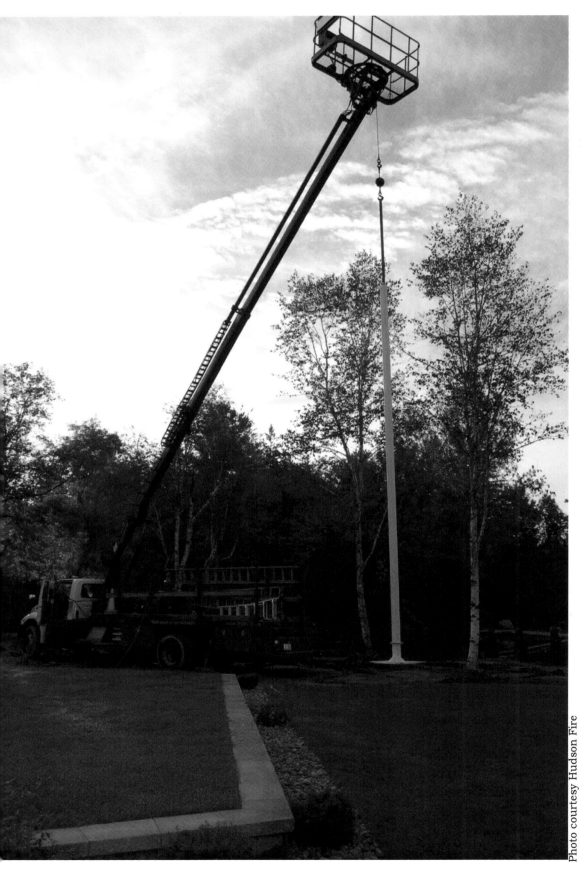

Barlo Signs, International made and install the second tower just two days before 9-11. Here they are shown installing the base pole.

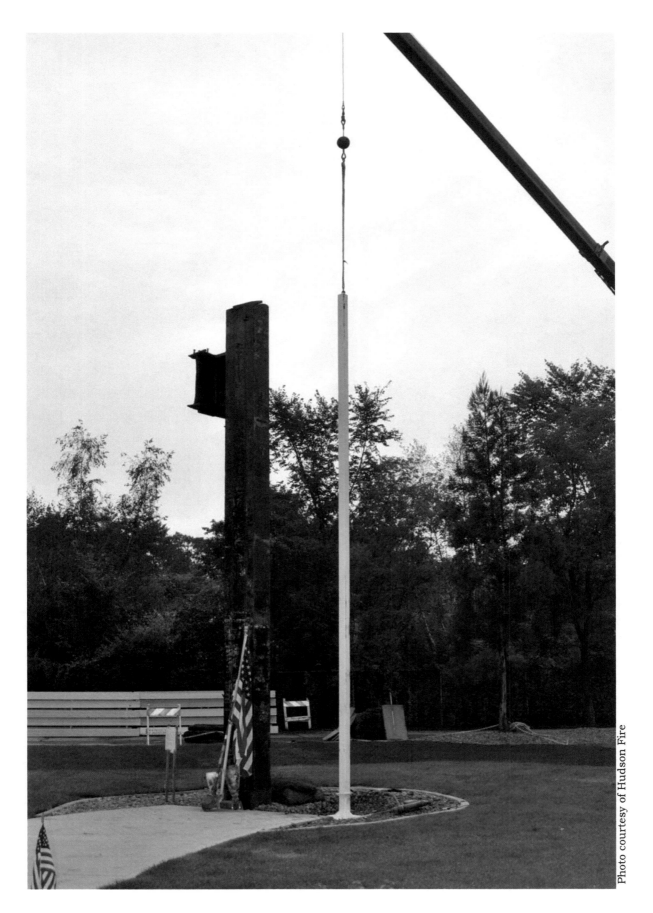

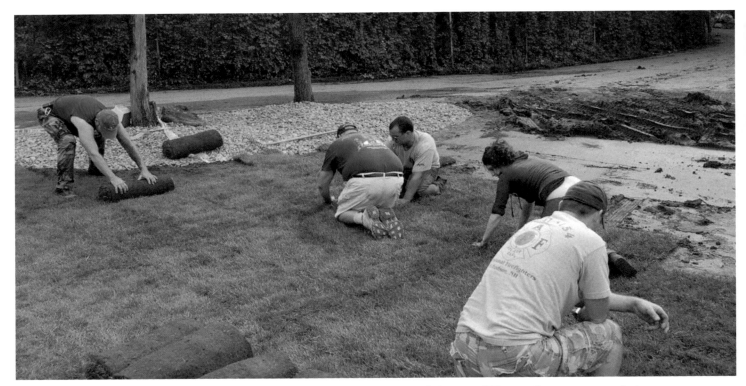

While Barlo Signs is busy delivering and installing the second tower, firefighters and volunteers continue with the landscaping work. Among the volunteers are Dave Morin and Brian Alley (in the center).

Photos courtesy of Hudson Fire

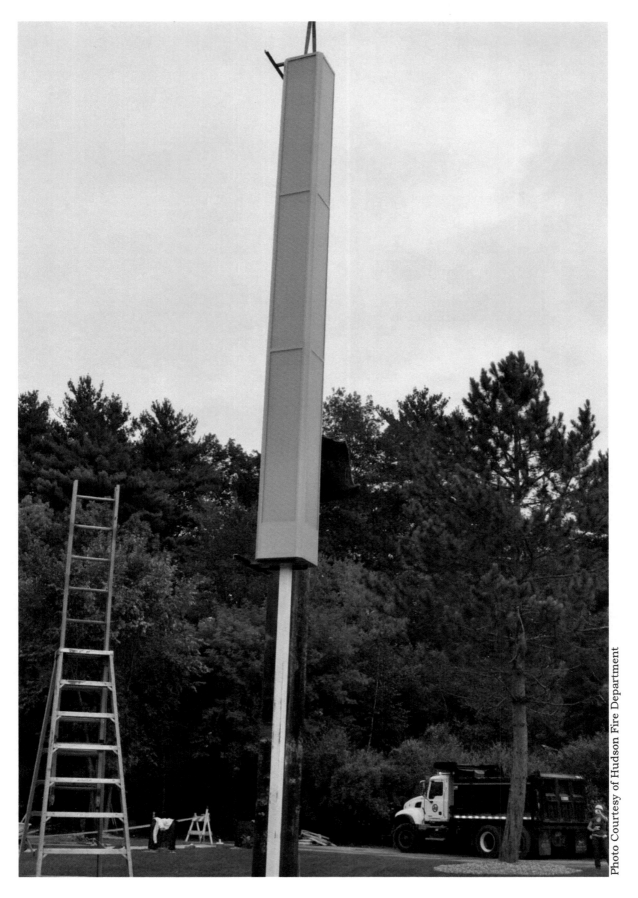

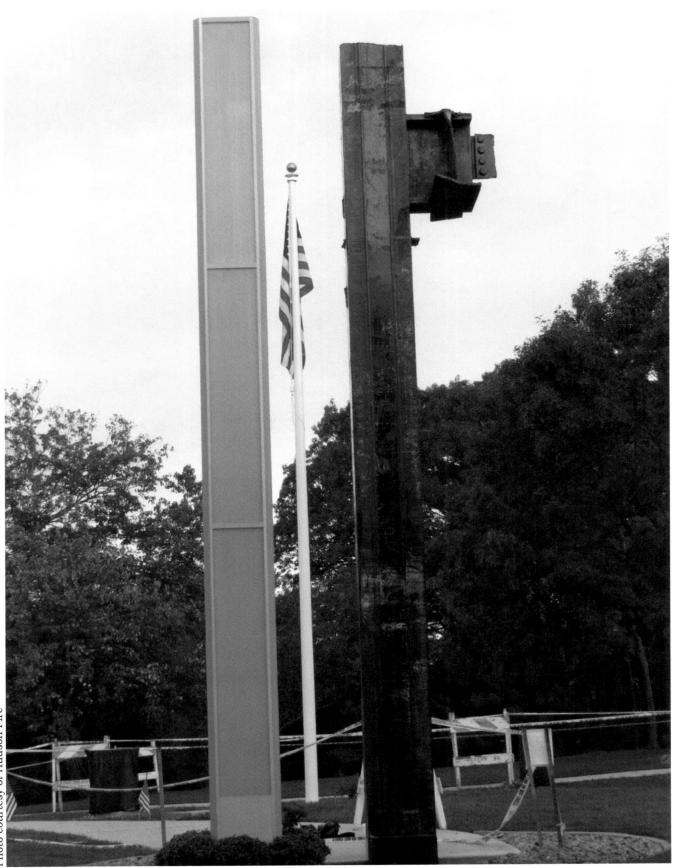

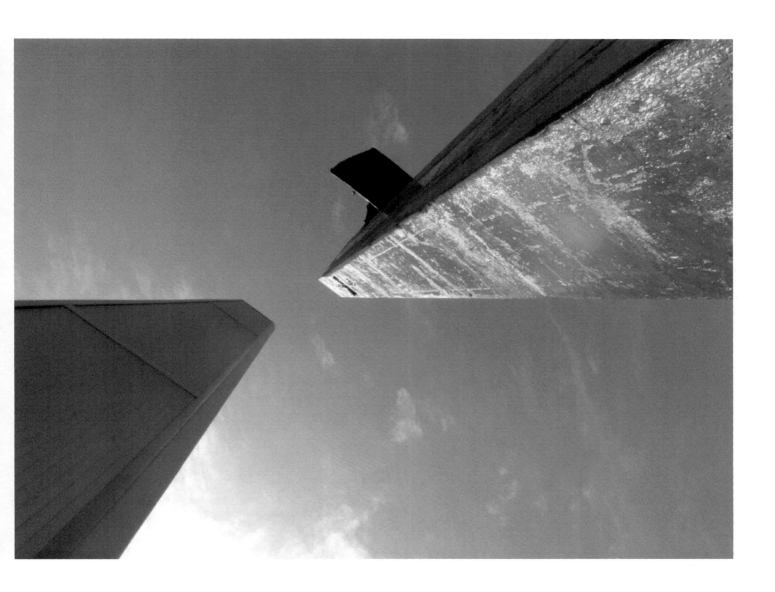

The towers soar into the skies.

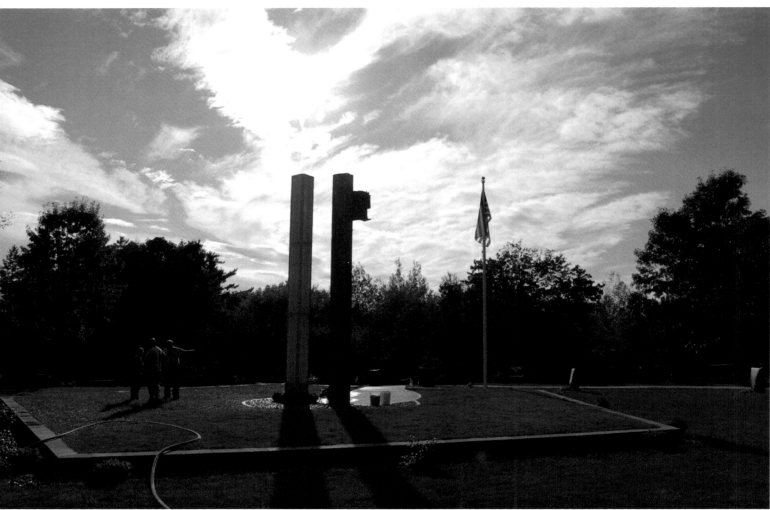

Photo courtesy of Hudson Fire

Eric Lambert, Captain Todd Hansen and Captain Dave Morin water the new-born grass. The landscaping is complete, days before the ceremony.

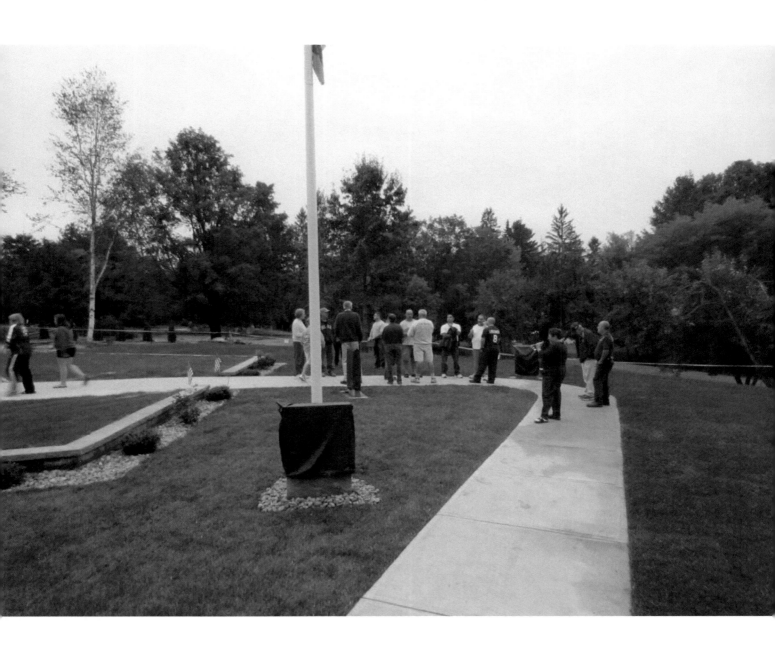

The Hudson 9/11 Committee holds a final meeting before the ceremony.
They marvel at the difference from the rock-strewn area they started with
and what it has become.

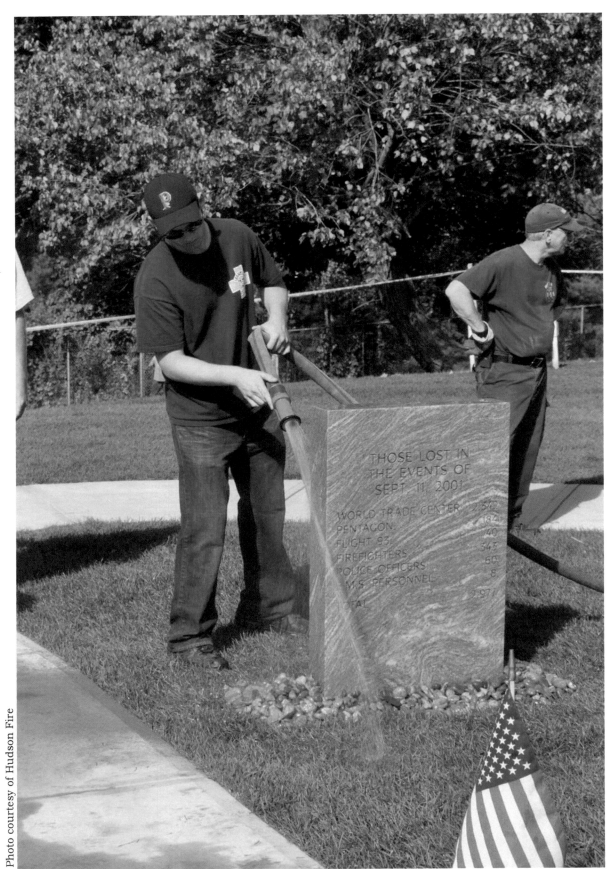

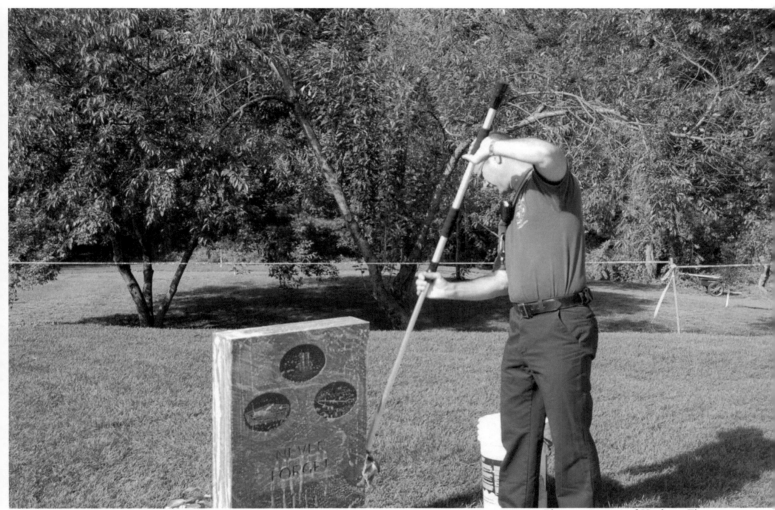

Photo courtesy of Hudson Fire

On the facing page, Mike Armend begins wetting the markers so that, above, Todd Berube can wash them.

After washing the stones, Todd Berube wipes them down.

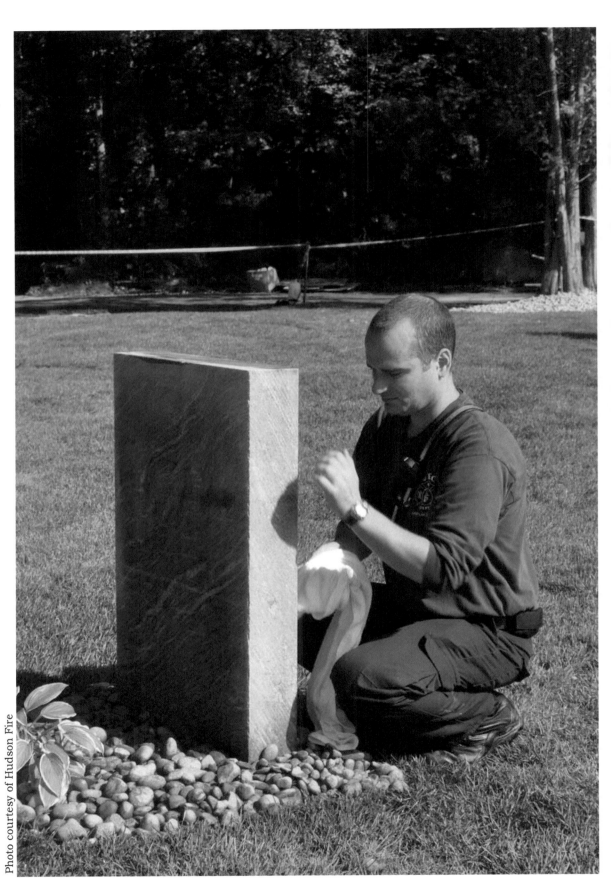

Photo courtesy of Hudson Fire

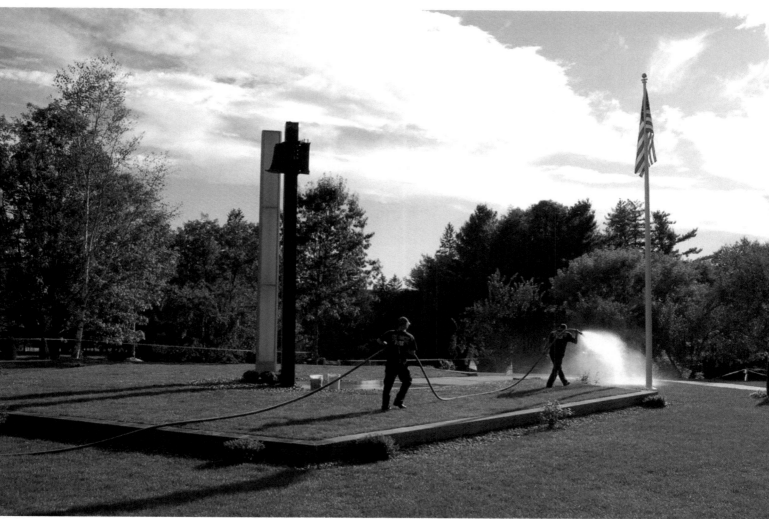

Members of the Hudson Fire Department water the grass, as they do every day. Manning the hoses seems to fit right in with their profession.

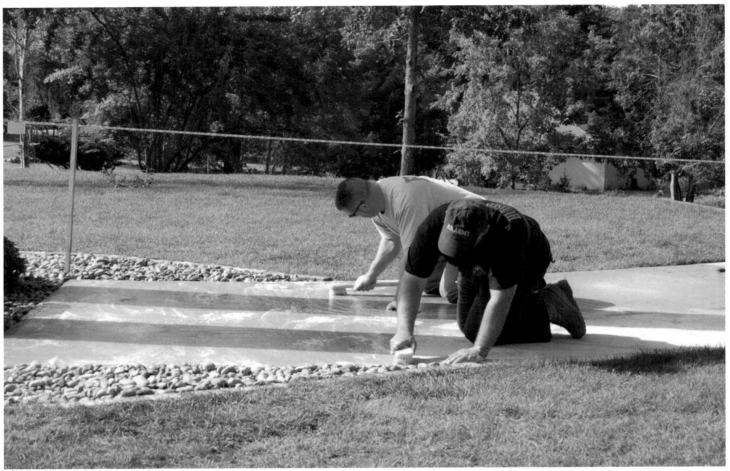

Photo Courtesy of Hudson Fire

The walkway to the towers will be spotless for opening day, thanks to the firefighters.

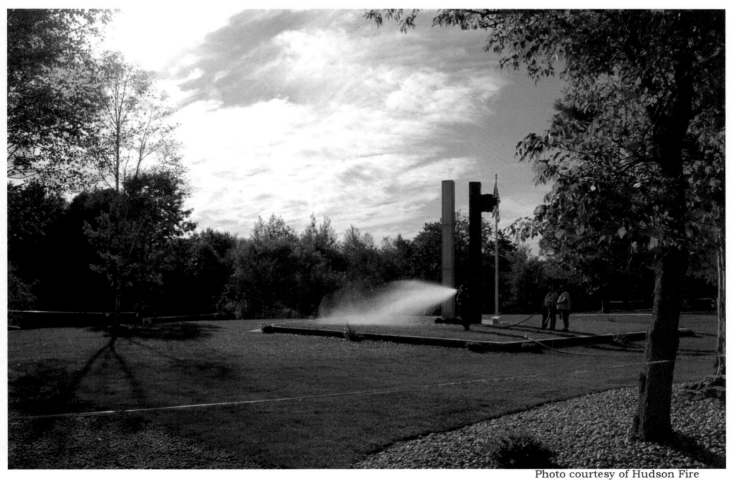

The entire area gets a final watering prior to the public opening.

A Nashua, NH, resident, Esther Ross, went to the site of the Memorial the day before it opened to the public. When she explained that she would be out of town the next day and that her cousin, Herman Sandler of the firm, Sandler and O'Neill, was located in the South Tower, Dave Morin offered her a private preview of the site. Following her tour, she wrote a letter to the Fire Chief. These are her comments:

Mrs. Esther Ross

Nashua, NH

To: The Chief, members of the Fire Department, Officials, and residents of Hudson:

Dear Chief,

Our family wishes to thank all of you for the commentaries and implantation of the steel beam from the World Trade Center remembering those lost on the 9/11 attacks.

We lost our beloved cousin, Herman Sandler of Sandler & O'Neill in the WTC on that day as well as 66 of the associates at his firm. We join so many families in their loss as well and must tell all of you how grateful we are to have this near us and to have this happen. We remember all the bravery of the responders and are all thinking of the families who have had losses like ours.

To all involved, may you have good health, personal safety and God bless America.

With sincere appreciation,

Mrs. Esther Ross and Family

Nashua, N.H.

P.S. Please feel free to share this letter as you wish.

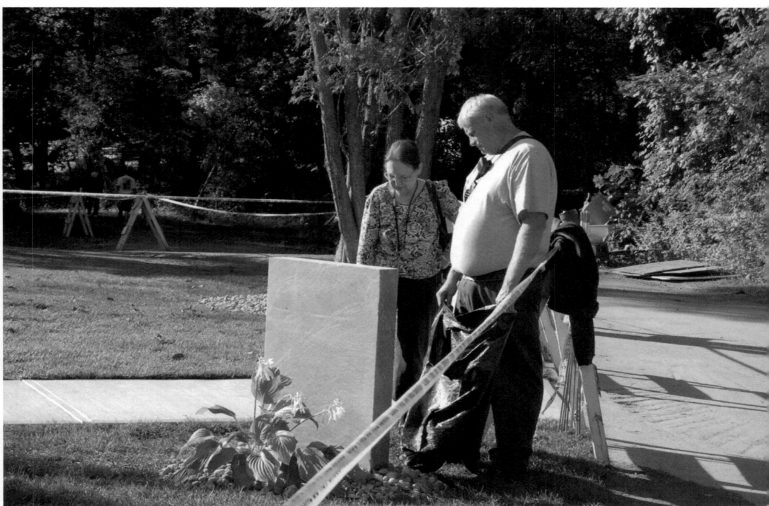

Photo courtesy of Hudson Fire

Dave Morin gives Esther Ross an advance tour.

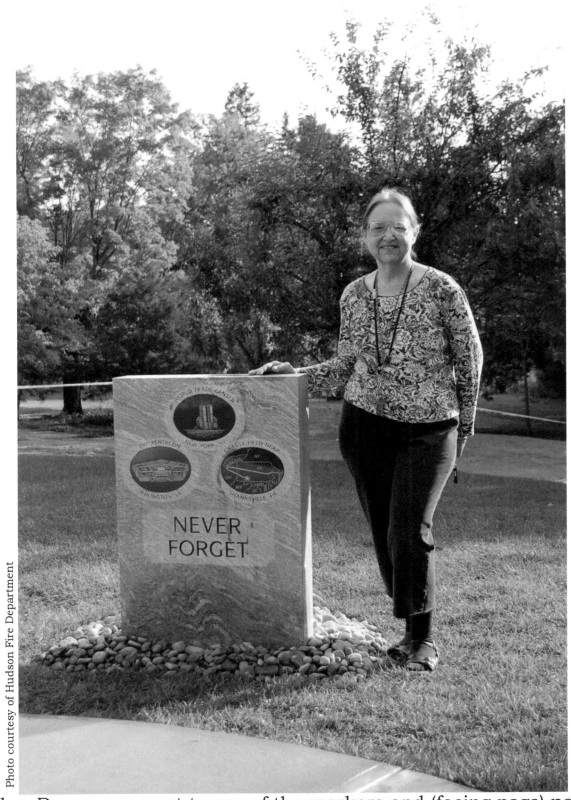

Esther Ross poses next to one of the markers and (facing page) near the
two Towers.

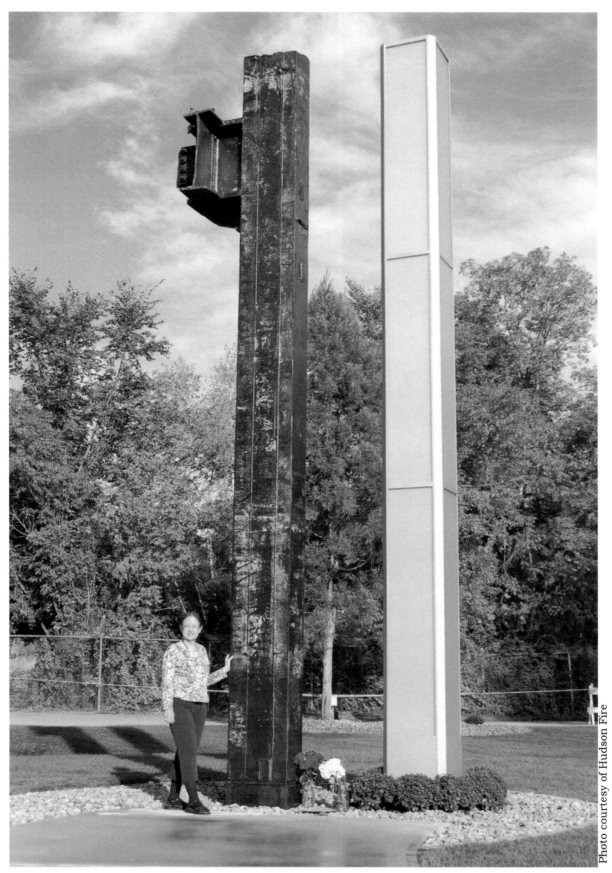

Photo courtesy of Hudson Fire
Department

Town of Hudson, NH

9-11 Memorial

at Benson Park

September 11, 2011

Dedication Ceremony and

Ten Year Anniversary Remembrance

In

memory of those we have lost
~Never Forget September 11, 2001

The Dedication Ceremony program is reproduced on these pages.

Order of Service

Processional. . .Honor Guards and Alvirne High School Marching Band

Prelude.........Introduction of Special Delegation and reveal of the stones and timeline of the events of September 11, 2001.

Invocation......Reverend David Howe

Flag Ceremony:

 ... Acceptance of an American Flag that flew over American troops serving our country-from Paul Moore, founder of Moore Mart

 ... Acceptance of the official 9-11 Flag donated by Firefighter Marin Conlon of the Hudson Fire Department

 ... Flag raising - Pledge of Allegiance - National Anthem

Honored Speakers...Governor John Lynch
 U.S. Senator Jean Shaheen
 U.S. Senator Kelly Ayotte

9-11 Memorial Observance... Selectman Chair, Shawn Jasper
 Moment of Silence
 Laying of the Wreath with Taps — Police Chief Jason Lavoie
 Fire Chief Shawn Murray
 American Legion - 21 gun salute then Amazing Grace - bagpipes

Committee Speakers.... Benson Committee Chairman Harry Schibanoff and Selectman / 9-11 Committee Member Roger Coutu

Special Address....Fire Captain David Morin, President of the 9-11 Memorial Committee.

Ceremonial Walk into the Memorial - Led by Captain Dave Morin with Elizabeth Kovalcin in honor of David Kovalcin, Hudson resident

Closing Prayer.... Reverend David Howe

Master of Ceremony...Declares the 9-11 Memorial officially opened

Musical Accompaniment — Alvirne B Naturals - National Anthem Aand Taylor Morin singing—"Where Were You (When the World Stopped Turning)"

<div align="center">~Guests are welcome to enter the memorial~</div>

World Trade Center Artifact

The steel is a 23 foot I-beam from Tower I of the World Trade Center. It is 56 x 12 inches and weighs 18,048 lbs. It arrived in Hudson, NH on May 12, 2011 and has been displayed at several parades, official ceremonies and special events throughout New Hampshire and Massachusetts before being set within the memorial site on September 2, 2011.

The Design of the Memorial

Representing Tower I of the World Trade Center in New York City - The honored 23 foot piece of steel stands erect in a symbolic remembrance of those we lost on the ground and for those who were aboard American Airlines Flight #11 on September 11, 2001. Beside the steel stands a glass tower representing Tower II of the World Trade Center and those who were aboard United Airlines Flight #175. The glass tower is a symbolic gesture demonstrating that even under great adversity the United States of America will always rise together, as one, to protect her freedom.

The outside perimeter pentagon shaped stone wall and the concrete walkway into the memorial represents the flight path of American Airlines Flight #77 and honors those we lost as the airplane struck the U. S. Pentagon.

The plush green space within the memorial represents the field where United Airlines Flight #93 crashed near Shanksville, PA and honors the brave passengers who it is believed tried to regain control over the aircraft causing it to avoid the potential target of the United States Capital in Washington D.C.

Several stone markers along the memorial path tell the timeline and story of the tragic events of September 11, 2001.

Thank you to all who helped support this project through donations, fundraising efforts, and following the journey of the World Trade Center steel.

9-11 Memorial Committee Members:
President — David Morin Vice President — Carole Whiting
Secretary — Torrey Demanche Treasurer — Dennis Haerinck
Member at Large — John Rudolph

Brian Alley Robert Buxton Martin Conlon
Roger Coutu Lafe Covill Gilles Dube
Christina Green Todd Hansen Elizabeth Kovalcin
Bill Leblanc Adam Lischinsky Rick McCartney
Corey Morin Michelle Rudolph Jason Sliver

~Additional thanks to spouses, family members and friends who often joined and assisted behind the scenes to make this effort successful.

Special thanks to the following contributors:

Aggregate Industries Area News Group
Barlow Signs Bay State Welding
Brox Industries Buxton Concrete
Country Brook Farms ` Continental Paving Company
Enterprise Bank Fillmore Industries Inc.
Hudson Firefighters Relief Assoc. Hammer & Sons Signs– Pelham
Hudson Highway Department Hudson Monument
Hudson Nottingham West Lions Club Hudson Quarry
Hudson Police relief Assoc. H.C.T.V. infomercial/coverage
Kelly Crane Inc. Kinney Towing
Lowell Sun - coverage Malley Electric
New England Sign Modern Protective Coating
Professional Firefighters of Hudson Nashua Telegraph—coverage
Tamarack Landscaping Sousa Developers
Winding Brook Turf Tim's Turf Farm
V.F.W. Post 5791 WMUR Television—coverage
Foley Buhl & Roberts - Structural Engineers
Harvey construction — Preliminary cost estimate
Maynard & Paquette Engineering Assoc. LLC - Civil Engineering & Surveying
Morin's Landscaping — Plan review and advice
PMR Architects PC - Original Design & Construction Documents

**With humbled appreciation we thank the
New York / New Jersey Port Authority**

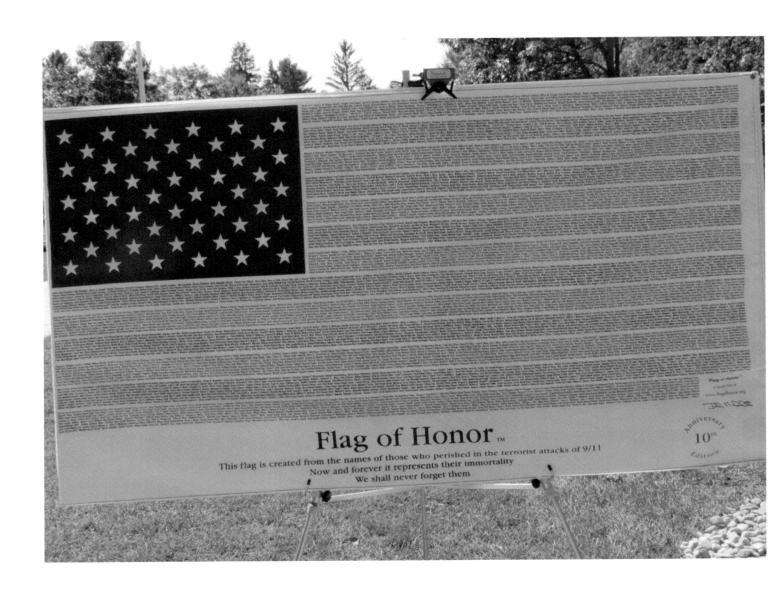

The first thing people see at the Memorial is this American Flag. The stripes contain the list of every victim from 9-11.

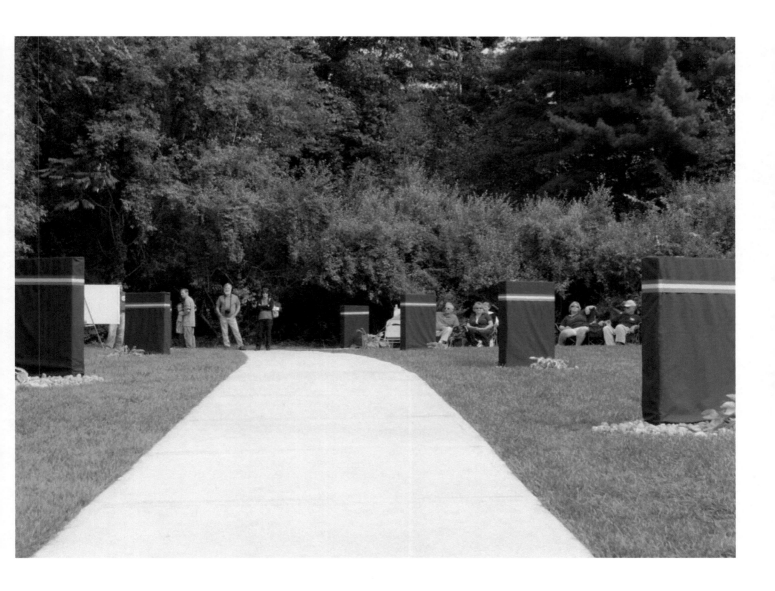

The time-line markers are ready to be unveiled along the walkway. The walkway is in the exact flight path of Flight 77, which crashed into the Pentagon.

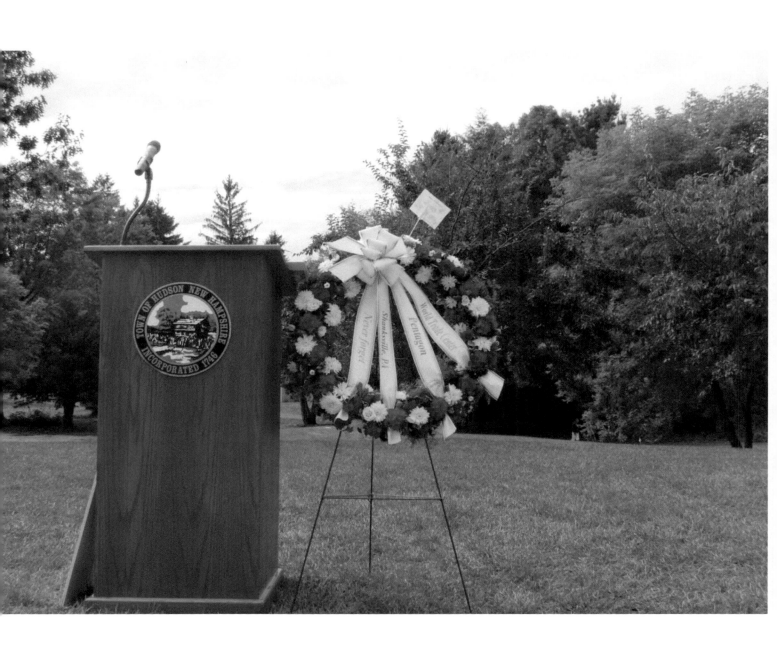

The podium stands ready for the ceremony.

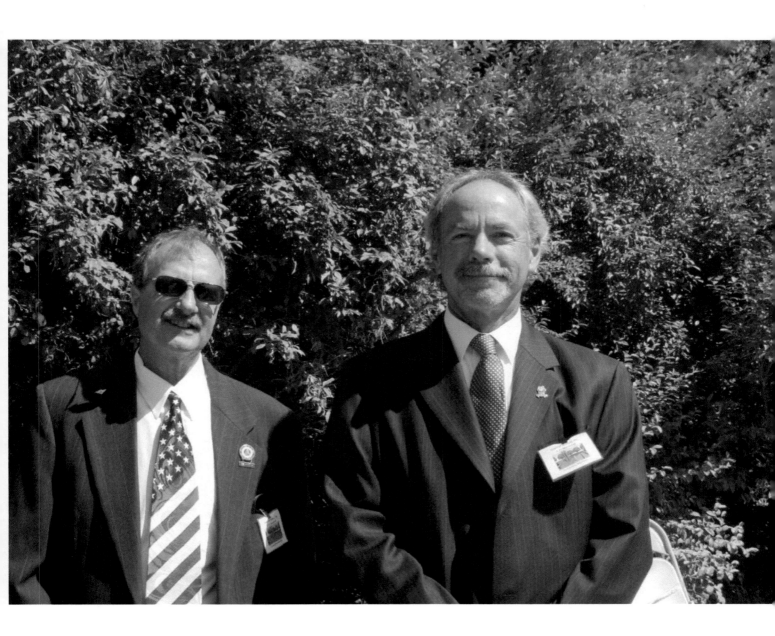

Gilles Dube (left) and Bill Leblanc are among the 9/11 Committee members who greeted each arrival.

On the facing page, Meg and Roger Doucette take some time for reflection and to pay their respects before the ceremony. They both serve as volunteers for the Salvation Army Emergency Disaster Services.

Roger, a retired Marine, became a New York firefighter in 1999. He was called to Ground Zero to perform search and rescue duties, where he remained for a solid week, after which he returned to help the Salvation Army assure that emergency personnel and rescue workers were well fed and cared for.

Only at the dedication did he find out that one of the airplane passengers was a girl he went to school with.

Both Meg and Roger found the experience at the beam to be very difficult. They still mourn for those who lost their lives and for their families.

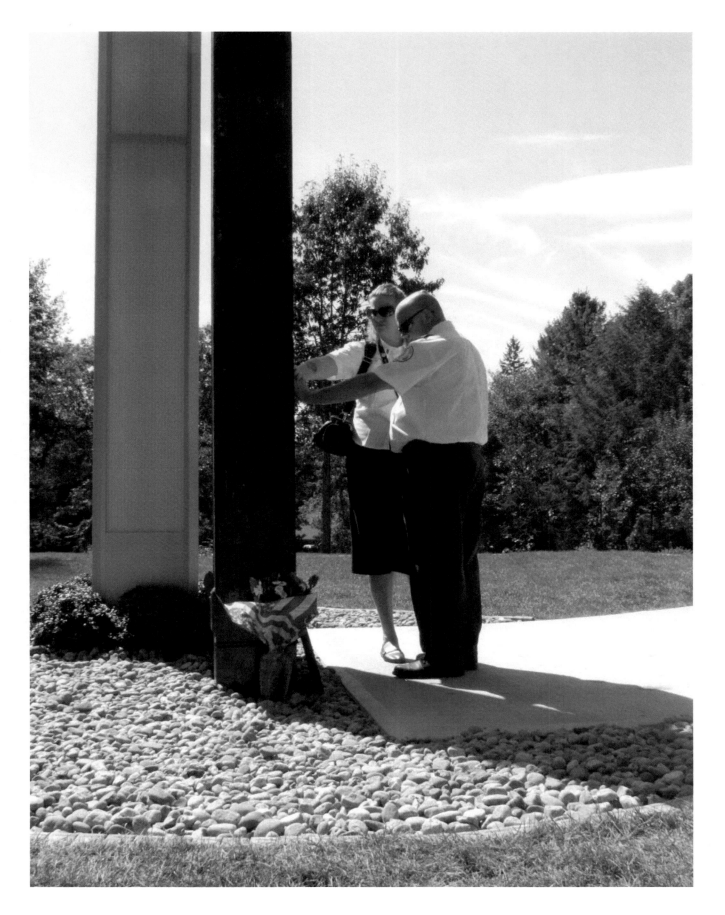

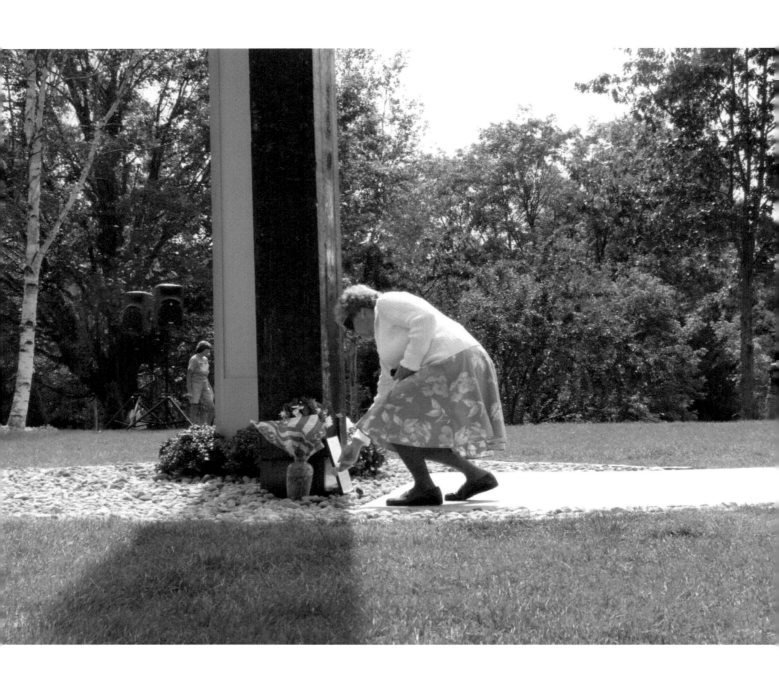

Many people, residents and non-residents alike, visit the site.

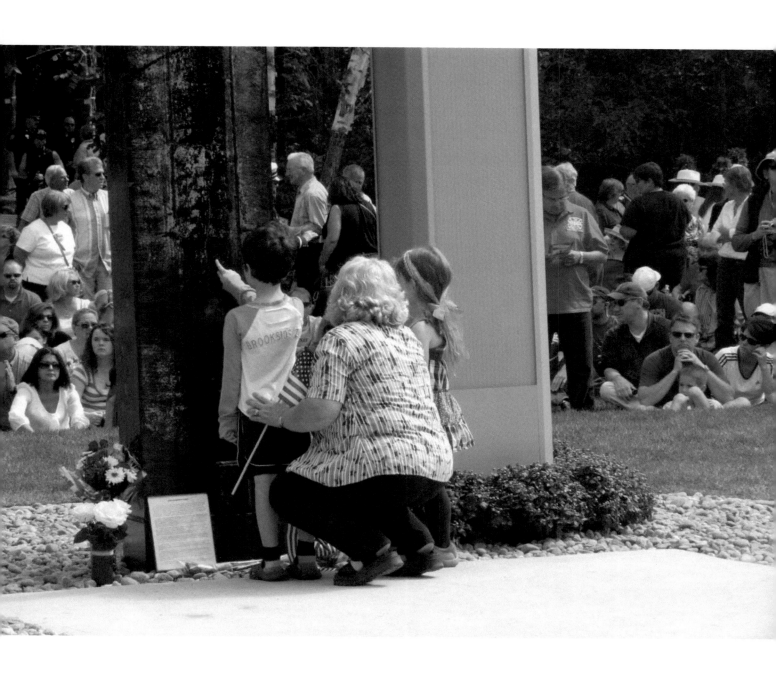

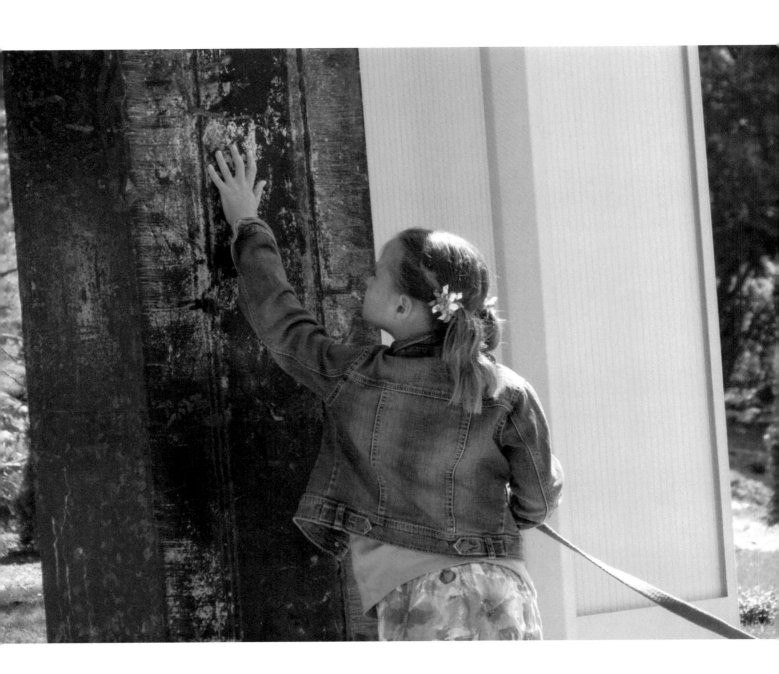

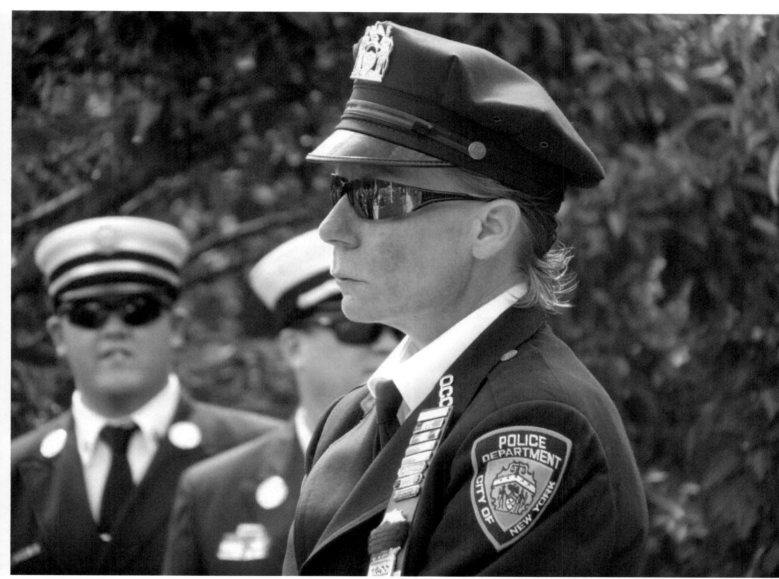

One of the heroes of the terrorist attack is Spike, a New York City police detective. She can recall the smell at Ground Zero. She searched from building to building within the 12-block crime scene. One building, she recalled, was an office building with its front sheared off. As she called out for survivors, she encountered a desk with a coffee cup, a pager beeping continuously, a lunch bag, and paperwork scattered everywhere. "All they did was go to work that day," she said. Spike now lives in New Hampshire and plans to visit the memorial often. "This is a gift to everyone. It's not about me, it's about everyone. Thank you," she said.

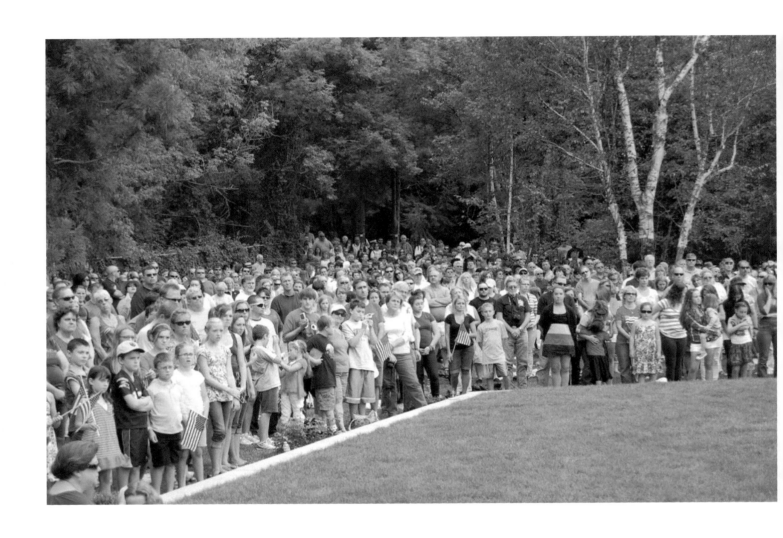

On the official unveiling day, the site fills quickly

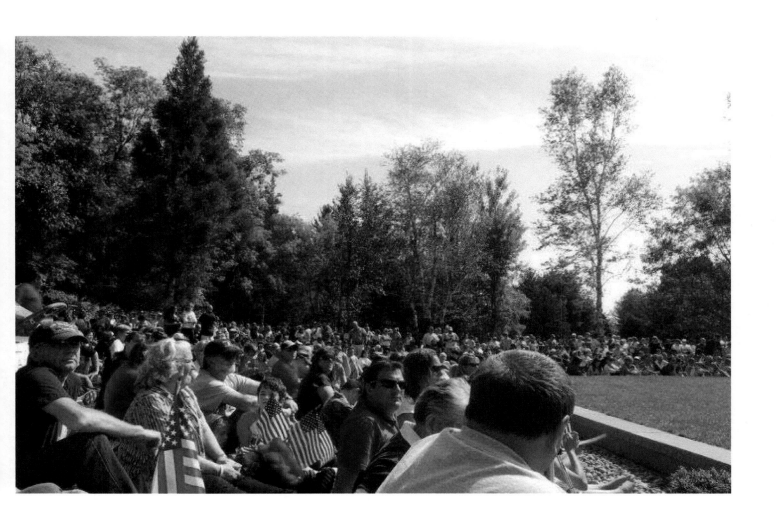

and walls of people line the Park to view the memorial.

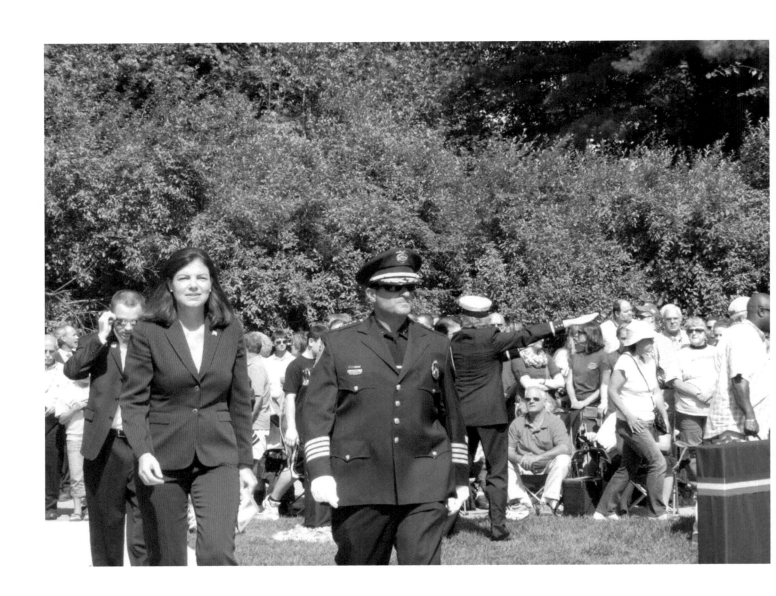

U.S. Sen. Kelly Ayotte is escorted to her seat by police chief Jason Lavoie.

JOURNEY OF A BEAM

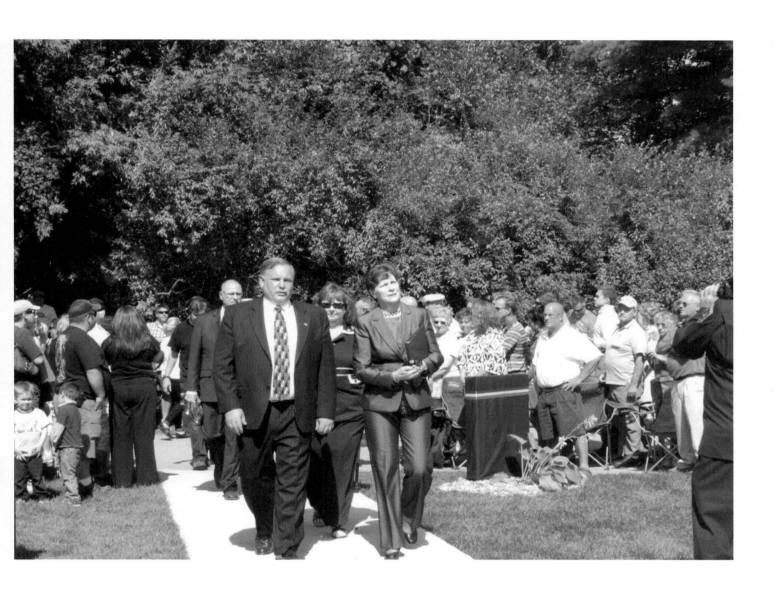

U.S. Sen. Jeanne Shaheen is escorted by Chairman Shawn Jasper.

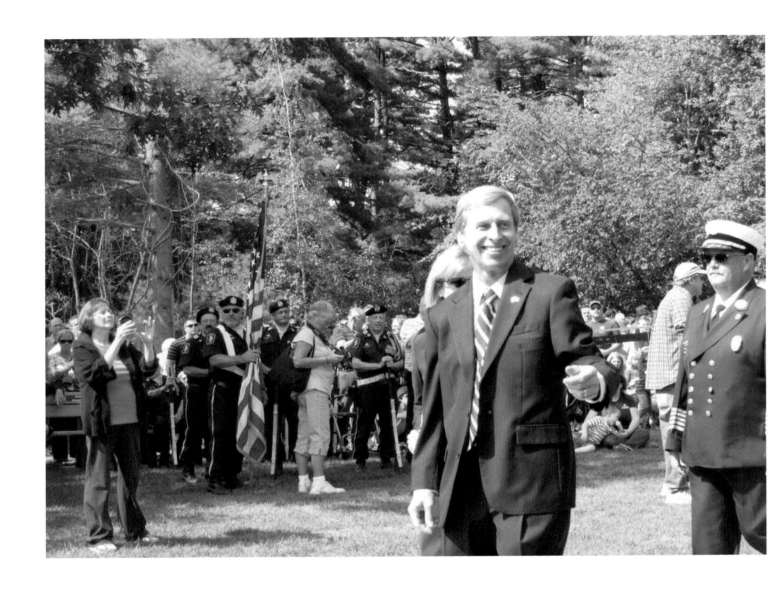

New Hampshire Gov. John Lynch is escorted by Fire Chief Shawn Murray.

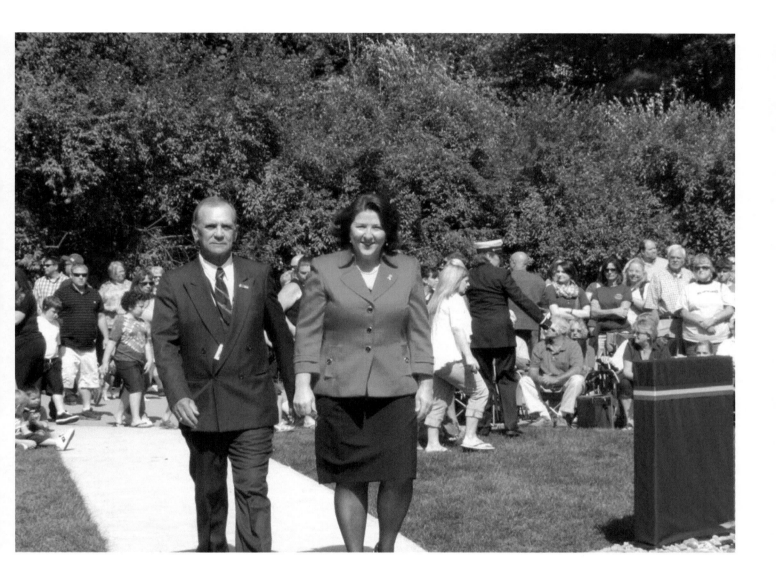

Nashua, N.H., Mayor Donnalee Lozeau is escorted by Selectman Roger Coutu.

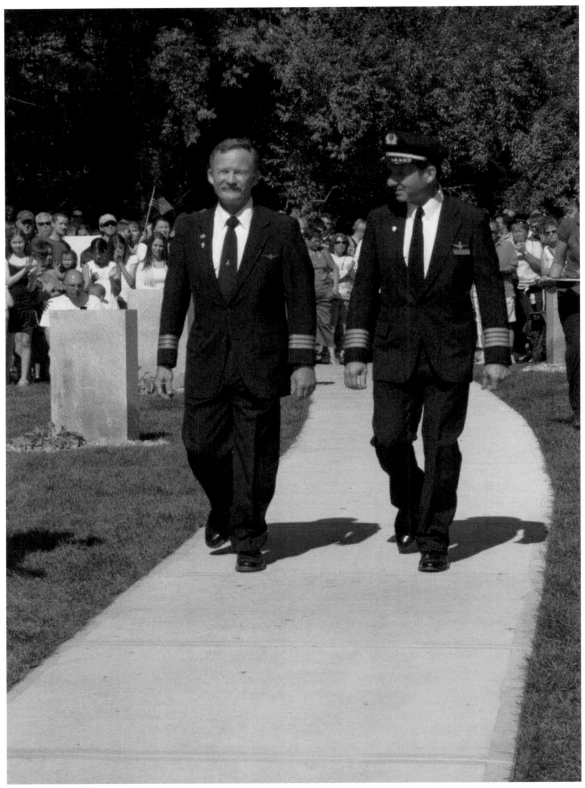

Mark Wilson and Rick Krajaweski, American Airlines pilots, walk toward the end of the flight path of Flight 77, that crashed into the Pentagon.

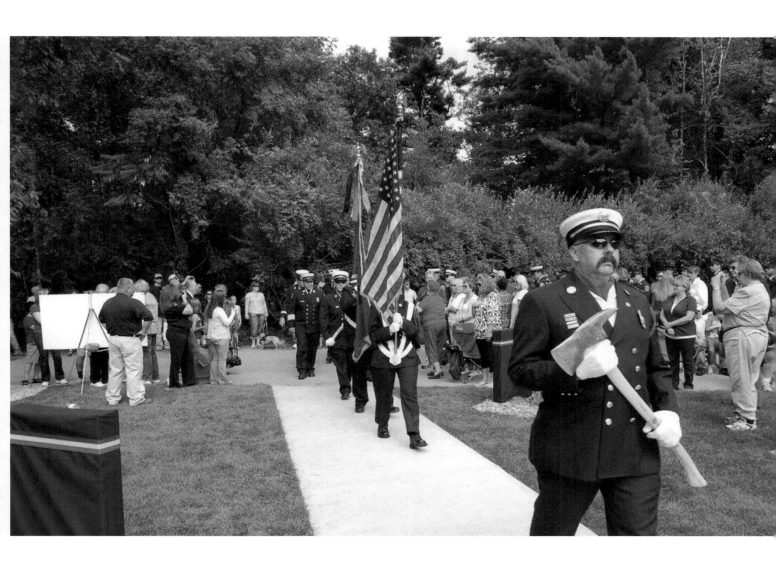

The Honor Guard enters the area to begin the ceremony. Leading the Honor Guard is Dave Brideau.

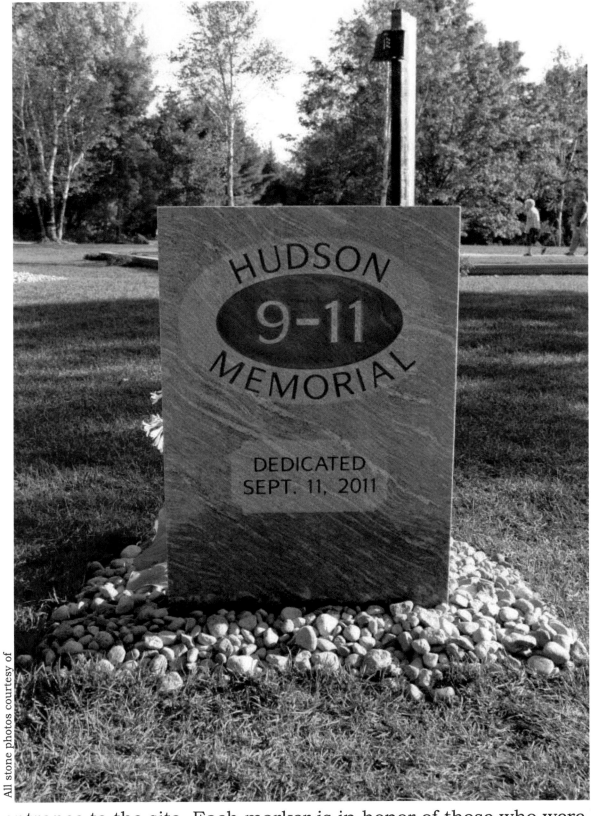

The entrance to the site. Each marker is in honor of those who were killed at a particular event.

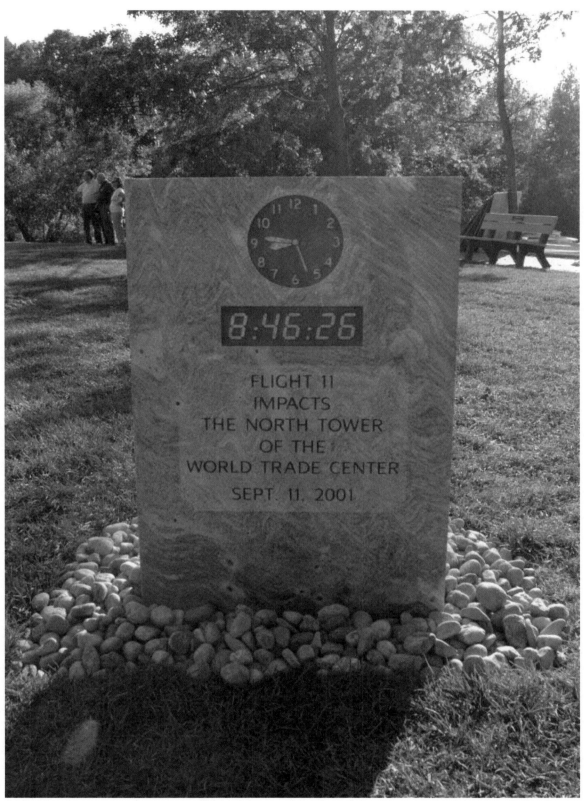

David Kovalcin, 42, was on flight 11. A Raytheon engineer and father of two, he was a resident of Hudson. His wife, Elizabeth, is a member of the 9/11 Memorial Committee

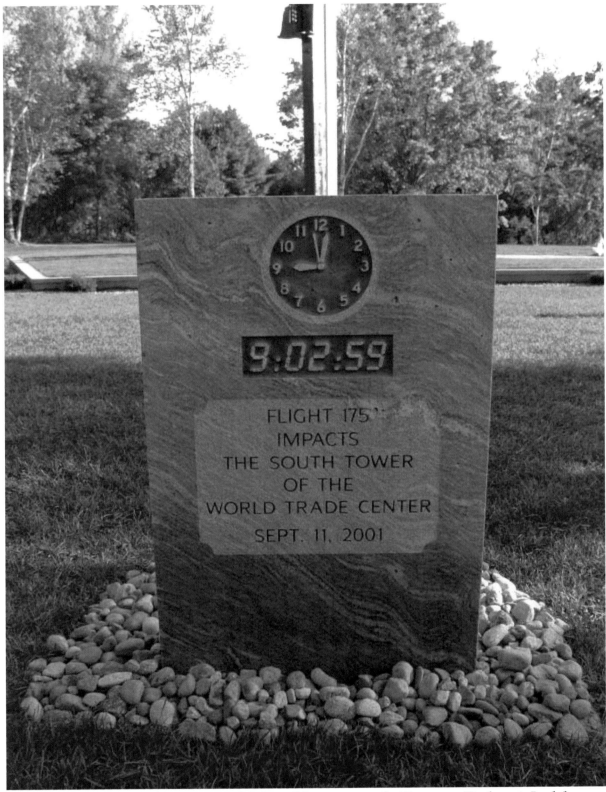

New Hampshire residents Carl Max Hammond, Derry; Robert Leblanc, Lee; Louis "Neil" Maraini, Derry; and Kathleen and Michael Shearer, Dover lost their lives on flight 175.

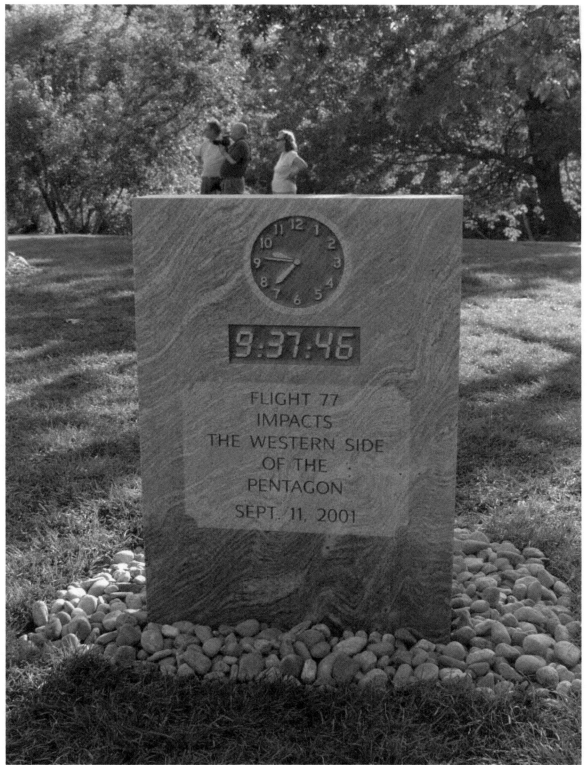

N. H. Resident Robert "Bob" Penninger, BAE system employee and electrical engineer was on flight 77. Gerald P. "Jerry" Moran of upper Marlboro, Maryland, was working at the Pentagon. They lost their lives when the plane crashed.

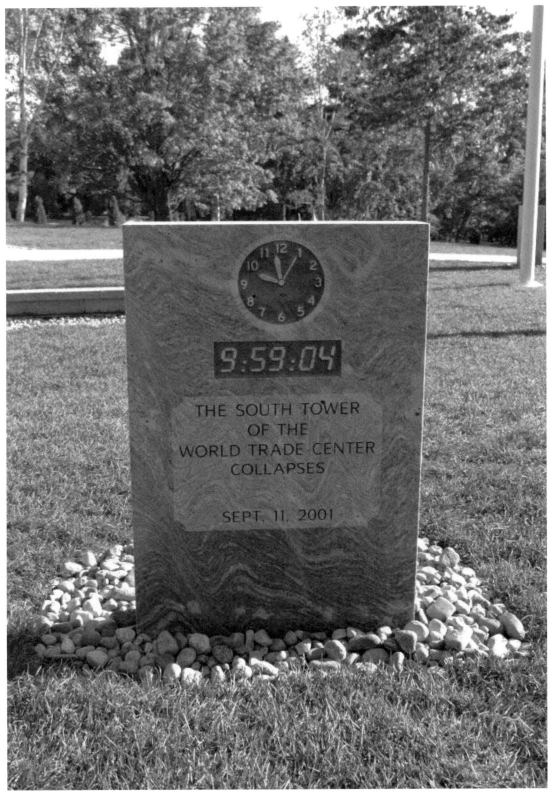

Brian Kinney of Lowell, Mass., was aboard flight 175 when it hit the South Tower. Kinney Towing of Amherst, N.H., assisted the committee with the transport of the beam on several occasions.

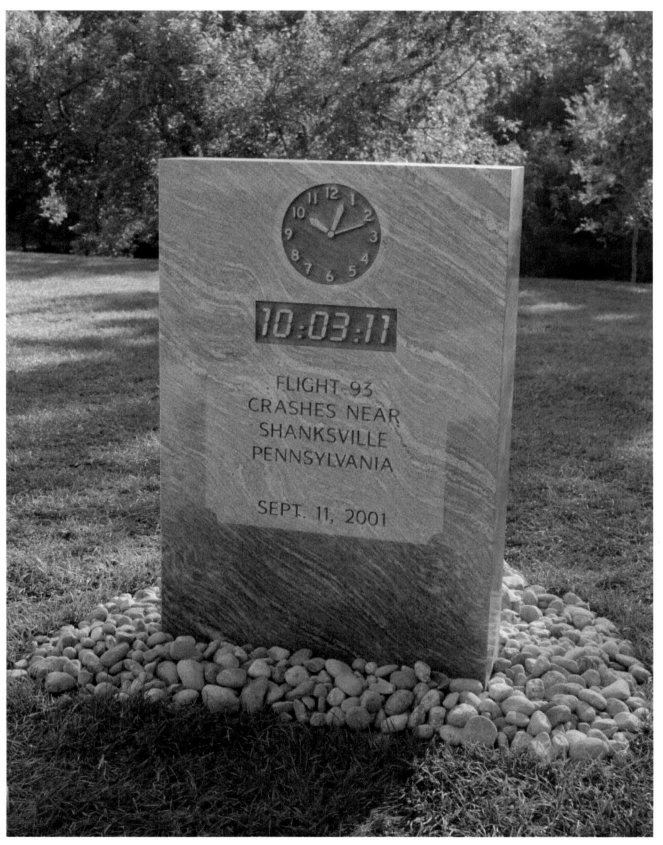

The passengers from Flight 93 helped to avoid a crash into the U.S. Capital.

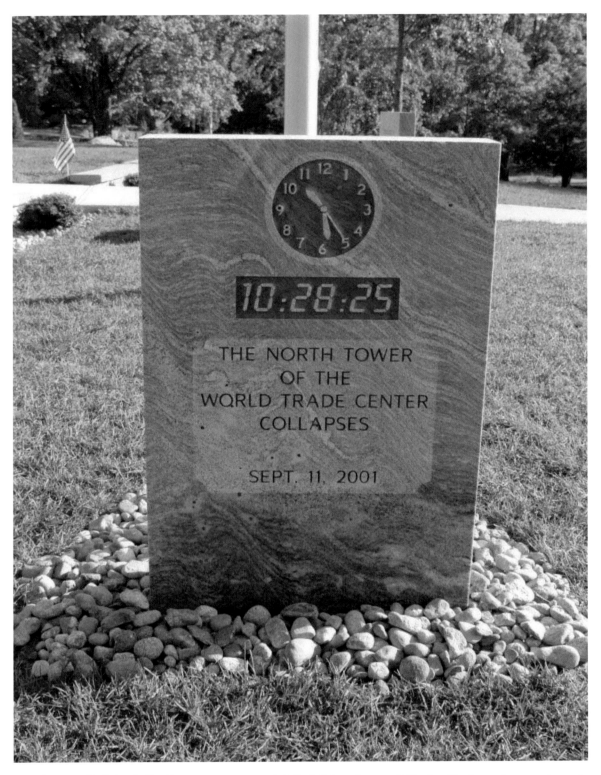

Madeline "Amy" (Todd) Sweeney, a 1984 Nashua High School graduate, was a flight attendant on American Airlines Flight 11, and relayed information that gave the FBI a head start on the investigation. Tom McGuinness of Portsmouth, NH, was the co-pilot on that flight.

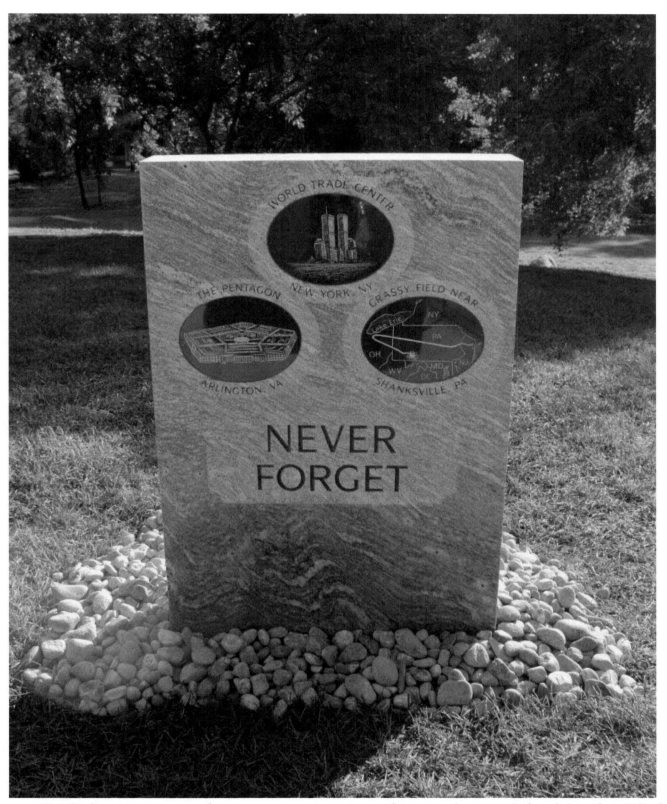

Three BAE Systems employees were among those who perished in the Flight 11 crash. Astronautical engineer Charles "Chuck" Jones of Bedford, Mass., was one of them.

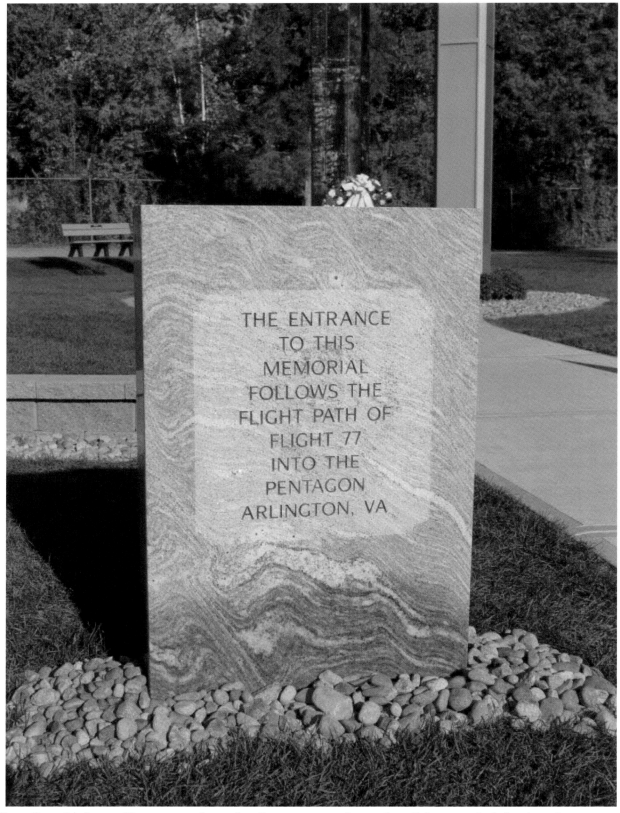

The final time-line marker before entering the Memorial is in the exact location where the plane hit the Pentagon.

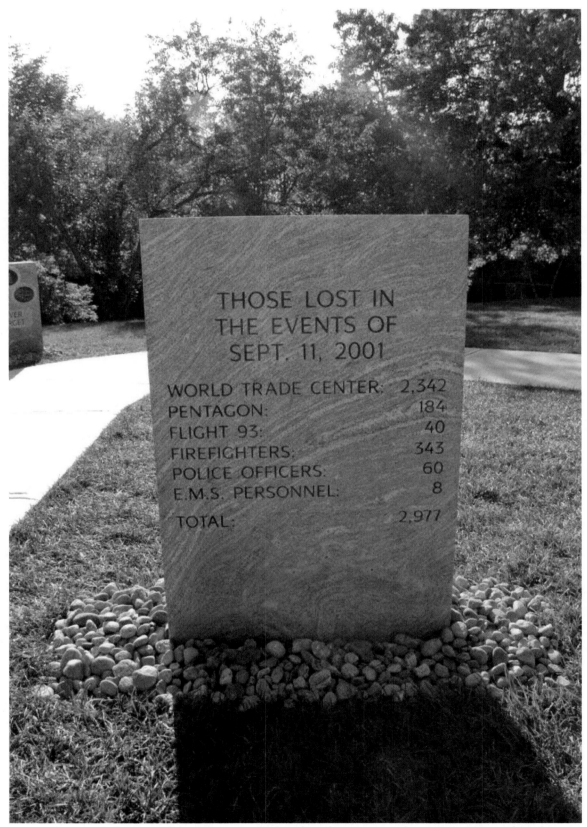

As visitors depart from the Memorial, the last marker recites the horrendous statistics.

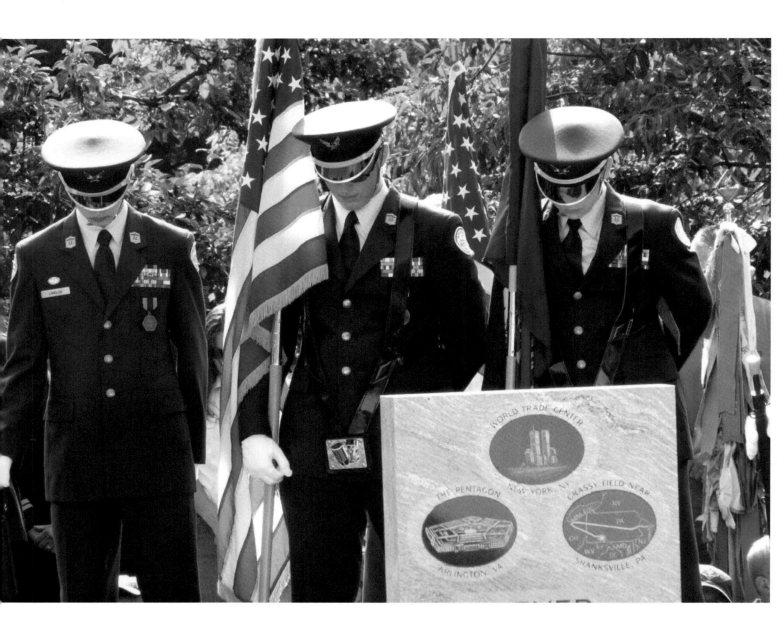

After the unveiling of all time-line markers, a prayer was offered by the Rev. David Howe.

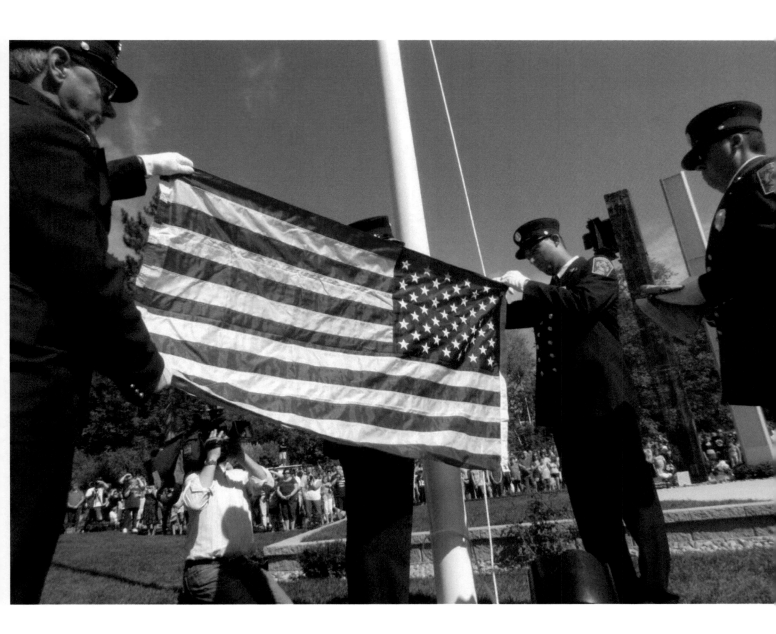

Bob Haggerty, Dennis Haerinck, and Sean Mamone prepare to raise the flag. The flag was donated by Paul Moore, the founder of Moore Mart, an organization that provides care packages to soldiers overseas. This flag flew over Kuwait.

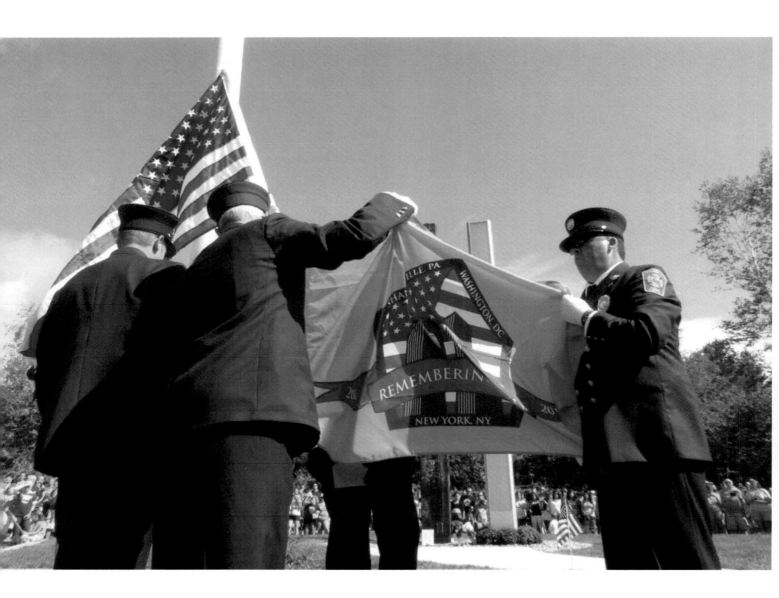

The official 9/11 flag will fly alongside the American flag at the Memorial.

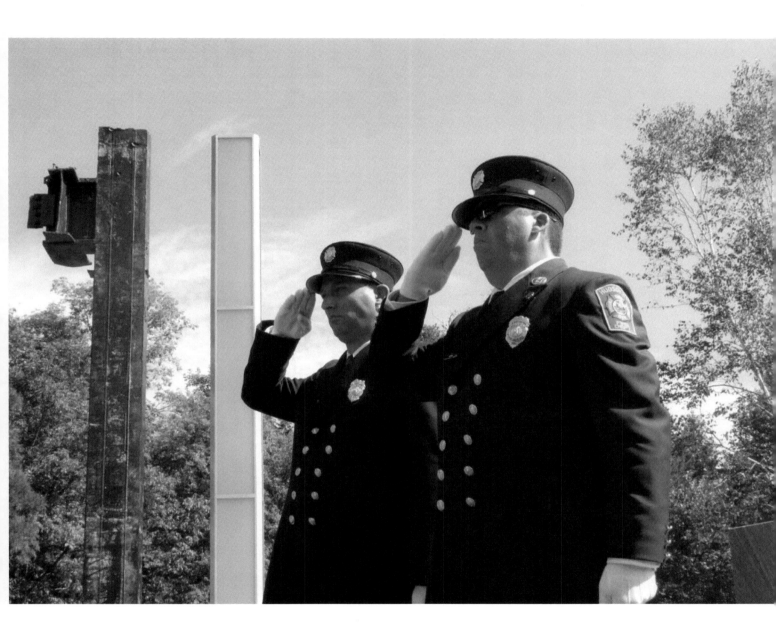

Dennis Haerinck and Sean Mamone salute as the flags are raised. Paul Moore led the assembled guests in the Pledge of Allegiance.

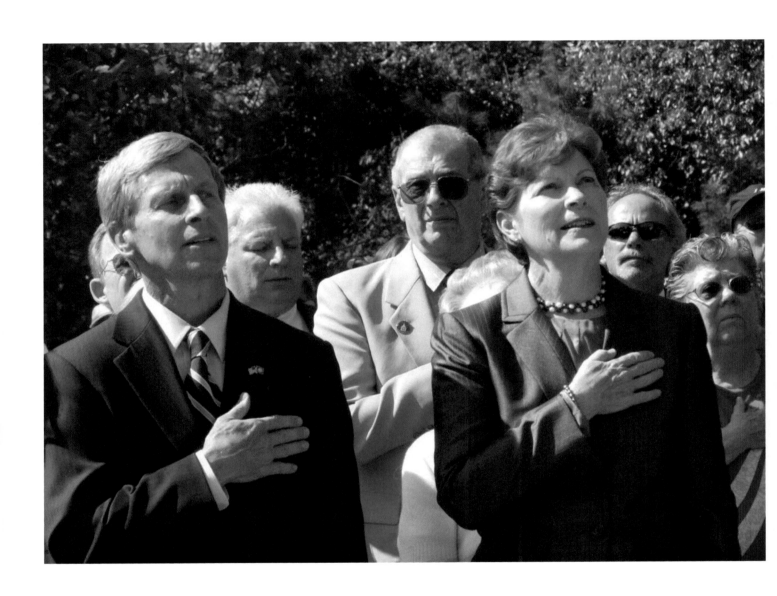

Gov. John Lynch, Sen. Jeanne Shaheen

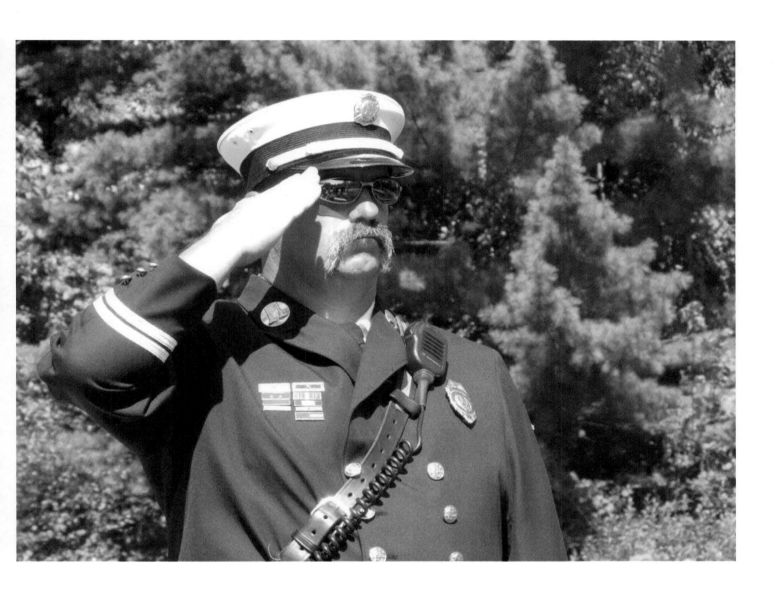

Captain Todd Hansen

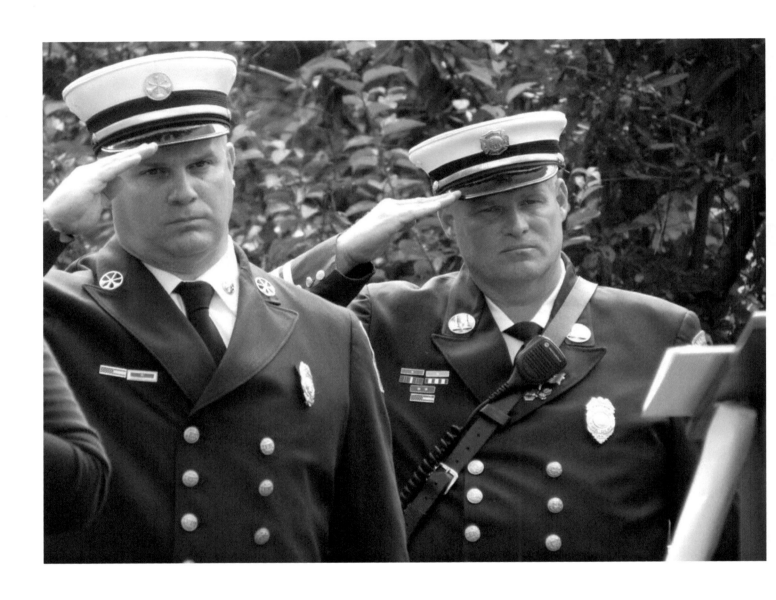

Deputy Robert Buxton, Captain Dave Morin

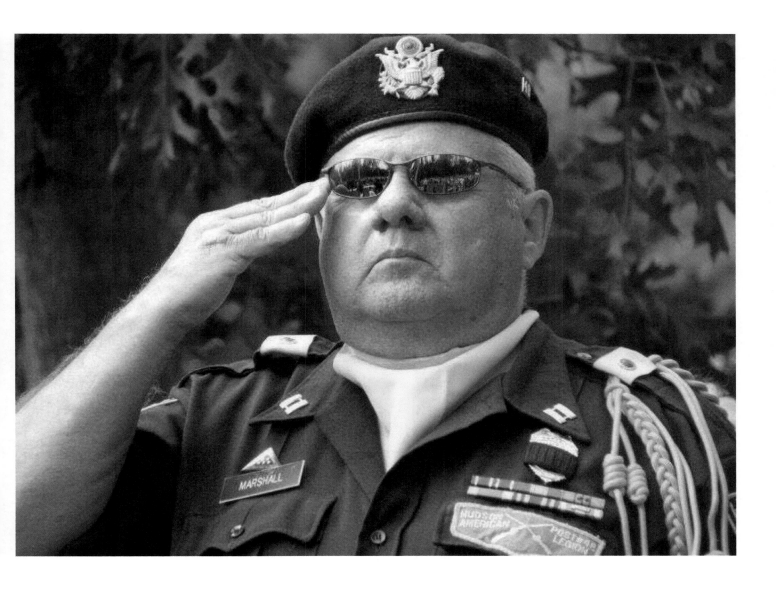

Retired fire Capt. Richard Marshall was the commander for the ceremony. He is also a member of the American Legion Post 48.

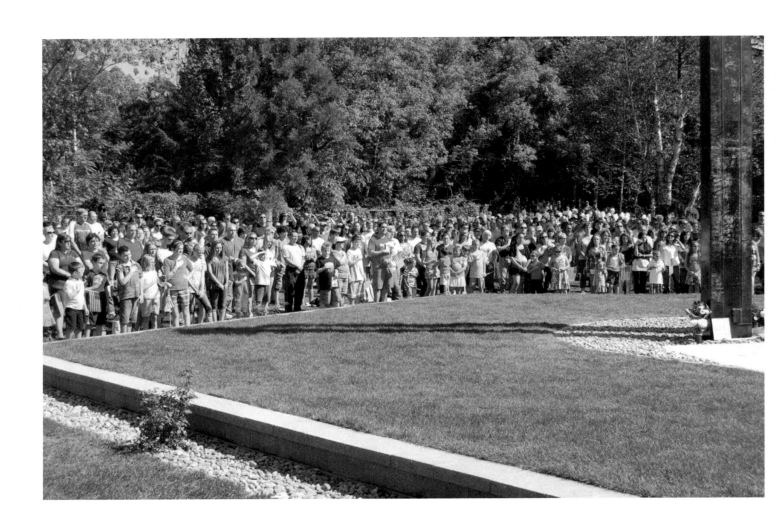

Everyone assembled takes part in the Pledge of Allegiance.

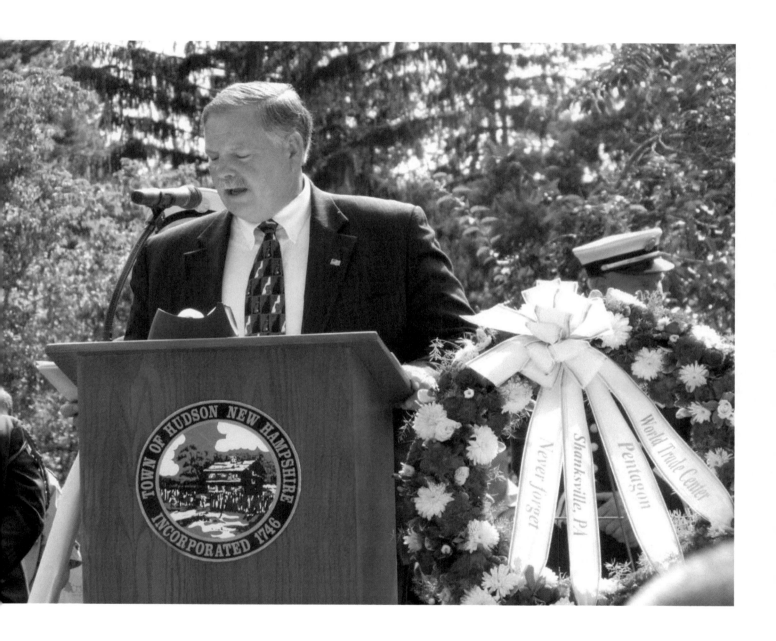

Chairman of the Hudson Selectmen, Shawn Jasper, led participants in the annual 9-11 Memorial Ceremony. The ceremony was followed by a moment of silence.

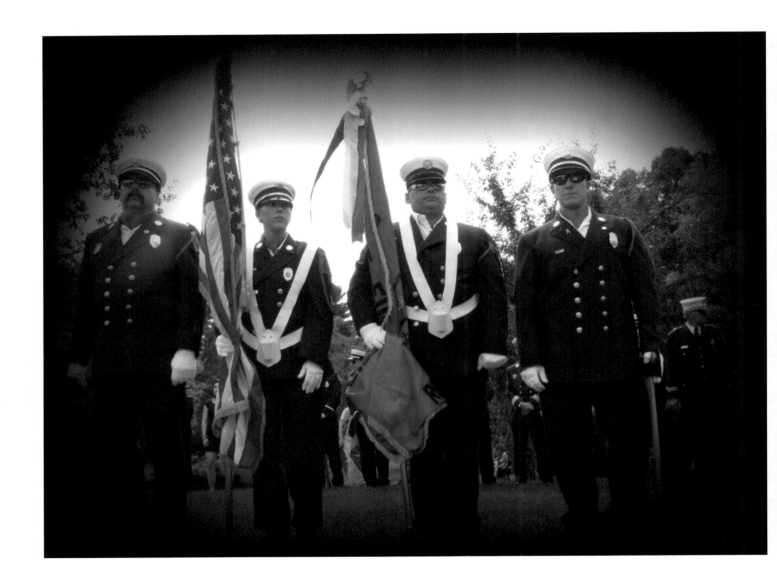

The members of the Hudson Fire Department Honor Guard are shown during the Pledge of Allegiance. The members are (left to right): Dave Brideau, Amanda Cormier, Gerry Carrier, and Dave Pierpont.

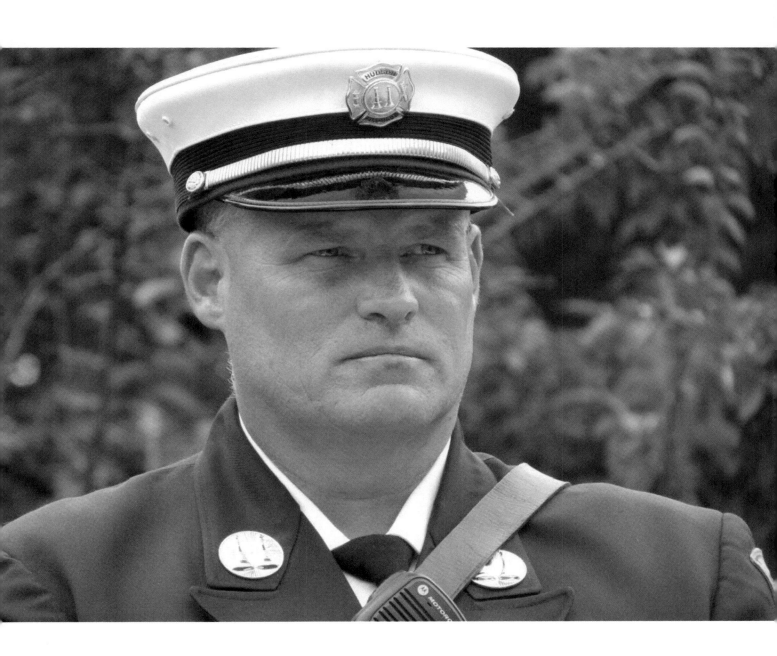

Captain Dave Morin during the moment of silence

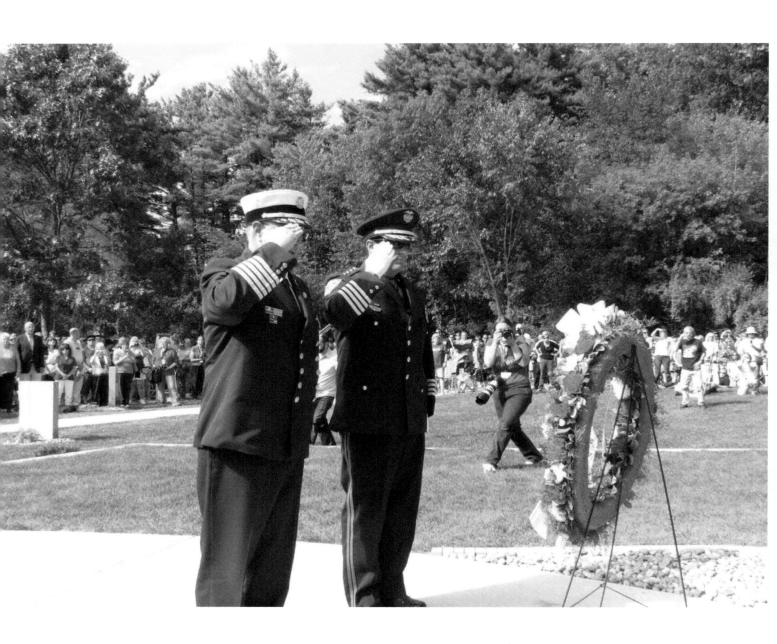

Hudson Fire Chief, Shawn Murray, and Hudson Police Chief, Jason Lavoie, lay the 9-11 memorial wreath in front of the two towers and salute.

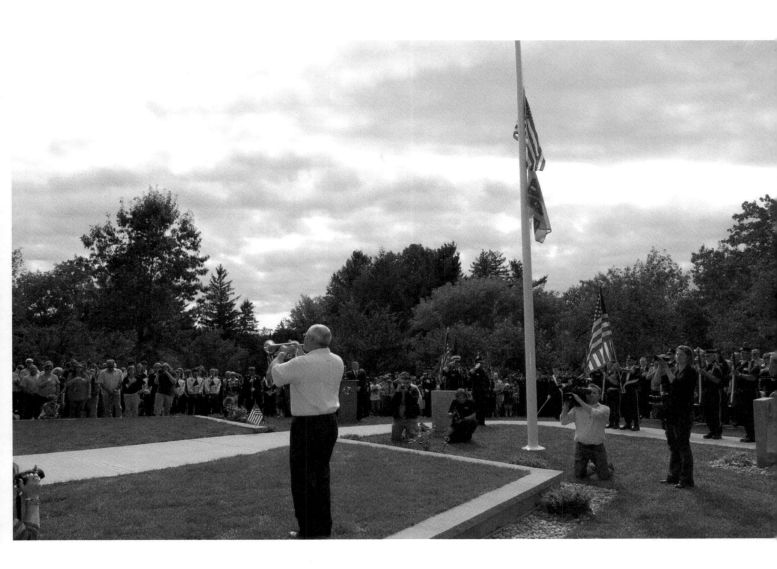

Bob Guessferd plays Taps.

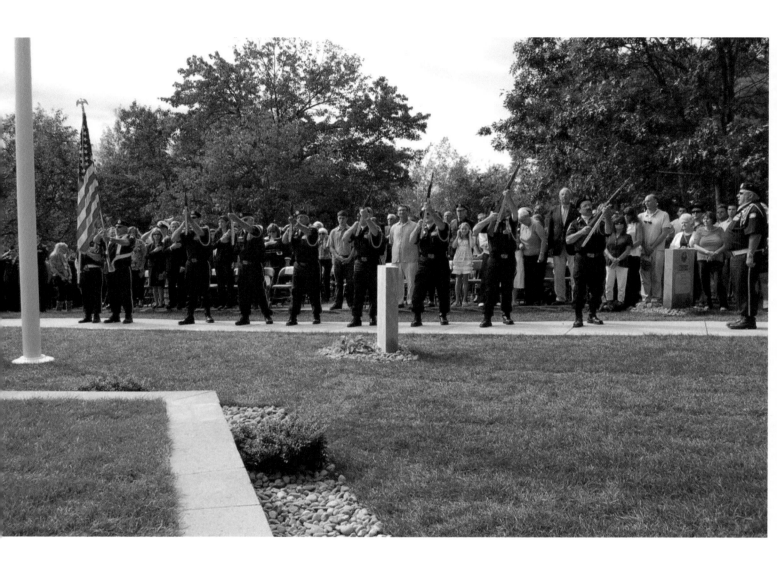

Members of American Legion Post 166 offer a 21 gun salute.

Bagpipe player John Keough plays *Amazing Grace*.

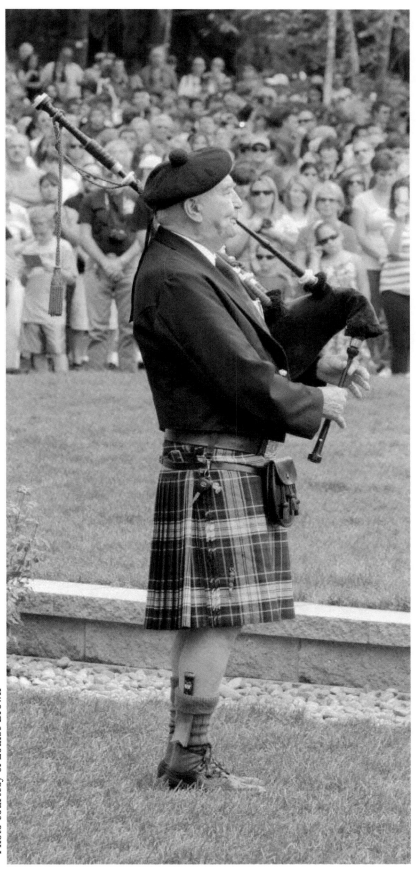

Photo courtesy of Louise Brown

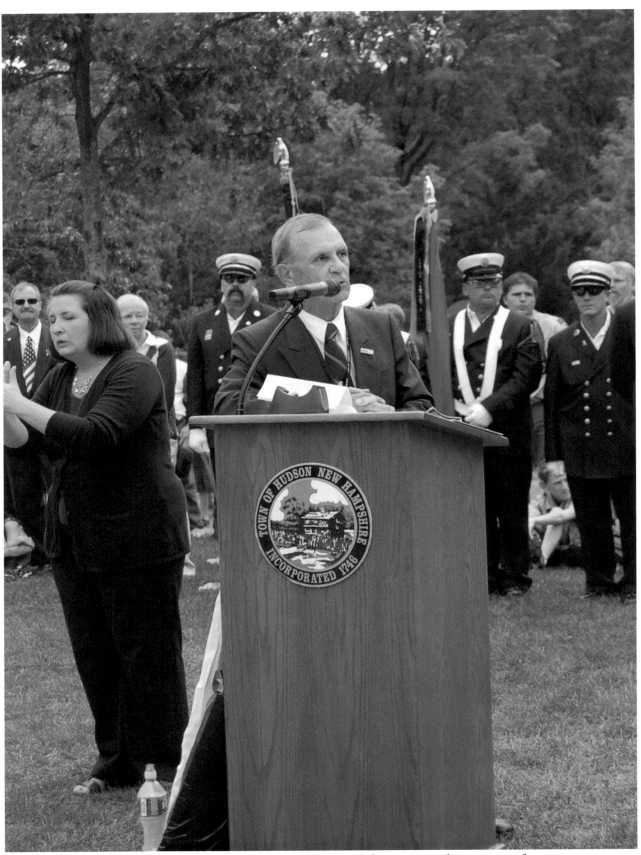

Selectman Roger Coutu addresses the crowd.

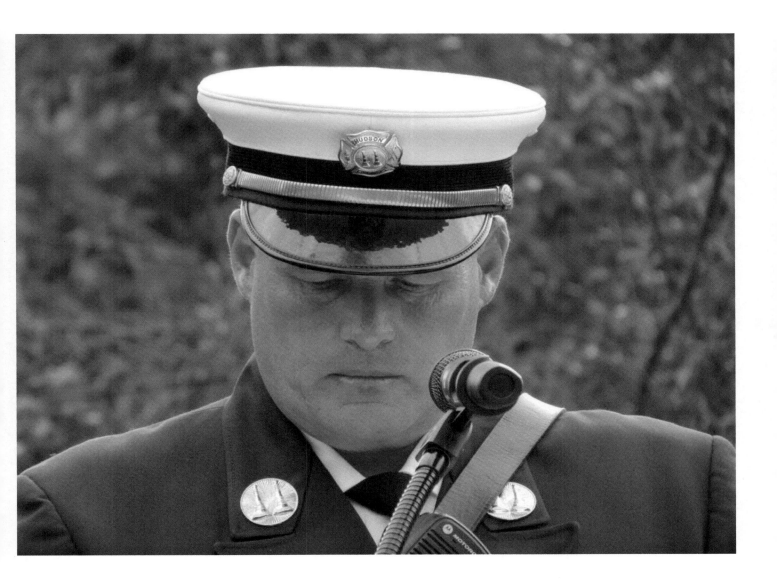

Fire Capt. Dave Morin, President of the 9/11 Memorial Committee, offers comments. He then introduces Elizabeth Kovalcin, widow of David Kovalcin, a Raytheon engineer who was a passenger on Flight 11. Morin invites her, along with her daughters, to join him and encourages them to select a rock from the entrance area.

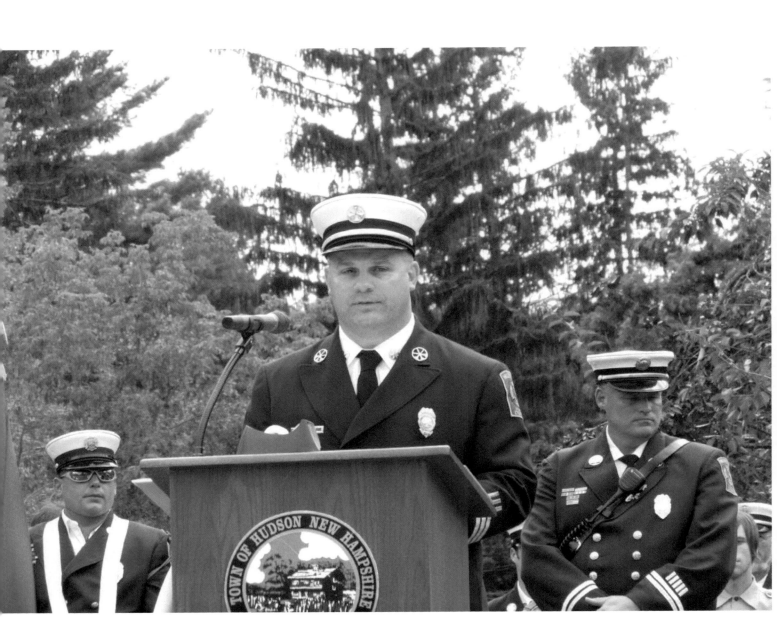

Deputy Robert Buxton explains the significance of selecting a rock. In the Jewish tradition, it is customary to leave a pebble or stone on top of a tombstone to signify that someone has honored the deceased with a visit to the grave. The 9/11 Committee felt this as a fitting gesture for this day.

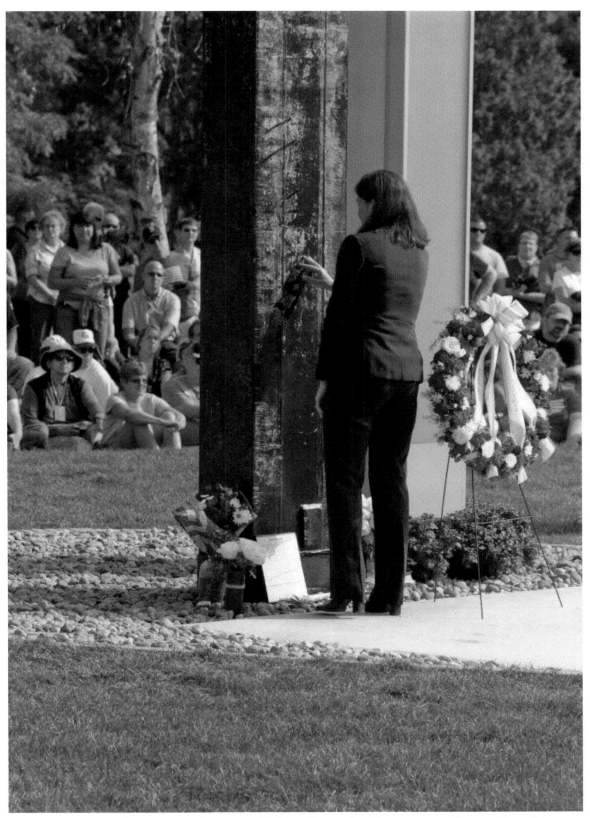

Sen. Kelly Ayotte honors the tradition by placing a rock at the base of the towers and takes the opportunity to pay her respects, touching the steel.

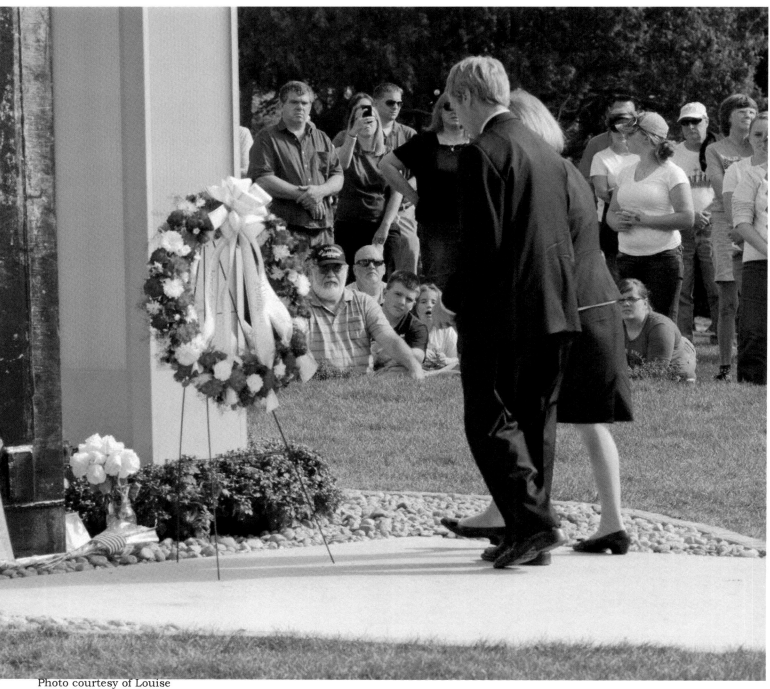

Photo courtesy of Louise

Gov. John Lynch and his wife, Dr. Susan Lynch, pay their respects by placing a rock at the base of the towers.

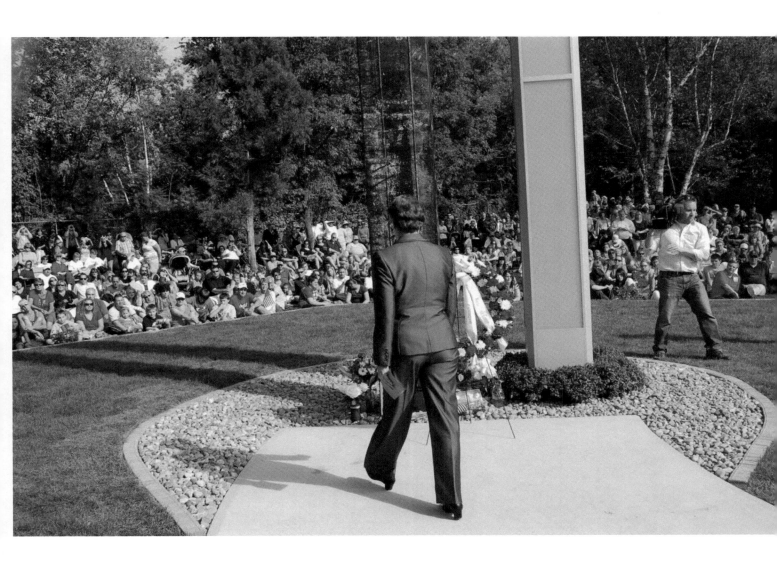

Sen. Jeanne Shaheen approaches the base to place a rock and pay her respects.

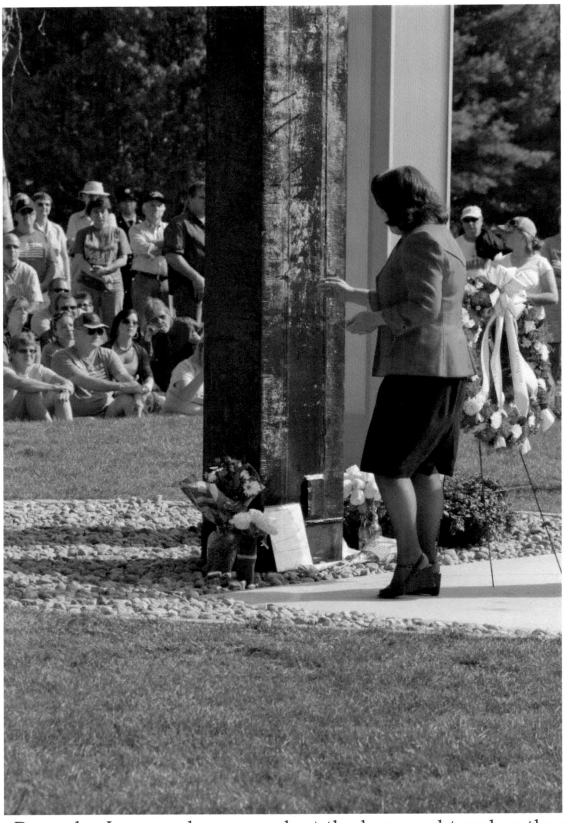

Mayor Donnalee Lozeau places a rock at the base and touches the steel as she pays her respects.

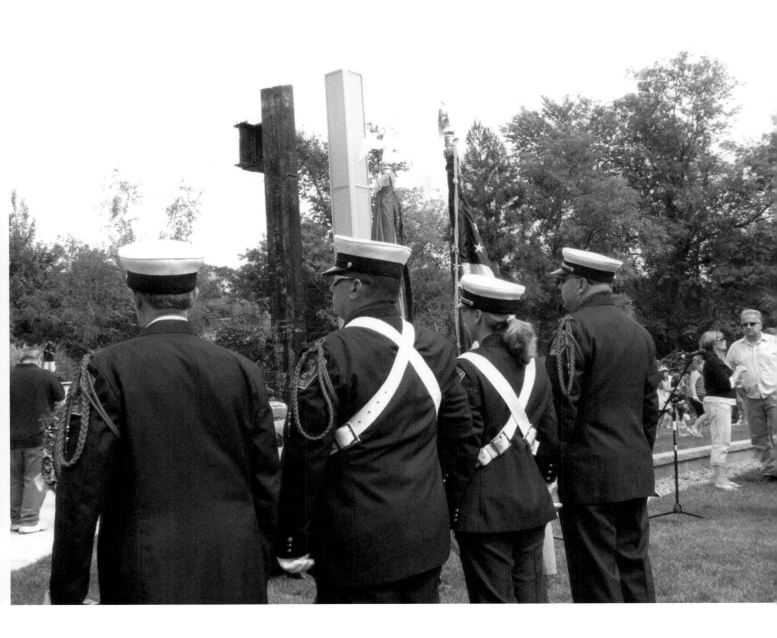

The Honor Guard watches in silence as each of the honored guests places a rock at the base of the towers.

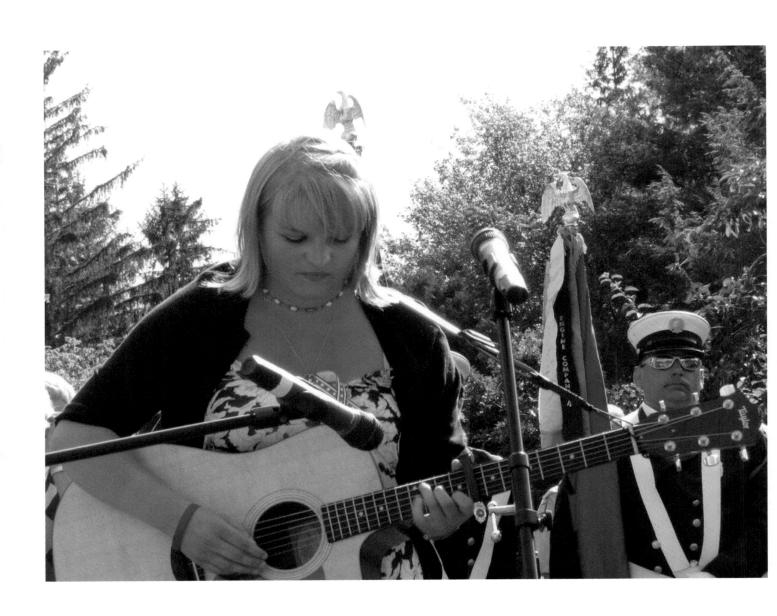

Taylor Morin sings, "Where Were You (when the world stopped turning)," while people wait to pay their respects.

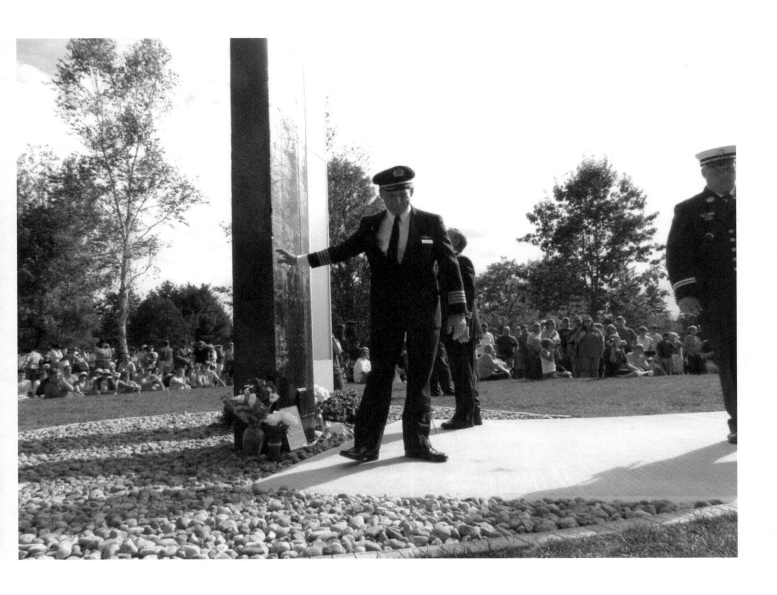

American Airlines Capt. Rick Krajaweski, accompanied by pilot Mark Wilson, pay respects.

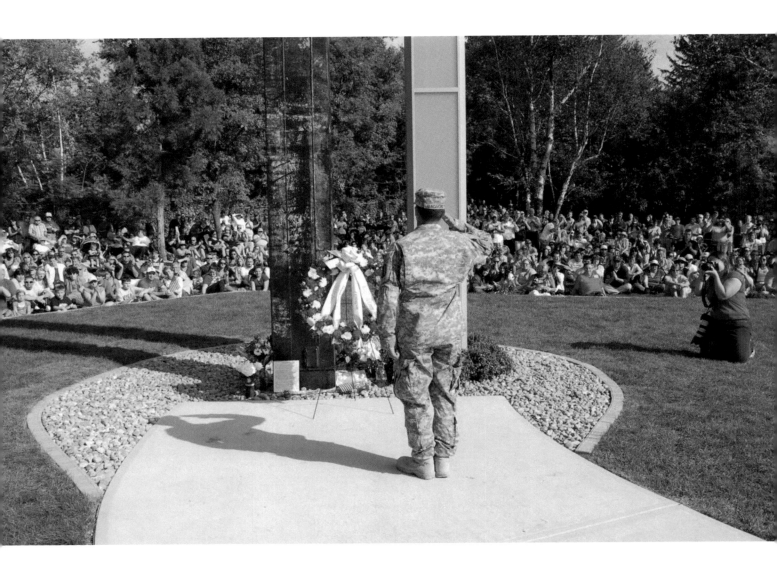

Jeffrey Gagnon, Army National Guard Specialist, salutes and pays his respects.

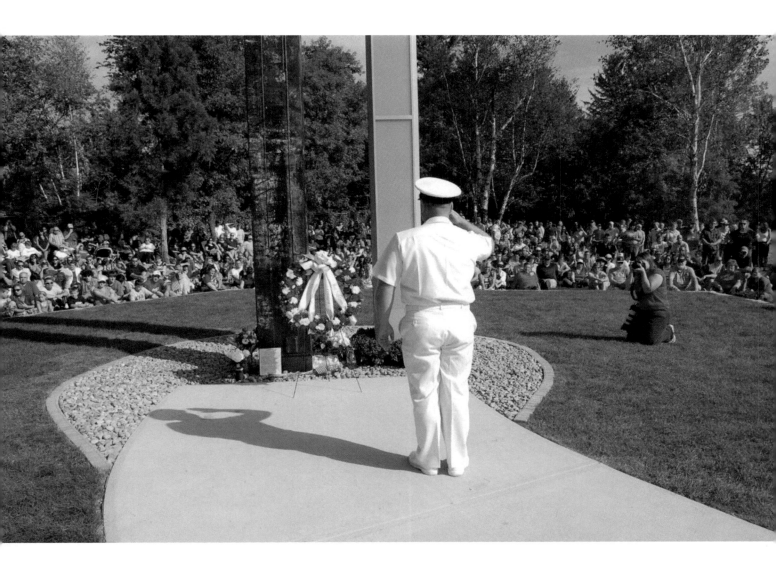

Drake H. Daniels, Jr., U.S. Navy Chief Aviation Structural Mechanic, salutes and pays his respects.

Photo courtesy of Hudson Fire

9/11 Committee members Deputy Robert Buxton and Captain Dave Morin are shown after the ceremony. The Memorial is now officially open to the public.

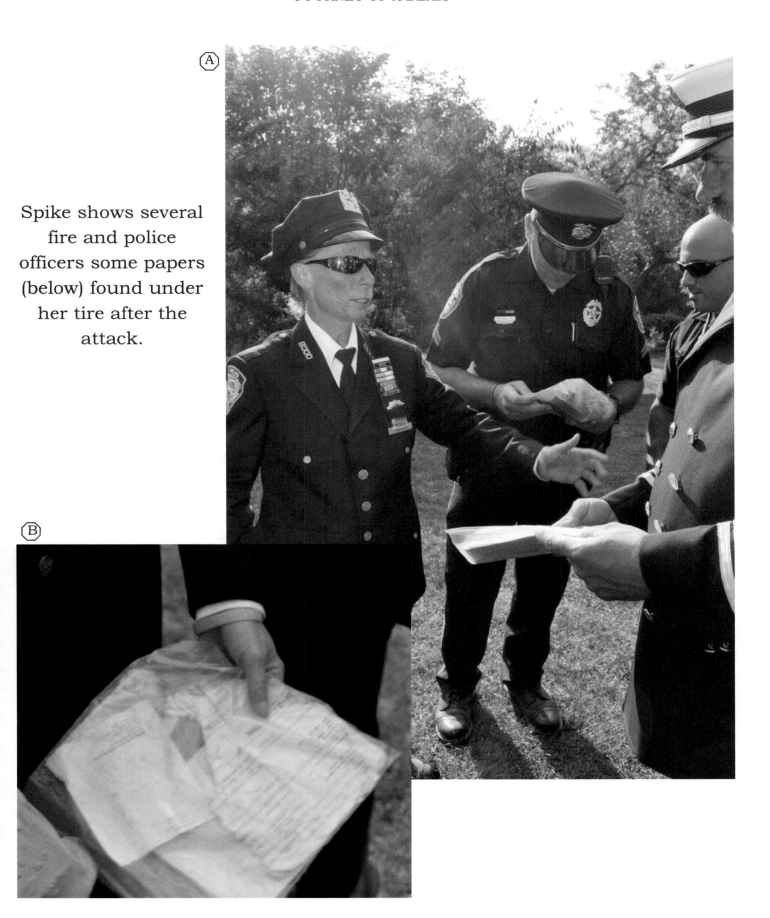

Spike shows several fire and police officers some papers (below) found under her tire after the attack.

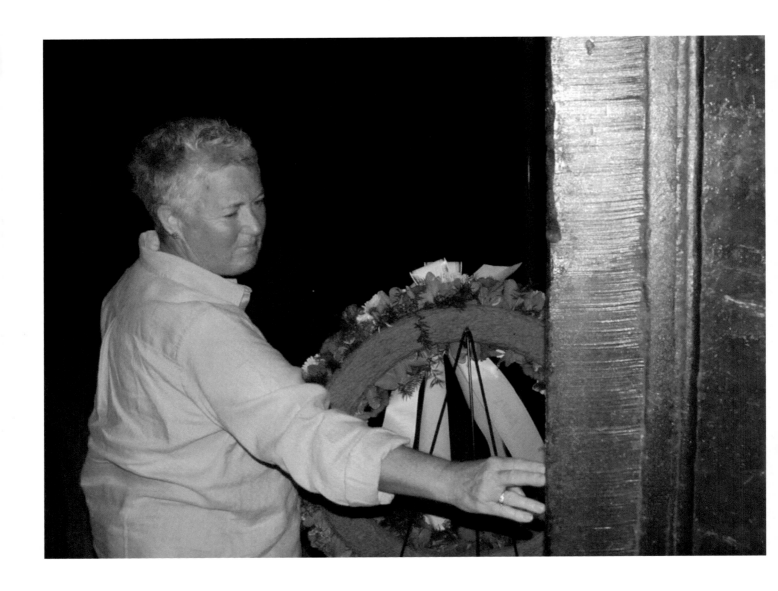

Later that evening, after the ceremony, Carole Whiting, accompanied by some other 9/11 Committee members, returns to the memorial where she is finally able to show her respects.

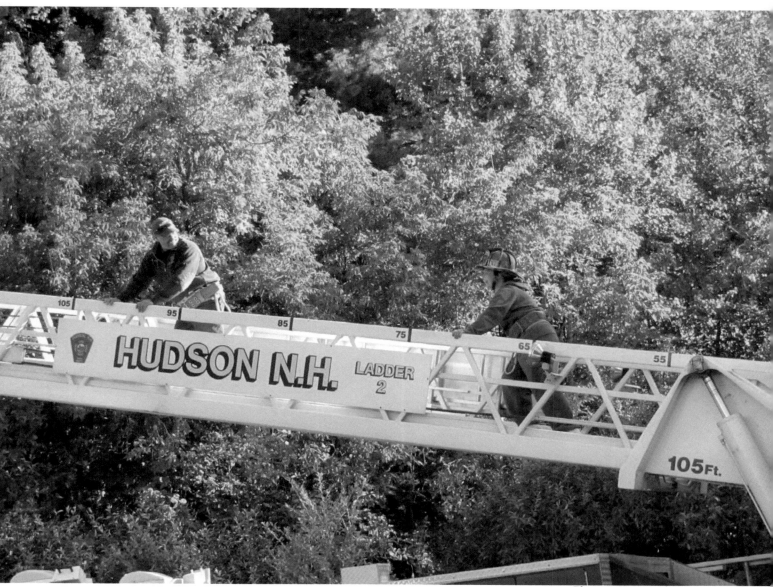

Photo courtesy of Dawn

During the week following the 9-11 ceremony, Captain Dave Morin arranged for a ladder truck and several firefighters to assist the author, Christina Green, in order to obtain some aerial photos. Despite being scared, the author is thankful that the crew was able to talk her through it.

Captain Dave Morin and Julie Hansen affix the safety harness and helmet.

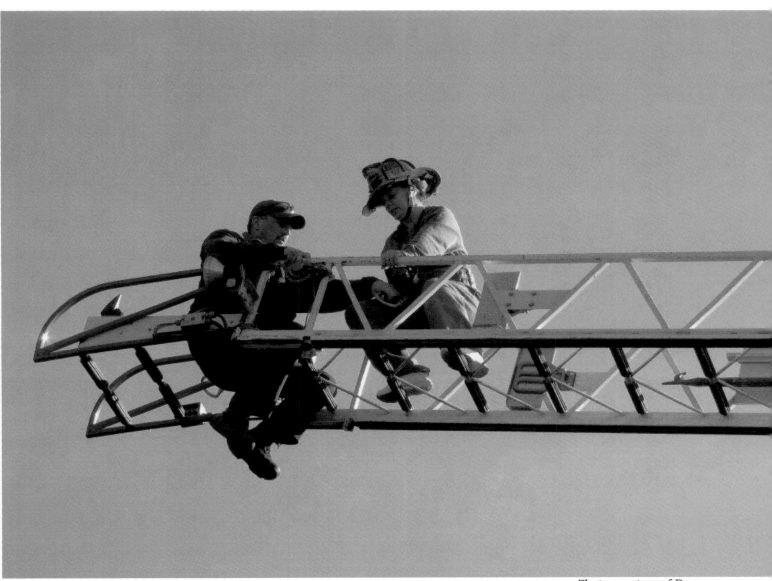

Photo courtesy of Dawn

Perhaps the scariest part of the day is getting safely buckled in.

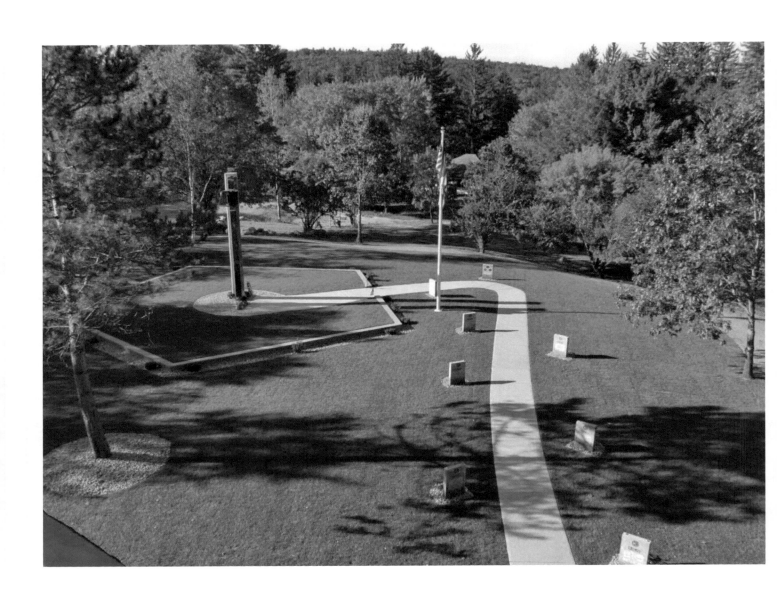

The view from above is breathtaking.

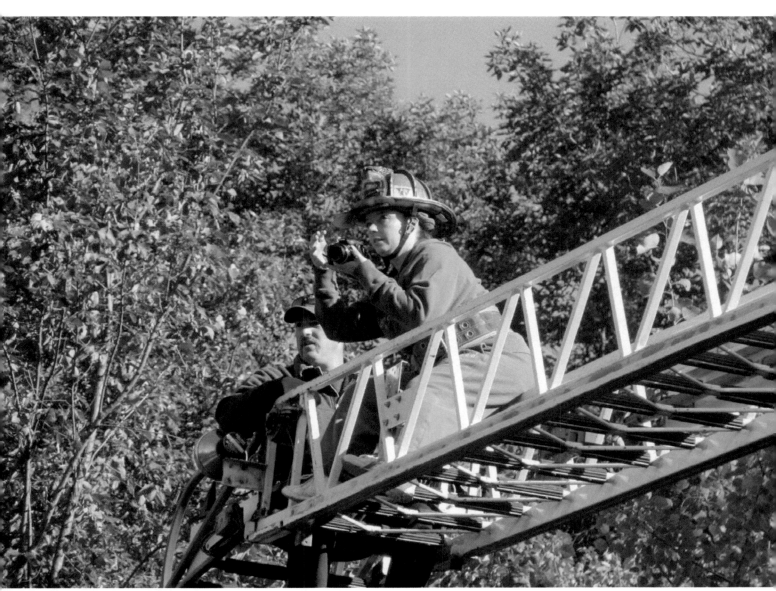

Photo courtesy of Dave Morin

The author in action.

Photo courtesy of Dawn Philbrook

Brian Alley and Erich Weeks let Christina Green off the truck after the aerial views were taken.

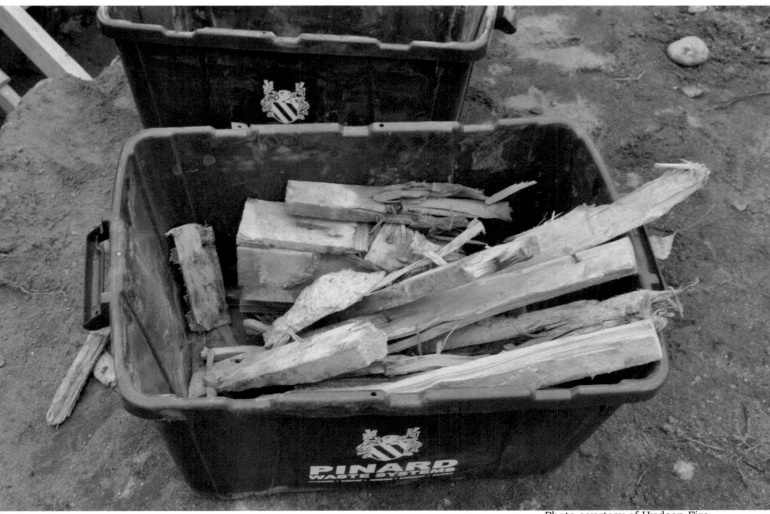

Photo courtesy of Hudson Fire

These wood pieces had been removed from the steel beam prior to the construction of the memorial. In the month following the ceremony, they would be placed inside the beam where it would be grouted and sealed.

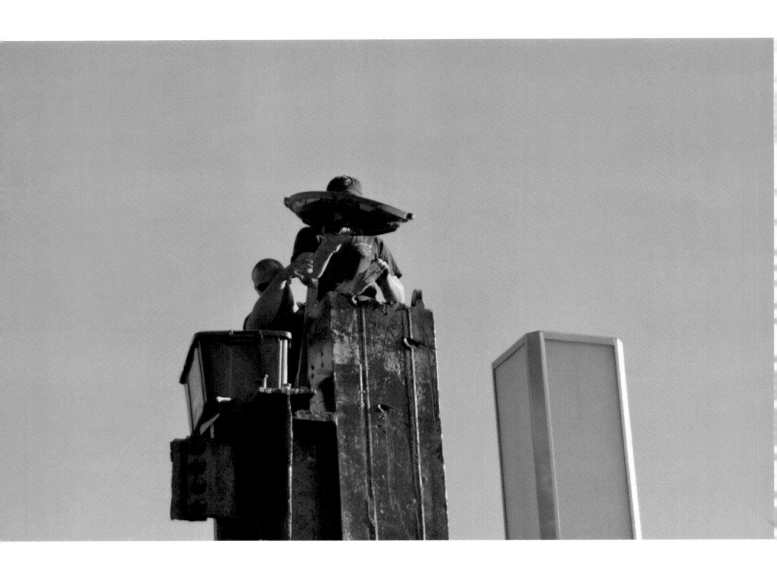

Brian Alley (left) and Corey Morin put the wood pieces inside the beam and seal it.

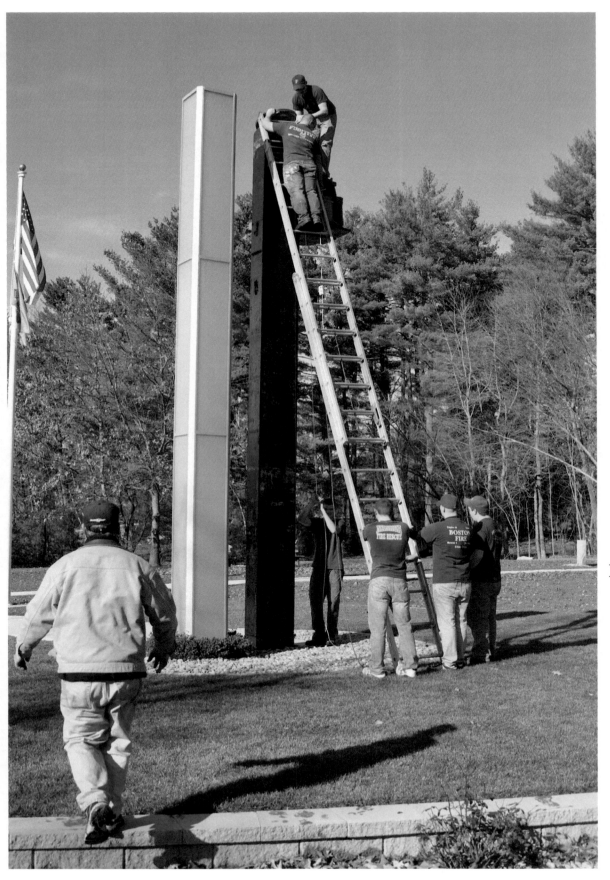

Performing the work: Several Hudson Fire Explorers assist Firefighters Corey Morin and Brian Alley on the ladder.

They include Nick Perault holding the rope; Paul Bourque III, Joe Kuhn, and Chris Wilkins supporting the ladder.

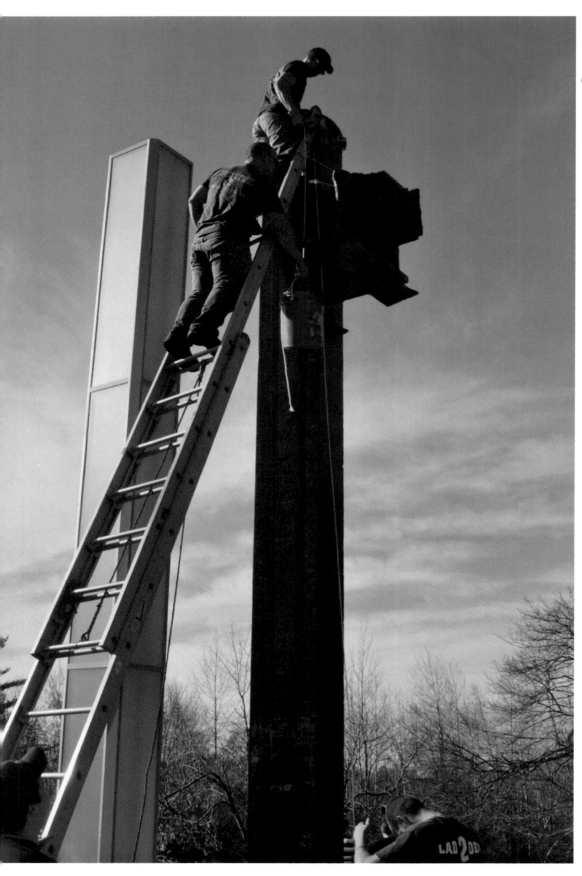

Brian Alley and Corey Morin at the top.

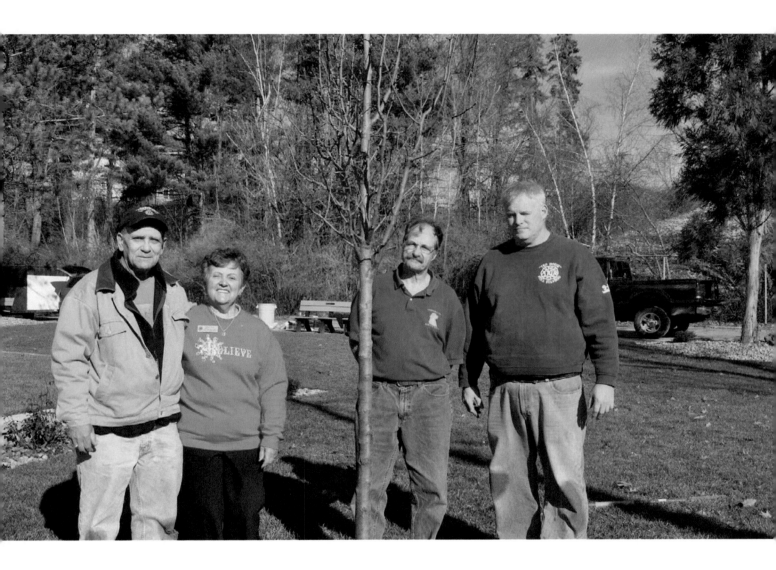

Roger Coutu, Lillian Bellisle, Bill Leblanc, and Dave Morin stand next to a pear tree. The tree, donated by the Hudson Nottingtham West Lions Club for the 9-11 Memorial, represents the "Survivor Tree," which was found in the wreckage of the World Trade Center Plaza. Lillian and Bill are members of the Nottingham West Lions Club.

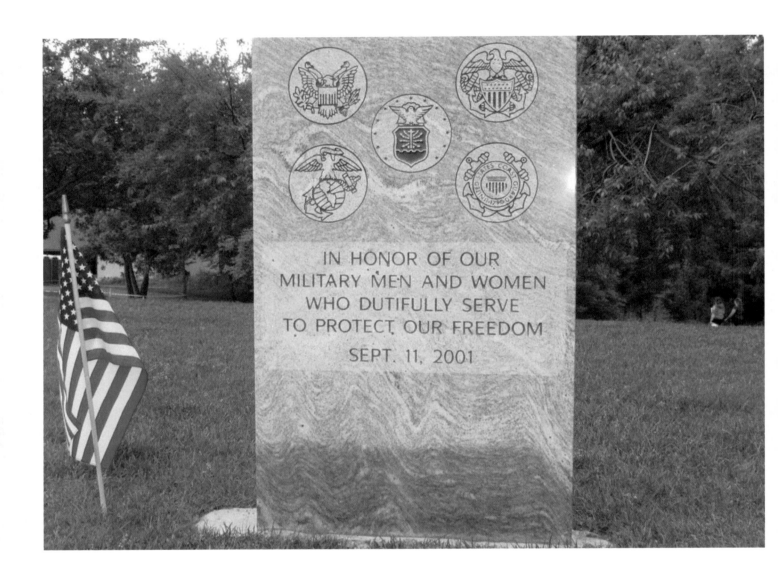

The marker shown above was placed on Memorial Day, 2012. It is the final item added to the Memorial. It is in memory of those members of our armed forces who gave their lives and in honor of those still fighting.

On this and the following pages are random photos taken at the site. They were taken at different times, in different light, and in different places within the Memorial.

 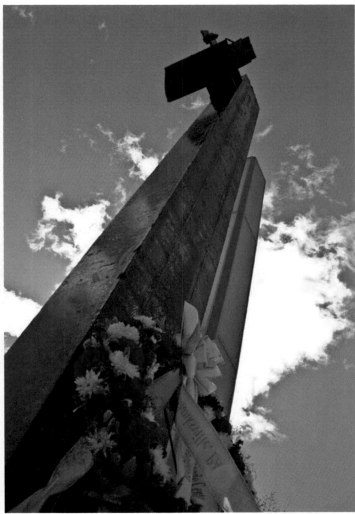

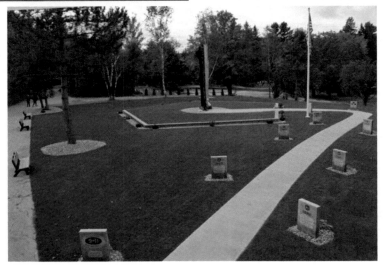

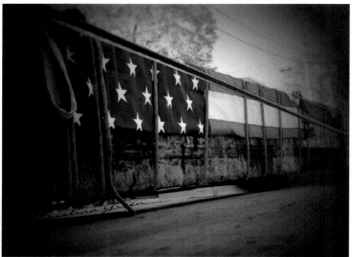

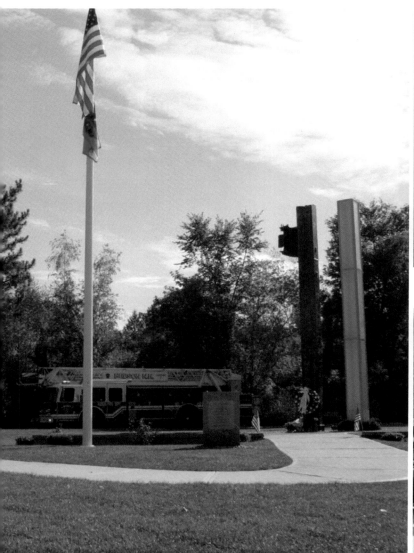

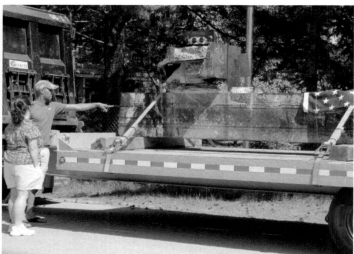

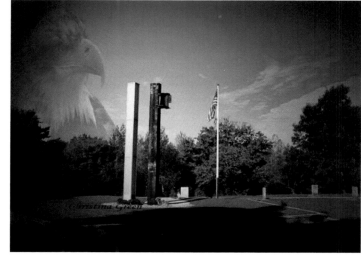

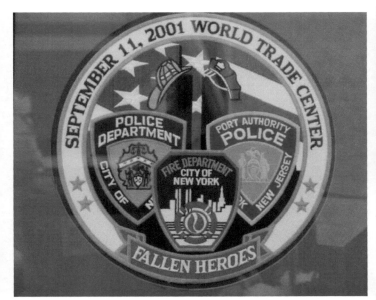

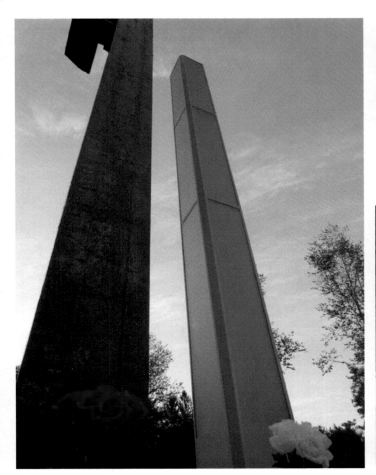

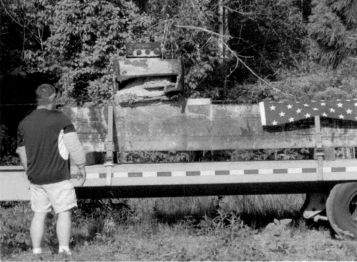

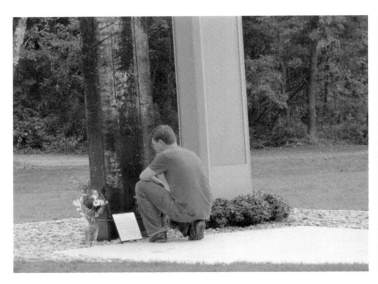

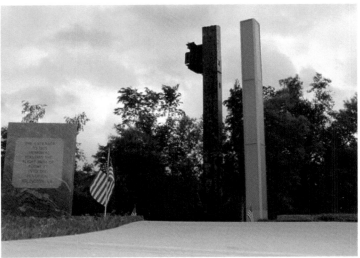

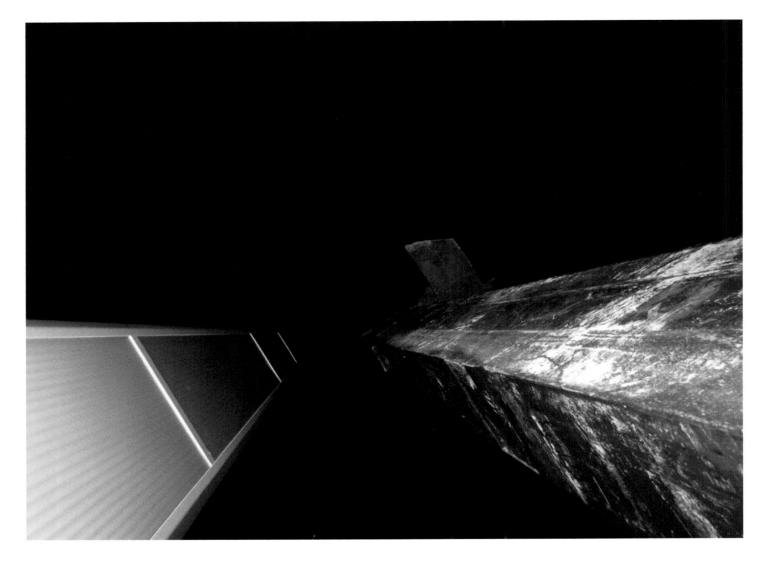

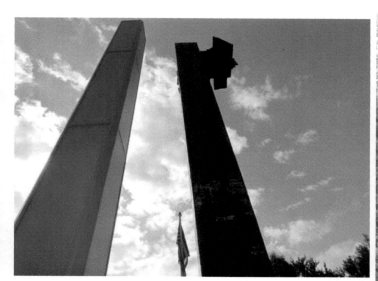

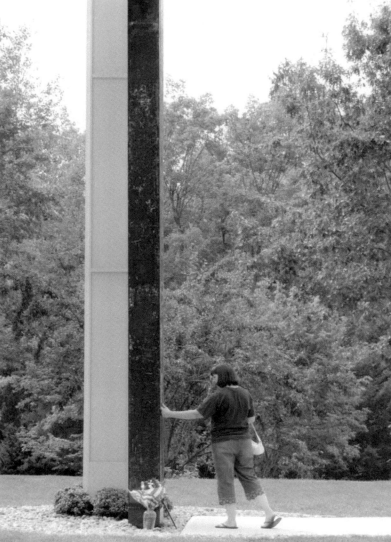

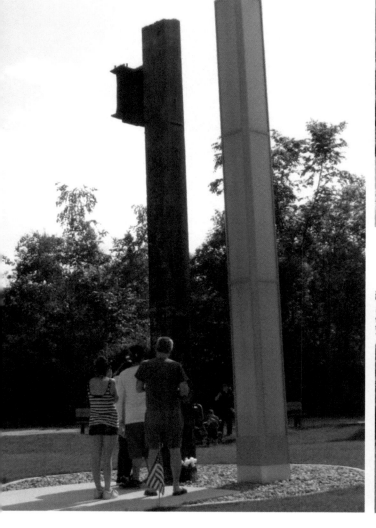

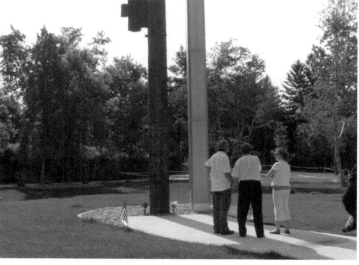

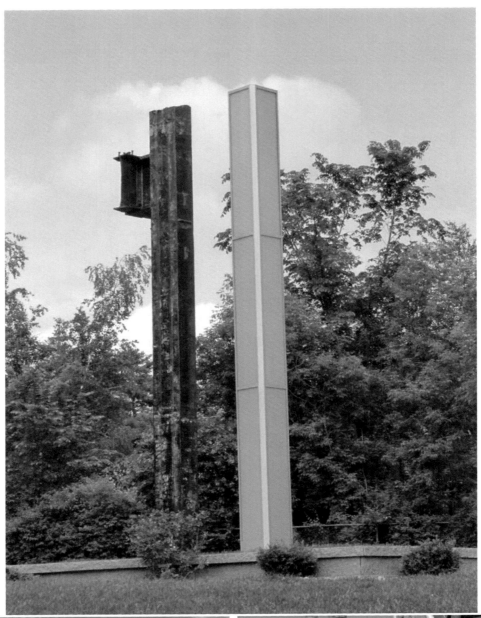

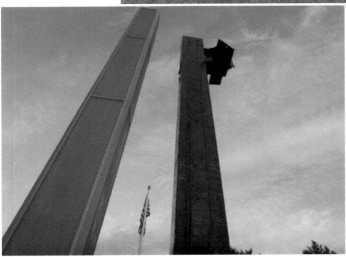

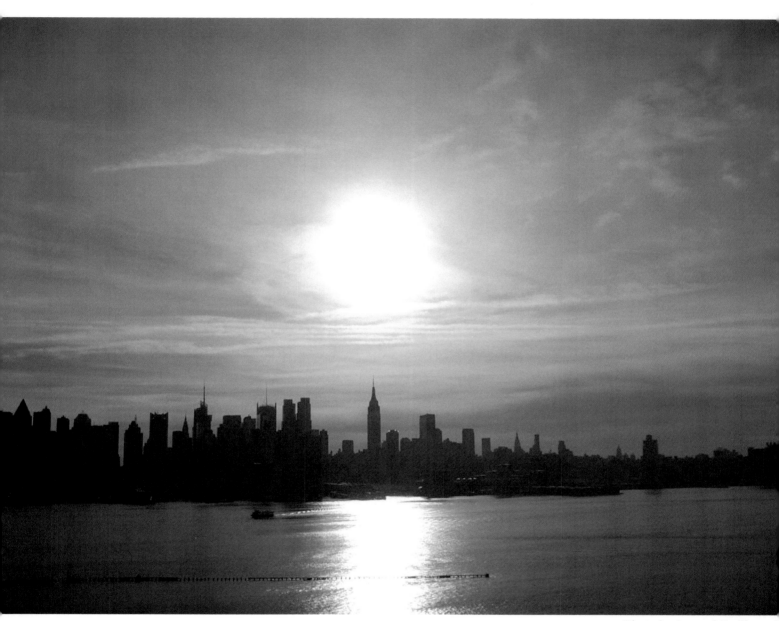

Photo by Samuel Zerillo

This is the New York skyline today.

About the Author

Christina Green received her first camera, a Canon, at the age of 15. She grew up in a creative family, including her mother, a painter. With her exposure, she became an expert behind the camera. The tricks and techniques she learned then were enhanced by her two best friends, both photographers.

In addition to the project which led to this book, Christina has served as a photographer for the company where she works, Nanocomp, a technology company which works for U.S. Military, Space and National Security interests. She is also the founder of Studio Christena's, which photographs a wide variety of events and subjects.

She lives in New Hampshire not too far from the 9-11 Memorial, upon which this book is based.

Photo Print Order Form

(please feel free to copy this page)

Photos are available in two sizes: 8 x 10—$25 each

11.5 x 17.5—$40 each

Offer valid only on photos by

Page	Letter	Qty	Size	Unit Price	Total

Shipping and Handling (any quantity) $ 3.00

Total quantity ordered: ☐ Total Enclosed $ ☐

Please enclose this page (or a copy) and send with complete payment to:

Studio Christena's

88B Barretts Hill Rd.

Hudson, NH 03051

Ship to:

Name: ...

Address: ...

City: ...

State: Zip Code:

CPSIA information can be obtained
at www.ICGtesting.com
Printed in the USA
LVIW021952251112

308646LV00002B